08-5 Thu
12:52 AM PDT

08-5 Thu
7:19 AM PDT

08-5 Thu
1:50 PM PDT

08-5 Thu
7:38 PM PDT

11 12 1 2 3 4 5 6 7 8 9 10 11 12 1 2 3 4 5 6 7 8 9 10

ELEGY FROM THE EDGE
OF A CONTINENT

Published by GOFF BOOKS, an Imprint of ORO GROUP LTD.
Gordon Goff: Publisher

www.goffbooks.com
info@goffbooks.com

USA, EUROPE, ASIA, MIDDLE EAST, SOUTH AMERICA

Colophon Information if necessary.

Text and photographs: Austin Granger
Book Design: Pablo Mandel / Circular Studio
Managing Editor: Jake Anderson

10 9 8 7 6 5 4 3 2 1 First Edition

Library of Congress data available upon request. World Rights: Available

ISBN: 978-1-935935-26-1

Color Separations and Printing: ORO Group Ltd.
Printed in China.

International Distribution: www.goffbooks.com/distribution

ORO EDITIONS makes a continuous effort to minimize the overall carbon footprint of its publications. As part of this goal,
ORO Editions, in association with Global ReLeaf, arranges to plant trees to replace those used in the manufacturing of the
paper produced for its books. Global ReLeaf is an international campaign run by American Forests, one of the world's oldest
nonprofit conservation organizations. Global ReLeaf is American Forests' education and action program that helps individuals,
organizations, agencies, and corporations improve the local and global environment by planting and caring for trees.

AUSTIN GRANGER

ELEGY FROM THE EDGE
OF A CONTINENT

PHOTOGRAPHING POINT REYES

goff BOOKS

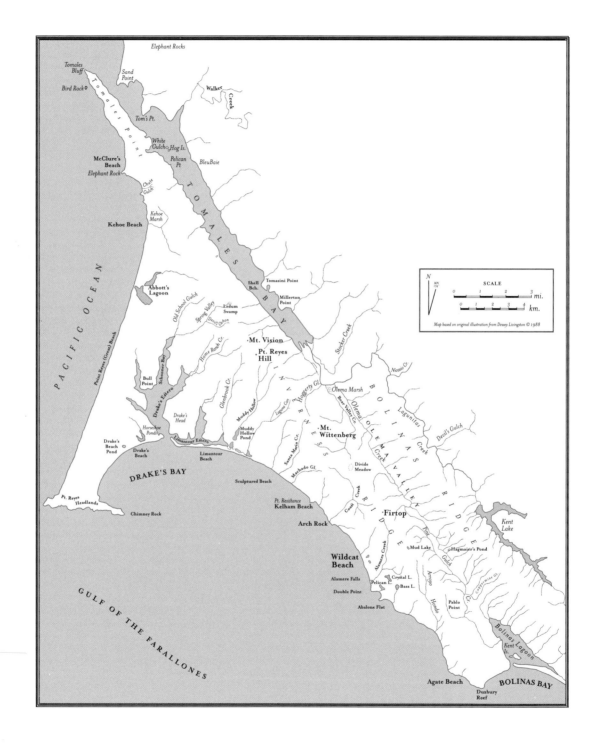

Table of Contents

For W.

Where Go the Boats?

Dark brown is the river
 Golden is the sand.
It flows along for ever,
 With trees on either hand.

Green leaves a-floating,
 Castles of the foam,
Boats of mine a-boating–
 Where will all come home?

On goes the river
 And out past the mill,
Away down the valley,
 Away down the hill.

Away down the river,
 A hundred miles or more,
Other little children
 Shall bring my boats ashore.

❧ Robert Louis Stevenson

ELEGY FROM THE EDGE OF A CONTINENT

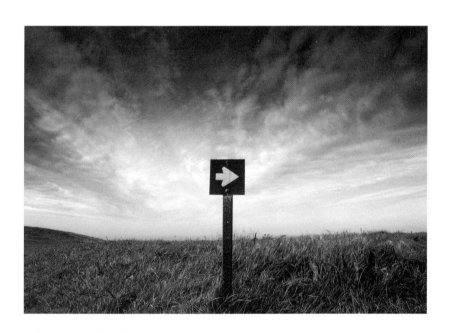

Introduction

New Year's Day, 2005

IN THE DARKNESS BEFORE THE DAYBREAK of the New Year, I bend down and kiss the cheek of my sleeping son, my love, my little light. I breathe in, consciously, as if trying to bring in a measure of his being, as if to inhale his faith in me, and become the man he thinks I am.

And then, after a kiss and some whispered words for my wife, my hearth, my anchor, who knows not why I go but loves enough to let me, I'm out the door and on the porch.

I sit there in the cold, on my red steps, lacing up my hiking boots and marveling at the street. There is a stillness this morning, an expectant hush that reminds me of Christmas, of the Christmas before Christmas, when everyone is still in bed. Under the streetlights, the dark, shining leaves of our magnolias look strange, funereal, like plastic bouquets in a mausoleum. The trees honor the old year while the revelers sleep it off.

How our minds make the world!

Late last night I heard those revelers from my darkroom, worlds away. Without any self-consciousness there in my sanctuary, I put on an absurd brogue, and offered them a poem:

I rise in the dawn, and I kneel and blow
Till the seed of the fire flicker and glow;
And then I must scrub and bake and sweep
Till stars are beginning to blink and peep;

And the young lie long and dream in their bed
Of the matching of ribbons for bosom and head,
And their day goes over in idleness,
And they sigh if the wind but lift up a tress:
While I must work because I am old,
And the seed of the fire gets feeble and cold.

Happy New Year everyone.

I have a picture of old Yeats up there in my gallery of saints—I pinned him to the wall with a thumbtack. His lips are slightly parted, his eyes focused on some faraway thing. It's the expression of a man who's left his body behind for a life of contemplation. He's got good company, Yeats does, among this motley bunch of friends I never knew. I must admit I took a certain pleasure in the matchmaking. I fixed up the Buddha with Hank Williams, Lao Tzu with Van Gogh, neighbored Nietzsche with Jesus and St. Francis. Here's Johnny Cash and Kierkegaard; I imagine they'd get on all right, but Salinger and El Greco? Whitman and Schopenhauer? Who can say? Here are my photographer brethren: St. Ansel and Brassaï and Minor White—could there ever be a better name for a photographer than Minor White? And here is Edward Weston, who died before I was born and yet, still he is my mentor.

Edward, the first time I saw your pictures, they stayed with me such that for days afterward, whenever I closed my eyes,

*I could see afterimages floating there in the dark, all those shells and rocks and trees and torsos, dancing behind my lids, burned into my mind. They frightened me, your pictures. For how could they hang there on that wall, trapped behind glass, and **live?** Impossible. And yet they did live; they lived within me as I stumbled around half dazed in the light, muttering to myself, vowing to myself; it is that which I want to do for the rest of my life. And I'm trying Edward—I'm really trying.*

Here are more musicians: John Lee Hooker, Leonard Cohen, Miles Davis… How many photographs have I printed to *Sketches of Spain*? I couldn't count them. But I swear if someone ever asks me why I make my pictures look the way they look, I'll tell them I try and make them look like the sound of Miles Davis. It's preposterous of course, and yet, it's perfectly true. It's that timbre that I'm after, that timbre that's ethereal and lonely and solemn and beautiful all at once.

I don't imagine Miles ever made it to Point Reyes, but he should have. He could have made its ode.

Lately, I've been considering taking down my saint's gallery and returning to the austerity of a blank wall. All those eyes up there are making me a little nervous.

Just what do I want from myself anyway?

It's been said that a photographer's darkroom is an external representation of his mind; that it is his inner self outed. If that's the case, I'm afraid I've drifted a few strokes past eccentric, and float now in darker quarters.

I've begun to write on the walls a little.

They're admonitions mostly, reminders to myself. A while back I spray painted the word *attention* in huge black letters. I laid it on too heavy though, and the paint ran down, escaping the bounds of its message. Now the old rebuke looks vaguely sinister, all those spidery drips like dried up blood.

Late last night, I heard the revelers from my hovel, celebrating their new year as I stood in the dark, loading sheet film into holders. I didn't resent their jubilation—each thing in its turn.

One might be surprised to learn just how difficult it is to get a darkroom dark. Sealing the windows wasn't so bad. I painted the panes flat black, then wedged thick pieces of cardboard into the frames, and then, for good measure, I sealed the whole thing over with opaque black plastic. It was the door that proved the real challenge. Even with thick black plastic sheets hung on either side, somehow the light always found its way in. After countless trials, I finally discovered that the only solution was to seal myself in with duct tape.

I mounted a louvered vent in the door so I can breathe. For bodily functions, I take care of things like an astronaut. I carry it out. I have an old water bottle I keep in the corner. I'm discreet.

I'll be the first to admit that sometimes it's a little unsettling to be trapped like that, but I always figure in the worst case, if some sudden panic descends, I could always kick out a window and dive out into my backyard, out into the blackberry bushes.

As far as the darkness goes, I rather like it actually. And I've found that my other senses have become accentuated, as if to compensate. Music is wonderful. And I've learned to do a lot of things—surprising things—without being able to see anything at all. For instance, I've become adept at the delicate task of loading sheet film into holders. The manufacturers cut tiny notches into a corner of the film, so that you can tell which way the sheet should face and what kind of film it is. It's like a sort of Braille. Each film has a unique notch code: deep v, deep v, little square; or half moon, half moon, shallow v. It's tricky at first, but with enough practice it becomes second nature.

My darkroom is listing like a sinking ship, a condition that lends it a certain lurching, funhouse quality. Squatting adjacent to my detached garage, its construction is at best haphazard. It was obviously built as an afterthought. Judging by the lack of foundation, I'd guess it was originally intended to be a potting shed.

The place really is sinking into the earth. Some of that's

my fault; I haven't cleaned the roof gutters for years, so when the rain comes, it pours straight down the exterior walls into the dirt, collecting there in an ever-deepening trough. Every season that water-side wall droops a little lower, while the other walls—the ones clinging pitifully to the garage—remain fixed in place. I imagine the whole thing will eventually tear itself in half.

In any case, the standing water isn't helping the mold situation. Neither is the humidity. It's like a jungle in there, at least in the summer, when the sweat rolls down my face and drips into my developer tray.

All the metal in my darkroom is coated with rust. It's a peculiar sort of rust, supple, almost velvety. It makes me think of antlers.

There are chemical stalactites hanging from the bottom of my sink.

My darkroom's a science experiment.

Sometimes, the heat and the combined smell of mildew and photo chemicals gets so bad I have to drop to my knees and take a breath through the vent, just to keep going.

The winter months are no picnic either. Oftentimes then, it's so cold in there I can see my breath. I have a terrible time keeping the condensation from fogging my glasses—not to mention my enlarger lens. I've actually started to hold my breath when making exposures, so as not to risk defusing the images with mist. I have a little space heater but only use it for emergencies. It tends to tax the electrical load and makes the enlarger light waver, which in turn throws off my printing times. And anyway, I can't help but think that running such an appliance with all that liquid sloshing around is a bad idea. One can imagine…

If the ceiling of my shanty were but an inch lower, I'd have to shuffle around all stooped over like an ape. As it is, the lack of overhead has forced me to print sitting down, with my enlarger resting on a squat table. I had to amputate the legs to make it fit. I've since come to learn that hardly anyone prints sitting down, but I didn't know that when I

started, and since I've always done it that way, for me it's not a hindrance.

With the exception of my heroes wall and a few pictures of my own tacked up (the ones that didn't make muster), my darkroom is a strictly function-over-form affair. There's a clothesline with wooden clothespins for hanging up film to dry. The sink is a repurposed laundry tub that sits on a plywood board with crumbling red bricks for its base. Wires are everywhere. Cords of every color snake up the walls and hang overhead, wrapped together into bundles with old bread ties and picture wire. Banks of power strips dangle from rusty nails. I have a whole household's worth of electronics plugged into a single outlet. I even have a microwave oven for drying test prints. Old St. Ansel taught me that trick.

On the floor, beneath a rotting, antique table, its top slowly warping like a record in the sun, are stacks and stacks of old, curling prints. I go through them once in a while, like a geologist sifting through strata. The further down I go, the farther back I get. My pictures of Point Reyes run deep. Interspersed though, I find little slices of other times, other places, other experiences. Here's Mono Lake. And here's that big Southwest trip I took—speaking of strata, there's the Grand Canyon. Lord it was cold that day! I remember setting up my camera at an overlook, and then abandoning it there while I hid in my car to keep from freezing. I sat in the passenger seat, blowing on my numb hands, trying to guess which way the clouds would go. Then, at what I was sure was the decisive moment, I'd leap from the car, run to my camera, and make the exposure—what joy! Here's St. Louis cemetery number one, in New Orleans. We went there after the terrible thing happened; here's my wife there with haunted eyes, her face bathed in a beautiful storm light.

Maybe it's not geology after all, but psychology; these prints the material manifestations of my mind. Seeing them all together like this, certain obsessions do seem to surface.

Just what is it about shipwrecks and ruins and dead trees and statuary and empty places? And what's with all the birds?

Certainly that Freud bobble head doll on the counter—the one my father gave me for Christmas—isn't divulging any insights.

What is for sure though is that what unifies these orphaned prints, besides their being a piece of my mind, and—further—representations of the world at large, is the fact that they are, all of them, failures.

Adams used to say that the negative is like a musical score, and the print of that negative is a performance of that score. The expression is essential. Sometimes he'd take weeks to work on a single picture.

Often, I've found that it's the simplest photographs that are the hardest to print. It's the ones that rely on being not too dark and not too light, but just exactly, perfectly, right in the middle. It's the subtle ones that get you. You make a print; it's too dark: it's drab and flat and lifeless. And so you make another, but this one's too light; it's washed out; it lacks substance. And on again and again, back and forth, until it seems you're after a mean that's shrinking as you chase it, searching for an edge the width of a single molecule. Exposing a sensitized paper to light, sometimes it comes down to tenths of a second; a tenth of a second separating a print you'd share with anyone from a print you'll tear to pieces. And just when you think you finally have it—that's when someone starts a load of laundry in the house and the power surges through your little shack and all your hard won times are thrown off and you have to start all over.

Sometimes I just want to burn the whole thing down.

There's no time in a darkroom, or at least, the time there is not related to that of the outside world. In the dark, with only the red safelights on, I might as well be out at sea in a submarine. I walk through my backyard under the midday sun to enter, and when I come out again, I'm afloat in the stars. I gauge time by way of record albums; five or six

makes a healthy session. I have two clocks; the times on each are different. Both are equally wrong. I salvaged one of the clocks from a box of my childhood stuff my mother gave me. It's a panda bear, with eyes that sweep back and forth to mark the seconds. Man, I tell you, if that bear could see, he'd have seen a lot; a little boy playing in his room, and then, all these years later, that same boy become a man, working now in a different room, drinking and muttering to himself. But through it all my panda remains serene. When I got him his ear had fallen off, but I found it and glued it back on. My son helped me. He loves to come in and watch that bear. He loves to come in and face the dark.

On the wall near the door of my darkroom, safely above the chaos of the countertop, above the duct tape and batteries and rubber gloves and chemicals and tools and CDs and the Freud bobble head and the beer bottles—there hangs a framed text. It's calligraphy on parchment paper, faded now, for it was done by my mother a long time ago, before I ever made a picture. It reads:

It was the best place to be, thought Wilber,
this warm delicious cellar, with the
garrulous geese, the changing seasons,
the heat of the sun, the passage
of swallows, the nearness of rats,
the sameness of sheep, the love
of spiders, the smell of manure
and the glory of everything.

A M E N E.B.

∾

I drive away from the house with the windows down. The air is clean and sharp. There was a storm last night. Broken sycamore boughs litter my street. The pavement is wet from rain.

Neil Young sees me off. I ring in the New Year with *Tonight's the Night*. When Young recorded this in 1973, two of his friends had just died from heroin, and his voice is so mournful and ragged and off kilter and earnest that you can't help but love him; you can't help but feel he's a friend of yours.

I brought this album on my big Southwest trip. It was one of ten. Some might think it masochistic to embark on a four-thousand-mile road trip with only ten record albums, but my idea was that, through repetition, the music would intertwine with the places such that when I returned home, and even years later, playing them would bring me back. And they do. Young's voice floods me with memories: of that holy hour I spent by myself at Delicate Arch; of the cemetery in Chloride, Arizona; of that cold night in Williams on Route 66, snowed in with the power out; of Death Valley; of sunrises at Zabriskie Point; of sitting on my dusty hood on the briny shores of the Salton Sea, drinking warm cans of flat Tecate. It all comes back now with the immediacy of a scent. Unforgettable.

The stoplights seem especially loyal this morning, changing on in their rhythms though there's no one around. They're almost heroic.

I pull into Jack in the Box and there's a dead possum in the drive-through. When I tell the kid at the window he barely feigns interest. I'm pretty sure the poor creature will be there all morning. What an ignoble end.

But back on the freeway it's like there's no one else in the world. The road's so empty it almost seems civilization might have ended last night, and I in my little room—I missed the whole thing.

I pass a car lot with a huge American flag hanging limply over a row of black utility vans lined up like caskets. I pass a miniature golf course with a windmill and a castle and a tyrannosaurus rex. Here are gas stations and storage lots, hot tubs and tractors, casinos and the backsides of bleak motels. And here's the Friedman Brothers' billboard; "IF WE DON'T HAVE IT, YOU DON'T NEED IT!" God I hate that sign. Every time I pass it I try and come up with stuff that they don't have. *Love! Sex! Sheet film! Salvation…*

I do enjoy this drive, though, in spite of everything. I never tire of it. I even like the depressing parts. For without them, where would the joy be in leaving them behind?

Now and again I pass a rural stretch, an odd holdout. Here is a ramshackle farm in shorn brown hills. Here are some stock ponds. Here are some cows. Then more fast food.

And a scorched field, with two iron staircases spiraling up to the sky like outstretched arms. I've been meaning to photograph that forever.

I exit into Petaluma. It's an old town, Petaluma, at least by American standards. Even discounting the Miwok who lived here first, it's the oldest settlement between San Francisco and Eureka. The town's big boom came in 1879, when resident Lyman Bryce invented the chicken incubator. Not long after, Petaluma fashioned itself "the world's egg basket," where promoters boasted, "Six million hens lay six hundred million eggs." The town inaugurated National Egg Day in 1918, an occasion celebrated with a parade led by an Egg Queen and her court of chicks. There was even a chicken rodeo.

I turn left at the old Wells Fargo Building, built in the twenties in the Neo-Classic Revival style. Like a lot of the banks of its time, it was meant to look like a Greek temple. It's actually terra cotta. In any case, it hasn't been a bank for a long time. Currently, it houses an antique store named— aptly enough—Vintage Bank Antiques.

Petaluma's past is evident at every turn, especially to one searching for it. Here's a row of 1880s iron-fronts, thought

at the time to be impervious to fire; an assumption proven wrong when most of San Francisco's own iron-fronts burned to the ground after the Great Quake of 1906. Here is the Masonic Lodge: a grand, three-story, Victorian affair, capped with a copper clock tower—the inner workings were brought around Cape Horn by boat. And here is the Mystic Theater, a music venue once a silent movie house, one of the earliest in California.

The times are stacked atop each other here like the old curled prints in my darkroom.

And in a sense, Petaluma's past is my past as well. My grandfather owned a shoe store here. Southwick's was at 155 Main, not far from the clock shop. A while back I tried to find the address but it seems that 155 was lost in one of the remodels. And anyway, Main Street's not Main Street anymore, but Petaluma Boulevard.

My grandparents came here from Berkeley in the early 1940s. My grandfather bought the existent store from a Mr. Agnew. My grandmother remembered Mrs. Agnew advising that she not wear bobby socks downtown. "You have to remember," my mother says, "things were different back then."

My mother used to visit the store when she was a little girl. She remembers a life-sized cardboard cutout of Buster Brown and his dog Tige, and the rows of shoeboxes, stacked floor to ceiling, white rough buck saddles and blue suede oxfords. She remembers the remodel—my grandfather gave away orchids to the first hundred women who came. Three months later was the big fire. My mother remembers all the light fixtures had melted; she says they hung from the ceiling like icicles. My grandfather had a fire sale after that, and started over.

My grandparents stayed in Petaluma almost twenty years. They raised their three children. They went to dances at the country club. They had a lot of friends. For a time, my grandfather was president of the chamber of commerce. He wasn't much older than I am now.

What an odd and wondrous thing it seems, to be passing through this same place; who of my ancestors would have thought it?

I'm sure my grandfather made his way to Point Reyes. He was an outdoorsman at heart. Well into his sixties, he back-packed all alone into the Sierras. I've read his journal from that trip. He wrote about the clouds. Wild places ran deep in him, so deep that even after Alzheimer's stole his mind, his body would still manage to load up his backpack and put on his boots and head for the door. My grandmother would have to restrain him.

"Where are you going?" she'd ask, and he'd just point off to the horizon and say, "Out there."

I wonder if my grandfather ever stopped in at Gail's Central Club for a pint after work. Maybe he looked out the window there onto the street. Maybe he peered into the empty space his grandson would momentarily inhabit fifty years later. I wonder if he would've felt something then.

I'm in the country now, speeding west on Point Reyes-Petaluma Road, past sagging, sun worn barns and cows and sheep and half-wild dogs that bark at me as I fly by. The telephone wires have disappeared from overhead and the sky—herebefore unnoticed—reclaims its proper place. I greet my landmarks in the half-light like old friends.

There's the lone oak on the left, the one with the huge boulder against its trunk. From this angle it looks as if the two are joined, as if the tree sprung right out of the rock itself.

And here is Volpi Ranch. One time I drove by here and all the goats were laid out in a perfect row along the front fence. They were motionless, shoulder to shoulder, their heads lolled out on the ground. I thought for sure they'd been killed, and it made me sad all day. But then, passing by again that evening, I found the goats miraculously resurrected. It seems that what I'd seen that morning was just something that goats do sometimes.

I pass the row of giant cypress, the fire department and the cheese factory. I pass the rocky outcrop with the American flag that always reminds me of the marines on Iwo Jima.

It is here, near the Nicasio Reservoir, on the eastern side of Black Mountain, that the Point Reyes peninsula begins to assert itself. It is here where it makes itself felt. For so often, especially in the summer months, one will be driving along this road, through these sunlit fields, and then, in the most fearsome way, will encounter a barrier—a sheer wall of fog so dark and high that one's first, unselfconscious response is to stop the car and turn around. It almost seems as if a concentration of the will is required to pass from one condition into the other, as if one must freely choose to plunge into an abyss. And the leap is breathtaking. In just a few yards, you go as if from day into night. Here, only seconds separate the earthly from well—something else entirely.

∾

Not far from the village of Point Reyes Station, I cross a creek by way of a little purple bridge with a scrawl of graffiti on it that reads, "GO HOME." I suppose the command is addressed to me, but still it makes me smile. *Can't you see? I am going home.*

I slowly coast down the final hill into town, as carefully as landing a plane. I hang a left at the Pine Cone Diner onto Main Street, pass the Palace Market and the taqueria, the kite shop and the Bovine Bakery. There's Cheda's garage, where I once went to ask for help after locking my keys in the car. They fashioned a jimmy for me—no charge. I remember the walls were lined with elk heads. There must have been dozens of them. I had to wonder if the mechanics ever found it unsettling, to work under all those dead animals. Here on the corner is the Old Western Saloon. Occasionally there'll be a white horse tied up out front.

One time I went in there and watched a baseball game. I pretended I was a local.

The most striking building in Point Reyes Station is undoubtedly the Grandi Building. Once a stately hotel, now abandoned for decades, the hulking mass of dark brick still dominates downtown. Some people call it the black hole. These days, the Grandi Building serves mainly as a giant community bulletin board, its walled-off sidewalk arcade perpetually covered with a patchwork of revolving notices. Galaxies of old staples shine in the void.

The wall of the Grandi is stenciled with signs. They read, "NO PARKING," until some wag went and meticulously transformed all the P's into B's. Point Reyes Station's "NO BARKING" ordinance gets me every time. The best part of the joke is that, without fail, there are always cars parked along that wall.

One time I had a show of my Point Reyes photographs at a gallery back in Santa Rosa. Before the opening, I drove to Point Reyes Station and pinned up a bunch of my postcards on the Grandi Building. They hung there amidst the "Dog for Free" and "Fireman's Pancake Breakfast" announcements, the signups for "Fútbol Juvinal," and the call to a political rally: "Bring our future home…and not in body bags. Stop the war in Iraq…end colonial occupation!" Point Reyes Station, out here at the edge of the continent, may well be this blue state's indigo heart.

A heart at rest on this New Year's morning; it seems all 800 residents are lying long in their beds. On the weekends, on nice days, Point Reyes Station is overrun with motorcyclists and bicyclists and hikers and tourists of all stripes, trolling the art galleries and the cafes and spilling out all over the sidewalk in front of the bakery.

I try not to come here then. I'm no day-tripper.

This place is in me.

And yet, I fear I am not in it. Sometimes it seems my destiny is to forever be off to the side—there and still not *there*.

I've found it is difficult to witness existence and wholly

exist at the same time.

Still, putting those postcards up was my way of finally stepping forward, a way of introducing myself. And more, I wanted everyone to know that my intentions toward Point Reyes were pure. I wanted them to see my pictures so they'd know how much I love it here.

I'm not sure if anyone came.

I skirt around the southern end of Tomales Bay, and then head north, up narrow, sinuous, Sir Francis Drake highway, with the forested slopes of Inverness Ridge on my left, and the bay's dark stillness on my right. There beneath the water runs the San Andreas Fault. It's hard to believe that under such tranquility could wait the most unfathomable violence.

At the hamlet of Inverness, I pull into the grocery store's empty parking lot. I turn off my engine and sit for a while. I always stop here. It's my ritual. There's an old fishing boat out back behind the store, stuck in the mud, disintegrating. I think I've photographed it a hundred times.

Across the street is Vladimir's Czechoslovakian restaurant. Vladimir Nevl is something of a legend around here. Back in the old country he was a champion equestrian. That was before the Soviet coup d'etat in 1948. As the communist tanks rolled in, Vladimir escaped by skiing through the mountains into Germany. After that he traveled. He built roads in the Australian desert. He went to wine school in France. Then he came to Inverness and opened up his restaurant. It's been here since 1960. Though well into his seventies now, Vladimir still gets up early each morning and drives down to town in his red Renault to begin preparing the day's meals. He's the cook, the bartender, and the waiter. Most memorably, he's the storyteller of his own adventures. On occasion, dressed in traditional Czech garb and knee-high riding boots, Vladimir has even been known to demonstrate his skills with a bullwhip, right there amidst the

tables of startled patrons. I hear his whip skills remain sharp.

My wife and I ate there once, a long time ago, before we were married. I remember asking Vladimir for a glass of wine and him returning with a bottle. He plunked it down on our table and said, "Good Czech wine. You keep track," and then unceremoniously disappeared back into the kitchen.

Midway through our dinner of garlic rabbit, klobasa, and Moravian cabbage rolls, we came to realize that Vladimir, out there on the far shore of Tomales Bay, does not accept credit cards.

Panicked whispering ensued. I certainly didn't want to cross the old man. Who knew what he was capable of with that whip?

Then we noticed another couple across the way that seemed to be engaged in the same worried discussion. They were shuffling through a wallet. Our gaze found theirs, and in hushed tones we confessed to each other that none of us had close to enough cash to cover our meals, which with all the alcohol were quickly becoming extravagant.

We plotted a strategy. The other couple had come by motorcycle, and being that the night was cold, and that we were in the same predicament, it was decided that the boyfriend and I would sneak off and take my car back into Point Reyes Station in search of cash. The women would stay behind to distract Vladimir, who had been flirting with them both all night.

And so, half-drunk on Czech wine, we two strangers set off to find an ATM machine while, it turns out, our girl-friends sat fireside, nibbling on hot apple strudel with cream. Hours later, after coffees with plum brandy, the four of us poured into the empty street, under a night sky ablaze with stars, and we laughed there, and reveled in the world, exactly as it was.

I wonder where that couple is now.

I put on some Bill Evans, but the pianist, all alone, is just too

damn melancholy—even for me. And so I opt for silence. *It's a New Year for God's sake.* As I pull away past Vladimir's, I can see his wooden sign in the pre-dawn light. There's a horseman with a golden crown and a purple cape and black riding boots. He's surrounded by yellow flowers and green vines that curl around him like initials from some old, illuminated manuscript. *Vitame vas*, it says beneath, Czechoslovakian for welcome. And then I see, strapped to one of the poles holding up the sign, a very old pair of skis.

I pass the waterfront inns, the Golden Hinde and Motel Inverness. There is the Russian style dacha, hovering above the bay on stilts. On the roof there are the silhouettes of a dozen cupolas. I pass the kayak rental shops and the "LAUNCH FOR HIRE," sign and then, up near Teacher's Beach, I leave Tomales Bay behind and head west.

I'm racing now, trying to beat the sun.

The bishop pines on Inverness Ridge grow so close together that their crowns interlock. From a distance, the stand looks like a rainforest, or else an Asian landscape painting, the kind with fog shrouded peaks and wind bent trees, and perhaps, if you look very closely, a lone fisherman on his skiff. He is rendered minuscule to show his relationship with the world rightly.

The Miwok Indians who once lived here considered Point Reyes to be the abode of the dead. That seems about right to me. There is a feeling that overcomes those who wander here, as I have on innumerable days, that the peninsula stands somehow outside of everyday experience. It is otherworldly, this place, or rather, it seems neither here nor there, but someplace in-between. It is a difficult thing to define. I know only that nowhere else on Earth have I so strongly sensed the immanence of the spirit. And I am not the only one.

Study a map of Point Reyes and the names of its features read as if from fiction, from myth, as if from some ancient allegory: Point Resistance, Mount Vision, Secret Beach…

There is a tangible air of mystery that permeates Point Reyes as surely as its summer fogs.

I often find that in attempting a description of the peninsula, ordinary adjectives fall short. And so I've come to say that Point Reyes is a terrible place; it is terrible in the awesome, forbidding, haunting, lonely, fearsome, and yes, beautiful way of the word terrible. Terrible with a capital T. Terrible, I imagine, in the Old Testament sense.

I've always wondered though—if the Miwok considered Point Reyes the abode of the dead, then how did they view their existence here? Was Point Reyes their purgatory? Is it mine?

I'm past the pines now, twisting through a thicket of manzanita. Under my headlights, the bare branches look like lightning, or a Jackson Pollack painting, all those lines flung up in a fever, representative of nothing but my own mind.

The road is flooded from last night's rain. It always floods here, in this very same spot. The water's not so deep though. I can skim right over it.

I see more familiar sites, flowing by like passages from a favorite book.

Here's Schooner Bay, and the side-road that runs along the water out to Johnson's Oyster Farm. The roadbed is made of crushed oyster shells; in the sun it's so white you can hardly look at it.

And there, atop that hill, hidden away in the eucalyptus, is a cemetery. I'd have never found it if I hadn't spent all those hours pouring over my maps. I remember the first time I went up, there were a bunch of cows roaming around. There was dung on the tombstones. Even the graves ringed with white picket fences weren't spared; the cows had somehow squeezed through the gates. And I remember there were little American flags strewn about—the kind you see on motorcade cars. They looked like they'd been there a long time. To tell the truth, I didn't stick around. I love cemeteries, but that one's always left me a little unsettled.

Point Reyes is full of ghosts.

I pass a cluster of giant cypress trees. They're half-dead now, white as bone, draped with thick dark moss. They look like they belong on some old Southern plantation. Though you'd hardly know it, there used to be a ranch down there. It was called F Ranch. You can still find a dirt road that leads from the site down to the bay. In the 1800s, Drake's Estero provided the ranchers on Point Reyes their outlet to the markets in San Francisco. A ship came twice a week. There was a pier on Schooner Bay where men slaughtered lambs and calves before loading them on the boat. All that's left of any of it now are a few worn pilings listing up out of the water like old tombstones.

There, on the seaward side of the highway, at G ranch, is a quarter-mile long colonnade of more old Monterey cypress. At the end of it sits the RCA building. Built in 1929, the Art Deco style structure once housed Marine Radio Station KPH, which received transmissions from ships at sea. It's inactive now, rendered obsolete by the advent of global communications satellites. The station signed off the air on the 12th of July, 1999. The last commercial Morse code message, delivered by way of a chrome plated telegraph key, was the same as the first, sent 155 years earlier, "What hath God wrought."

I'm above Creamery Bay now, another finger on the hand shaped estero that spreads through the heart of the peninsula. There's the spot where once I spent a couple of hours trying to photograph cows. I've found cows to be generally uncooperative subjects, but on that day I promised them that if they would just come a little closer, I'd never again eat their brethren. To my astonishment, they did come closer then, and I made their portrait. I kept my word to them too, at least for a little while.

I've come to think we don't give the bovines enough credit. One time near here I passed a cow standing over her dead calf, and when I came back by that afternoon, more than twelve hours later, she was still there. I'm quite sure she was mourning.

This part of Point Reyes is barren and sweeping, moor-like.

The openness is broken only by the occasional ranch, the cows, and by the telephone poles and their wires leading out to the headlands. The emptiness makes each thing seem significant.

∾

From the road two hundred feet up, I see the sun rise above Barries Bay. It is a New Year. The air is strikingly clear, a belated gift from last night's storm. Even the most distant things look so close it seems I could reach out and touch them. The vision feels superhuman. It makes me think of the first time I ever put on glasses—of being shocked to learn that people actually saw like that, and that that was the way I was *supposed* to see. I wonder—is this how the Miwok saw Point Reyes?

∾

I come to the crossroads near Drake's Beach. There's the field where I stood before a storm making a photograph of starlings. The little black birds are everywhere in the autumn months, swirling madly over the fields like brush strokes in a Van Gogh sky.

I read that Van Gogh went to the middle of a field to shoot himself in the heart. He missed his mark though, and had to return home, fatally wounded. He died two days later with his beloved brother Theo at his side. Some say his last words were, "The sadness will last forever…"

On the day I photographed the birds, the field was so muddy that when I set my tripod in the furrows the legs sunk into the earth. And I sunk a little too. I was rooted to that field. I must have stood there an hour with my thumb on the shutter release, as still as a scarecrow, waiting for the birds to pass before me. The sky was low and dark and fearsome for the middle of a day. A hard rain was surely going to fall.

And then the starlings streaked over the horizon, as fast as

arrows. Just before reaching my position, they jagged left and I tripped the shutter, reflexively, like lifting a shield. I felt as if I'd literally captured the scene, as if the starlings and the telephone poles and the wires and the field—all those straight lines—had been sucked into my magic box, that I'd caught a tornado by its tail. I thought my camera would break apart from the force of it. How could it possibly hold it all?

My camera really did feel heavier on the way out.

I wonder—what does a furrowed field and six-dozen starlings weigh?

∾

I'm going so fast my tires are squealing a little in the corners.

This is the day—I can feel it!

Way down below to my starboard, the Pacific extends out beyond measure, as incomprehensible as space. On my port side is Drake's Bay, and beyond that, more ocean. I'm on the tip of a spear.

At 'A' Ranch I reach the road's last split. The right fork leads to the lighthouse, but I take the left—yes, the one seldom taken.

The road here is barely a car wide, cut into the side of a steep hill. If I strayed over that left edge, even a little, I'd flip and roll all the way down into the bay. The lane is so narrow in fact, that if another vehicle should come from the opposite direction, one of us would have to defer, and back up all the way to the beginning. It doesn't happen very often.

But today—there's a van in the parking lot. *A van in the parking lot!*

Unhinged, I drive to the point farthest from the intrusion. I need a moment to reset my expectations.

Through my windshield, I see a man get out of the van and initiate an elaborate series of stretches. He peers about as if he has never before seen his surroundings. He looks a little disheveled. I hazard that he slept here last night.

What a place to awaken to!

I climb out of my car—what else can I do?

The two strangers assess each other from across the distance.

"Happy New Year," I offer.

"Oh, yes, Happy New Year," he replies, in a way that informs me he didn't know it was New Year's Day until just now. He has a German accent. The man then spreads his arms and grins wildly, exultant at what is before us.

I smile back at him, despite myself, "Yeah…"

Sunbeams are pouring down onto Drake's Bay through cracks in the lingering clouds, forming coliseums of shadow and light that shimmer and turn for a breath, or two, then vanish. Three white fishing boats bob in blue-violet waves. A rainbow lights over the distant green hills, flickers a little, fades, then shines forth again, twice as bright as before.

It's all so beautiful I can hardly stand it.

The elephant seals are barking from some unseen place. Their deep, sonorous bellows sound almost subterranean, as if they were reverberating out of the earth itself.

"Elephant seals," I offer, knowing that any comment beyond a simple fact would be absurd. I haven't the slightest idea whether the German will understand me.

He turns and lifts an eyebrow.

I strap on my pack, sling my tripod over my shoulder, and motion toward the trailhead. "I'm off to make a picture," I say, hoping my new acquaintance won't want to follow me. I work alone. It's nothing personal.

I needn't have worried. A woman reveals herself to have been in the German's van; they're a couple.

I wave at them and smile, then beat a hasty retreat.

Photography's a lonely passion.

∾

I'm worried about the wind. It's the worst sort for making pictures, with moments of hopeful calm dashed by sudden, juddering gusts. Down on the bay, I can see swaths of water

being chopped by odd downdrafts, like jungle under a rotor. The wind is not kind to view cameras, and if mine were blown over, it would surely be smashed to pieces. As unpleasant as such a prospect is though, it is not what concerns me most. I have been trying to make a picture of this place for so many years, a picture that might do justice to my feelings for it…to contemplate failure yet again (and on a day such as this) is what is truly unbearable.

I swear if I can just get my picture, the wind can have the damn camera.

I take to the muddy trail, almost jogging. The high grass on either side is bowing and rising and quivering in the wind. And I'll admit it—I'm quivering a little too.

Soon I'm at the big white park service house. The commander of the lifeboat station used to live here, a long time ago. The station is still down there on the bay, though it hasn't been used as such for years. Back when it was active, they'd launch the lifeboats with a marine railway. The tracks ran from inside the building right down into the water. The men stationed there saved a lot of ships. Some of them died trying. They're up in the cemetery on the hill, with the eucalyptus and the cows.

How I love this house! Sometimes I daydream of coming to live here when the rest of the world ends. A while back, I left one of my photographs on the doorstep. It was on a night near Christmas. I wrapped it up and everything. I snuck up on the porch and propped it by the front door. It was the classic picture of Point Reyes, the narrow bridge of the headlands, with Drake's Bay on one side and the Pacific on the other, and then, right there in middle, this very same house. It makes me happy to think of my photograph hanging up in there somewhere. Maybe it's over the mantle.

I could walk this path blindfolded. First there's the neck, and then the steep uphill stretch—the ground there raked with grooves from where the rain runs down—and then, finally, the plateau, where the wind always doubles.

When I reach the top, I turn around and look back the way I came, then go over to the cliff's edge, right up to the brink. Two hundred feet beneath the toes of my boots, the Pacific roils on, hammering at the sea stacks and scouring the bluffs. Here at the edge of the continent, where you can so clearly see the earth's unfolding, you can't help but know in your bones the certainty of change. A hundred million years ago, Point Reyes was an island, and most of the rest of California had yet to rise from the sea. Even now, like some colossal ship, the peninsula is moving northwards at two inches a year.

Geologically speaking, everything'll be gone in just a moment.

Those Chinese landscape painters had it right; we are all the little fisherman on his skiff.

∾

Gazing across Drake's Bay, I follow the sweep of the shoreline. There is the mouth of the estero and Limantour Spit. There is Sculptured Beach and Secret Beach, and further on, Point Resistance. From here I can see clearly how the places are connected. I follow them from left to right like reading: Millers Point, Wildcat Beach, Double Point, Abalone Point, Bolinas Point. It strikes me now that all of my days on the peninsula—all of those diamond days—are connected too; all of them lie within me, and all of them have shaped me as surely as the sea has shaped this coast. All of them have led me to this exact moment.

∾

I'm on the level crest that leads into the ocean. Head down, I sway in the wind like the grass. At times, it's a struggle to stay upright. The winds here can exceed a hundred miles an hour. There's nothing to stop them for three thousand miles of ocean.

I came here a few times as a boy, though I don't remember

much. My mother tells me we had to leave once because the wind gave me an earache. She says I cried all the way home.

I stagger on, perversely determined to seize my picture. And if the camera should shake? Well then, let it shake. The image will be then a reflection of its subject. But how much better if I was granted a moment of stillness—I ask only for a moment—so that I might reveal this place in all its Terribleness.

No matter how many times I walk this trail, I am never prepared for the view of its end. There, at the bottom of the last, steep slope, a barren hump swells from the sea. It looks like a stage, like a pulpit, like a place for a last stand. It looks like it's been waiting for you.

It's been over ten years since that night and still, the sight of it causes me to shudder. Even now, gathering its recumbent syllables together in my mind makes the hair on my neck stand up. The sound of it itself has become a talisman.

Chimney Rock.

I have consecrated this place.

Chimney Rock, Point Reyes—the end of the earth.

I should begin here, at the beginning of everything.

1

Chimney Rock

August 3rd-4th, 1993

CHIMNEY ROCK IS EVEREST. It is Angkor Wat and Shiprock. It is Krakatoa, Kilimanjaro, and Machu Pichu. It is Camelot, Chartes, Mecca, and Quarantana. It is Timbuktu, Sinai, and Easter Island, it is Stonehenge and Pompeii. It is Eldorado. It is—a place apart.

Telling the story of that night is difficult. For I find that when I look back on it I experience a sort of mental vertigo. The memories are vivid but I don't know how to place them. They have no sense of time or proportion. On that night, the simplest actions seemed infinite, and yet somehow, whole lives were lived in a moment. The inane blossomed with cosmic significance, while the cosmos was as common as dirt. It's like the night broke into bits, into pieces of a puzzle to which I haven't the key. I do not know what the puzzle is of. The whole thing is just too big. And everything's jumbled up. Well I guess it happens sometimes. I make do. I stitch a patchwork with what I've got. I try and find a pattern.

What do I remember?

I remember the wind. I remember the yawning precipices and the dark, swirling waters. I remember the cold blue beacon, just offshore, pulsing in the void, as regular as breath. I remember the forked trail on the face of the hummock; the shape is so seared into my brain, it's become a fundamental structure of my universe, something I see everywhere—as elemental as a circle. Even now, I can conjure forth these paths in my mind as easily as I can the face of my own son.

Strangely, I can't say just why we came here that night. That is, why we picked it over all the other places. As I said, I'd been here as a boy. I have a picture of my mother and grandmother sitting in the grass amidst the wildflower bloom, a calm and blue Drake's Bay the backdrop. They're smiling—at peace. It's one of my favorite pictures.

Perhaps we chose Chimney Rock because it's the farthest one can get from the rest of the mainland. Way out in the ocean, at the knife's edge of the continent, it waits like the nation's last post. Or its first. Sitting on Chimney Rock is like sitting on the hood of the country. It's the cockpit.

In any case, it was a fateful choice—is there another kind? I mean, had we picked a different spot—well, what then?

A different life, I suppose. Each and every decision is loaded, but for better or worse, we'll never know what with.

My friend Stephen and I left Alameda late that night. We'd had a couple of beers. It was a spur of the moment decision. We could have those back then. We could leave when we wanted.

We stopped at a gas station on Park Street and a woman there asked us to help jump-start her car. We considered the aid a proving of our good intentions. The night began well.

I don't recall much of the drive. I'm sure we talked. There was a lot of catching up to do. I was back in our hometown after four years away in the Navy. I'd shocked everyone by enlisting after high school. People said I didn't seem like the sort of person who would go and join the military. And they were right.

I remember Stephen's hat. It had the word *Soul* stitched across it in a bold script. It seemed to me then that there was a lot to that hat. Was the *Soul* defining him as such; was it a description; a statement of belief? Or was it something bigger; *Soul* writ large. Or maybe it was *Soul* as in soulful, or *Soul* as in soul music: a Wilson Pickett, Al Green, Marvin Gaye sort of soul. Maybe I was thinking too much into it. It was probably just a hat.

I remember pulling over past Inverness so Stephen could throw up. He was carsick. Sir Francis Drake Highway gets a little hairy in places. And anyway, I was probably driving too fast.

I remember the bishop pines and the dark emptiness of open fields, and the alphabet ranches, their letters going backwards as we sped out toward the headlands: E Ranch, D Ranch, C Ranch…

I remember us marveling at the radio towers, at their red lights beating silently in the dark like some strange city. Those towers were always so mysterious before I knew what they were.

I can never decide whether learning about things enriches my experience of them or takes something away.

We pulled into the parking lot around midnight. It was foggy. It's always foggy in August. I remember when I went to roll up my window the handle came right off in my hand. We joked that our karma had taken a turn for the worse.

It felt odd being out here at night, as if it were forbidden somehow. The feeling brought a memory from when I was a boy. I'm out playing in the neighborhood when I realize I've missed my curfew. The night is falling. I hurry home under the street lamps. All is quiet and still. And then, spurred by some mysterious, unbidden cue, I suddenly see things—all the things of my life—in a way I never have before. For the very first time, I see myself from the outside. I become self-aware. The wedge is driven and the world's a stage. It is precisely the same feeling I get when I wander those same streets now, thirty years on. One can never get back.

∽

After some words to bolster our courage, we got out of my little car then. I remember it was much colder than we expected.

I had my wool peacoat on. It was the only thing I'd kept from the Navy. I always wore that coat. Stephen's hair was whipping around in the wind. His Soul hat couldn't contain it all. It was funny to me, his hair like that, like he was some kind of crazy blond Rastafarian. After that night he cut it all off.

I carried my old boombox and some music to share. We had our flashlights and some orange juice from the gas station. We had our usual sacraments…

Not far from the trailhead a red fox leaped out of the grass and bounded across our path. We nearly died from the shock. "Fox!" we both shouted.

We were in our early twenties then. It hardly seems possible. When I consider all of the things that we did not yet know, consider the people that we had not yet

become—it's just hard to fathom. We didn't have children then. We didn't know the names of our children. I hadn't yet gone off to Santa Cruz to study Philosophy. I hadn't had a single thought of that future, not a single thought of all those people there who would prove so unforgettable. Though we knew our wives, we didn't know them as such. I hadn't been to Italy, or Boston, or New Orleans. Stephen knew nothing of his times in Costa Rica, or Amsterdam, or Germany. Neither of us had any notions of the Black Rock desert—*our* desert. It seems impossible now, that back then we hadn't an inkling of any of it.

And I had no idea that after that night I would come to spend every spare day for more than a decade roaming this same peninsula, searching for something within it.

Who was I without Point Reyes?

It all seems such a crapshoot. A left turn here—a right turn there—and this is what determines...*everything*?

We stole quietly past the park service house, fearful of rousing the rangers. "I don't think we're supposed to be here," I whispered. There was a light on in an upstairs window. I remember we thought that room looked so cozy with us shivering outside in the fog.

We threaded our way down the hard-packed trail—it split the grass like a part in a head of hair. The wind was blowing around us and the seed-pods were shaking with a sound like rattlesnake tails. We could hear the sea lions barking down in Drake's Bay. It almost seemed like they were laughing.

Soon the peninsula began to narrow, and with the darkness on either side, it felt like we were walking a wire, as if our position was so precarious, one strong gust would send us head long into the abyss.

We weren't afraid though. We were sure back then. We were sure that nothing terrible would happen, in the way that people who haven't yet had anything terrible happen to them can be.

The grass was getting higher. It was nearly to our chests.

In the spring, Chimney Rock is home to one of the most spectacular wildflower blooms on the whole coast. I've been here then. I remember a day when it was calm and sunny, and every inch of the land was covered with goldfields and lupine and poppies. There were people too: amateur naturalists sauntering about with their guidebooks, photographers hunched over their tripods, and everywhere, children, running and laughing, nearly delirious with the wonder of it. How strange it was to see the land like that! It was like a dream. I knew Chimney Rock as a solemn place, as parched and windswept and haunted. It was as if my battlefield had become a playground.

It made me wonder—which is the truer face?

I have a book of photographs by Richard Misrach. They are of the Golden Gate, made from the back porch of his house in the Berkeley Hills. Compositionally, all of the pictures are exactly the same, and yet, each and every one is entirely different. One would think that, even considering the changing of the light and the weather, some basic mean would emerge from such an endeavor. That is to say, it seems that in a sequence of a hundred such photographs, one would be granted some sense of the subject's underlying nature. But there is no such sense. All of the pictures are completely different. In fact, they are so different that by the end of the book, you wonder whether anyone can *ever* know what a thing truly looks like. Or really, if there is such a thing to know at all. You wonder if maybe underneath all of our ephemeral impressions—there is nothing.

෨

We came to a little white arrow on a post. I've photographed it a dozen times since. I remember we laughed about that sign. It seemed so much more than it was meant to be. It wasn't simply a sign then but a guide—a directive. The path was our Path, in the larger sense of the word.

Do other people think this way?

Stephen and I followed the arrow dutifully. It's a good thing too, for if we hadn't, we'd have plunged over sheer cliffs to our death.

We trudged across the long flat ridge. At times, the wind was so strong it nearly knocked us down. I remember the grass whirling around its roots like storm-tossed wheat. We felt small there on that plain—exposed.

Then the grass began to shrink, dissipating until the ground was barren and rocky. Our path turned to the right and we reached the top of the downhill slope. At the bottom was Chimney Rock.

We didn't go down there at first. We were scared of that hump. It rose up from the Pacific like a cobra. We needed some time.

So we sat down and we rested. Like alpinists readying for a final push, we gathered our strength. We sat on the wet, rocky ground and talked and drank our orange juice.

And then, with fear and trembling, we ate our sacraments.

∾

The ground went first. A humble gray pebble grew in interest without at all changing its appearance. We watched, astonished, as it became *significant*. The dirt beneath us blossomed with connotations. It made me think of the desert, of Morocco, of the shores of the Dead Sea, of holy lands. *And why not?* I reasoned. This piece of ground is a part of the fabric of the very same universe, and as all things sprang from the same source, is not then each and every thing an equal representative of the whole? Knowing a place is knowing everyplace. Knowing a thing is knowing everything.

Jerusalem or California—at root, what's the difference?

Things fell apart pretty quickly after that.

I remember us doing Tai Chi. We felt powerful and good. But then, somehow, I became a puppet on a string, no longer the master of my body, and I was flung about so violently I feared I might go over a cliff into the void.

I remember Stephen's hair twisting around in the wind like the grass we'd come through. It was all of one piece, the wind and the grass and my friend with his *Soul* hat.

But the wind. *The wind!* The wind was a character unto itself. I forced out some notes the next day, "Wind was howling, overwhelming, relentless, relentless…"

I remember standing near the cliff's edge and opening our jackets as wings. The air held us up. We leaned out, further and further, until it seemed we'd reached an impossible, untenable angle. And yet we held. The wind held us.

At one point I saw, with the utmost clarity, Stephen drop to his knees and vomit blood. He says now it never happened. He says I misunderstood. He says he just stooped over to pet the coyote brush.

Stephen says that for a while I looked just like my mother and the odd thing was that I felt like her then. I could feel her *in* myself. I remember looking at my hands with a flashlight and they were my mother's hands, thin and translucent. I could see all the veins running within them, branching precisely like the path that we stood upon.

Biology. Geology. Genetics.

We must have walked over that hump and up and down that forked trail a hundred times. The split seemed especially meaningful. We'd walk together and part ways there, and then meet up again on the far side. Then we'd repeat the process, only this time we'd switch trails, to see what it was like to go this way instead of that, to see what it was like to walk in the other's shoes.

Free will. Determinism. Destiny.

And that bench. *That bench!* Perched there at the edge of the continent with its seat boards sloped forward, it was like it *wanted* us to slide into the ocean. I can still hardly look at it. Sitting on that bench was like riding the rails on the continent's cowcatcher.

Investigating it with our flashlights, we discovered two brass plaques riveted to its base. We knelt on the ground and traced the text with our fingertips. The metal was cold and

wet and rough with rust. We found the messages difficult to comprehend, not because they were obscured, but because reading itself had become somehow tricky. Words were interacting with their word neighbors in unusual ways—banging into each other like bumper cars, before careening off with newfound meaning. Certain words seemed especially defiant—refusing to toe the line. Shrugging off linearity, they orbited around other words like electrons. Whole sentences were derailed. It was slow going. We might as well have been trying to decipher an ancient Hebrew manuscript. We knew though that we'd discovered something important, something profound, and without a doubt, something meant for us. And so we persevered, chanting the texts aloud over and over until their import finally became clear.

<div align="center">

"IN MEMORY OF
BURBANK JUNG
(11/3/24 - 1/29/90)

TO YOU POP

I love you pop, so I tell you now. I never told you then so
I need to tell you now, but, now it is too late, because you are
no longer here. So I cry in my heart so you can hear me there.
Rest in peace Pop."

</div>

And the other:

<div align="center">

"IN MEMORY OF
STEPHEN ERNEST MASTERS
Sept. 20, 1964–Mar. 27, 1992

'O Captain! My Captain!
our fearful trip is done.'

WE WILL MISS YOU STEVE
WE HOPE YOU HAVE FOUND PEACE"

</div>

The night turned darker after that—more earnest. It wasn't a lark anymore. We were going the distance—onboard for the full ride. This is why we came, isn't it? We came for a reason. We came to look right into the terrible eye of everything, and if that meant being torn to pieces, well then, so be it.

We were sure that Stephen Ernest Masters had committed suicide. Perhaps, we speculated, his life's last moments were spent on Chimney Rock, right there on that very bench. Maybe he just stood up and walked right off the edge—

My own friend Stephen and I talked of it that night in the howling wind. We huddled there with Jung and Masters and talked of death.

"What would happen if we jumped off the cliff?"

"No one would understand," I said. My voice sounded strange, detached, unconvincing. Yes, what *would* happen if we jumped off the cliff? I mean, why not? For a moment then it seemed death really had lost its sting, and we were curious.

"I didn't mean that we should," Stephen qualified.

"No, of course not," I said, but it seemed to me that the cat was out of the bag, that the option was on the table.

But then, as if some part of me were throwing up a further defense, I said that maybe we were *already* dead; that fundamentally, there was no divide between this and that, that stepping off the cliff would simply be like a river returning to the sea. We'd just become what we were all along. Right? Besides, what's the hurry? As seen against the backdrop of infinity, our lives are like a bolt of lightning. We'll both be dead soon enough.

I used to love to say stuff like that. I was just starting to take philosophy classes at the Junior College. By the time I got my diploma, the best I could do was say I didn't know anything at all. Who can think on such things and not get tied in knots?

The night grew colder then. As the wind swirled around us, we rocked back and forth on our bench, talking to each other through clenched jaws. We tried to climb out of the well we'd dug.

At some point I remembered the music I'd brought. I put my hand in my peacoat pocket and held the cassette, as carefully as if it were a living thing. I knew what was in there and caution was required.

I'd read about the Master Musicians of Jajouka, Morocco before I ever heard them. I'd read that their music had been passed down from father to son for four thousand years. I'd read that it was so powerful it could cause madness in the listener. That was enough for me.

I'll never forget the first time I heard it. It was in my old room at my mother's house. I sat on the floor in front of the stereo, furtively unwrapping the disc like it was some forbidden thing. I put on my headphones, not wanting to inflict madness on the neighbors. By the end of the first note, I was terrified. "This is really no joke," I muttered to myself. And I've never lost that sense of it, the sense that you don't so much listen to this music as unleash it. And once it's in you, there's no going back.

That night on Chimney Rock I told Stephen I had something I wanted him to hear. My poor friend. He had no idea of the power that would emanate out of that old, insignificant looking boombox. I readied the tape. I remember the boombox had big square buttons with depressions molded in them for your fingertips, the kind of buttons that stay down when you push them. I remember that pressing *play* seemed to take more effort than it should have, as if I were cocking a gun.

A single sharp note, like from a snake charmer's flute, fierce and beautiful at once, lifted into the air and hovered there, sustained so long it seemed impossible. And normally, it would be. But the Master Musicians can breathe in circles. Inhaling and exhaling at the same time, they can hold a note forever.

The drone ended abruptly with a weird, angular melody. It felt like an announcement. And it was. Drums entered like hoof beats, like artillery, and with them more of the flute-like rhaitas, maybe twenty but it felt like a thousand.

The Master Musicians used to ride at the head of armies.

Jajouka is always out of proportion to its surroundings. The presence of it is titanic. It simply obliterates all else, or rather, it feels as if it's emanating out of everything. It just comes at you from all directions, including, it seems, from somewhere deep inside yourself.

We stood there, Stephen and I, stupefied, gawking at the boombox with our flashlights. We studied the tape heads laboriously turning around like the gears of some Rube Goldberg contraption. The thing was half full of water. It didn't seem possible that it could actually work in that condition. But more to the point, it didn't seem possible that such a sound could be coming out of it.

Overwhelmed, we ran away—abandoning our little camp as if it'd been swarmed by bees. After awhile, we forgot all about the boombox. Jajouka just became the sound of Chimney Rock. It became the sound of everything.

The wind continued. It engaged the Master Musicians and they engaged it back. The rhaitas' shrill notes overlapped, intertwined, and then rode off on the wind—only to return again from the ocean. Impossible—but it was happening all the same. The wind was unbraiding the music, freeing each strand to float off by itself. The wind and the melodies swirled around Chimney Rock like it was the eye of a hurricane.

And then the music sped up, intensifying, and the wind, it seemed, intensified with it. The rhaitas were slashing the air like knives. It was unbearable.

The writer Brion Gysin once described the sound of the Master Musicians of Jajouka as the sound of Earth sloughing its skin.

Then, all at once, as if the planet had frozen solid on its axis, there was a moment of complete silence, one…two… three breaths of silence…and then voices, the palpable warmth of human voices, the sound of men chanting. It was the villagers of Jajouka, Morocco singing softly in unison.

I think I wept.

The respite was short lived. The verse ended, and after another pause, one…two…three…the horns and drums returned, multiplied now, it seemed, a hundred-fold.

We didn't have the strength for this. We'd be crushed like bugs.

But what could we do? Things were beyond control. I began to believe that we had triggered a terrible chain reaction—that Jajouka was splitting the world apart at its seams.

The wind grew still more fearsome. It threatened to pluck us off the hill and cast us into the sea. It was not malicious so much as indifferent, and it was the indifference that was horrifying.

The music gained even more momentum, unstoppable. The horns were so awful in their intensity that I tried to duck under them, focusing on the drums like they were mental ballast. But the drums were speeding up too, dragging us into oblivion.

We dropped to our knees and tried to dig our fingers into the earth. We tried to hold fast.

It was in that moment that I saw, with perfect clarity, that we were astride a giant bird. Chimney Rock was its head, and the coast behind us was its wings. It was plain to see. The cliffs, the grass, the wind, the path, the beacon, the music, the continent and everything—all hung together in the blazing skein of a thunderbird. I was not hallucinating. I was not seeing things that were not actually present. That is, I did not think we were *literally* atop a great bird. And yet I saw this thing. It existed. In retrospect, I might say it was like looking at the stars and drawing lines in your mind to make the constellations: an archer, a serpent, a bear, a phoenix. The thunderbird was like that. And yet…if this was the case—if at root it was *I* who had conjured this vision to order the world—than why was it such a terrible thing to see?

I did not want to see it. I wanted it to end. It made me afraid in a way I had not been afraid since I was a little child.

∾

By then Stephen and I had become locked in ourselves. We were being battered by the same storm on separate islands, both going mad in our own way. But then, I had a little light of thought, just a little light, and I crawled toward the boombox. As I went nearer, Jajouka tore over me, the rhaitas ripping across my back like talons, coursing through my veins like electricity. It was like crawling into a fire. And then, head down, I reached in—I put my hand in the sun—and began desperately pressing at buttons. The music played on. For a horrible moment, I thought past reason that Jajouka had somehow gotten free, that it had become self-actuating.

It has been said that if the Master Musicians ever stop playing, the world will end. But they did stop then, and there was silence.

The world remained.

The hill became a hill again and the wind became the wind. My friend became my friend again. And I was just myself.

"Retreat!" I yelled. The order sounded more authoritative than I would have thought possible. "I know where there's shelter!" The general mustered his beleaguered troop.

And though I'm no leader, I led us off the hummock. We marched back though the swaying grass with our heads bowed down. My ears ached something fierce.

When we reached the narrow neck of the peninsula, the wind set us staggering. We grinned at each other, giddy with the sheer power of it. And then, clear as day, Stephen's *Soul* hat flew from his head and tumbled end over end across the top of the grass, one last dance before disappearing into the ocean.

We laughed then and it felt good to laugh. Humor normalizes like nothing else. It's those who can't laugh that are torn to pieces.

How is it that I became so serious?

"California!" one of us shouted.

"*California!*" the other responded, returning the toast.

"It is an active place," I said calmly, dryly, academically.

We laughed some more.

Punch-drunk, we lurched back to my little blue car and took refuge there. Though we were quite sure that the larger world had ended, at least we were warm and dry and out of the wind.

"Blam," said Stephen, a perfectly concise shorthand for all that had happened.

"Blam."

And it really was as if we had survived a tremendous explosion. We could still see evidence of it in fact, way back in the parking lot. Broadsided by violent gusts, my car rocked back and forth on its frame. Droplets of water swirled around the windshield. We could see nothing of the outside. It was as if we were in a submarine.

We turned on the radio, its soft green glow as comforting as any campfire. Slowly working our way through the static, we searched for survivors. To our amazement we found, as faint as if from another galaxy, some *conjuto*, the Mexican *ompah ompah* that carries on infinitely, as much a part of existence as air.

The fact that someone out there was playing this music after the end of everything was wondrous. It almost set us sobbing. It seemed so noble, like those musicians on the deck of the Titanic, playing on while their ship sank.

We huddled in my car for a long time. We were in no hurry to leave the lifeboat.

"Flattened," Stephen said and it made us giggle uncontrollably.

"Decimated."

"Complete and utter annihilation."

More giggling. Sighs.

The morning light came gradually, almost imperceptibly. It was overcast, as it always is in August. The light was flat and gray and the sky was low.

We got out of our pod to take a look around.

Stephen dug out a Frisbee from the trunk. It was red, with lobes like flower petals. We threw it a few times before losing it in the grass. It's probably still there.

A dozen black birds swirled over the parking lot, as synchronized as schooling fish. Long black trains hung behind them in the sky—an effect of minds trying to catch up—a memory of flight written in air.

We thought my old car looked sad, sitting there by itself in the parking lot. It looked defeated somehow, all slumped over like that. *Is that a flat tire?* It couldn't be. But there it was.

"That tire is flat."

"That *is* what a flat tire looks like. There's no doubt about it. *That* is a flat tire."

We obsessed about it from different angles. Then we took a break from all the looking and tried to come back at it with a new attitude. It was still flat.

"Well, dang it all," I said with a ridiculous southern accent, "I got me a flat tire."

"No, really," Stephen responded, as seriously as if someone had died, "You *have* a flat tire. Your car's tire *is* flat."

"I have a spare!" I exclaimed, pleased with myself for having solved the puzzle.

"Um…is that tire flat too?" asked Stephen, pointing.

The spoilsport.

It seemed impossible, or at least beyond coincidence— my car had sustained not one, but two flat tires from the blast.

We debated for a while. We considered the fact that civilization, if it continued to exist at all, was a long way from where we were.

I resurrected my academic tone to stave off the gravity. "Even out here, this far from the epicenter, the destruction is evident."

"Blam."

But joking aside, decisions had to be made. Action was required.

We quickly determined that we needed to be rescued. We needed to call someone who would rescue us. We needed a girlfriend. We needed a phone.

All this was easier said than done, of course. For how would the residents of the ranch down the road respond to two disheveled, wild-eyed men knocking on their front door at what–five in the morning?

So we put it off as long as we could. We drew petroglyphs in the gravel with our feet, musical notes and cyclones and birds—inscrutable messages for no one in particular.

We tramped through the roadside brush to study some cows across a barbed wire fence. We got right up close to their faces. I wished we hadn't. I've found that even under normal circumstances, if you look long and hard enough at any one thing, that thing becomes a whole lot more than you thought it was. Under focused attention, objects tend to break out from the confines of their original meaning, like the words on those plaques, or like repeating your own name aloud over and over until you hardly recognize it. Is that who I am? Is that sound me?

We were looking at the cows and the cows were transmuting, turning from cows to lions to dogs to people so fast we could hardly keep up. Their faces looked liquid—until they hardened up. Until their skin stretched back tight over their skulls and they were death masks. They were mummies. They were the man from Munch's *Scream*. Then their heads began to oscillate until all was a blur except their eyes—their wide, wild eyes—which stayed perfectly still. I fixed my attention on a single pupil and sought safe harbor there. I dove down into that dark, wet sphere, down as far as I could go…and I found stars in the naught.

"Everything is bottomless!"

My friends, there is not a single hairbreadth between a cow and a supernova.

∾

A great sound rent the air, so sudden and awful that Stephen and I crouched, as if missiles were about to rain down on us. The clamor was distinctly mechanical, a throbbing base overlaid with metallic clanks. We could feel the earth pulsing beneath our feet. We realized with horror that the war—the war at the end of things—had finally reached us, all the way out here at the edge of the continent. A tank was going to crest the hill. Paralyzed, we waited for our end. But then—*a truck!* What a relief. *It's just a truck.* The flatbed rumbled slowly toward us. The back was loaded with hay. Three Hispanic men sat shoulder to shoulder in the cab. We stood and waved at them. It was either that or run. They waved back. The driver stopped just short of us and killed the engine. He stuck his head out.

"Hola," I said, my high school Spanish limping back to me in some crippled, neglected form. "Mi caro esta um… enferma. Nosotros necesitos un teléphono."

The men grinned, amused. They were obviously pleased to have discovered idiots roaming their ranch. They motioned toward the back of the truck.

Somehow, we scrambled on. The truck lurched forward with such force we had to clutch the hay bales to keep from flying out. Stephen says I had the craziest smile on then. Looking back, I think our situation had simply become so absurd that the danger had drained right out of it. Our experience had become…whimsical. Those farm workers could have sprouted three heads apiece and it wouldn't have fazed me in the least. Just a few minutes earlier the whole universe was imploding—and now we're on a hay ride—sure, why not? It is we who make our world. It took all I had to keep from laughing like a madman.

The workers unceremoniously dropped us off at 'A' Ranch. We stood on the doorstep of the home there. I remember the sound of a little dog barking at us from inside. The traitor.

Our presence so announced, the fates were fixed. We couldn't run then.

So I knocked on the door. Stephen and I looked at each other and in that moment I thought, if I lived there, I definitely wouldn't open the door for him. I'm sure he thought the same of me.

It's strange, but I can't recall that woman's face. I imagine this amnesia is due to the fact that at the time, I was devoting every ounce of my mental energy to appearing normal. I tried to think of myself in the third person. I tried to think of myself as an actor. *How do normal humans act? How do they look at each other? What do they say in such situations? I must remember my lines…*

"Hello," I said. "We've had some car trouble. Can we use your phone?"

And then, in a miracle of kindness, she invited us—the crazy, wind-chafed savages—into her home. We sat in her kitchen as she made breakfast. We could smell the bacon and the toast and the coffee and it made us feel safe and good. I remember that it was very quiet there, except for the sizzling of the bacon, and the ticking of the clocks, which I thought were inordinately loud.

Stephen tried to call home but couldn't remember how so I took over. It really was difficult. If you stop and break down any one task into its multitude of components, or worse, let all the associations inherent in each and every thing spiral out to their ends, thoughts connected to other thoughts and so on in an infinite web…well, things do get tricky.

I managed by pretending I was a robot. When I got a ring I handed Stephen the phone. He sounded pained, apologetic, humbled. But no matter—his girlfriend was not unsympathetic. Rescue was on the way.

We thanked our host profusely, refusing breakfast, and went happily back into the wind.

When we got back to my car there was a park ranger there, peering into the windows. I realized with alarm that the inside of the car was in shambles; everywhere was evidence of minds unraveled: photographs and rocks and shells and the entire contents of our wallets strewn all over the place. It must have seemed pretty suspicious.

"This your car?" he asked, knowing well that it was.

We were doomed.

I nodded.

"How'd you get two flat tires?" the ranger continued. His interrogation was wilting.

If there was any hope of us getting out of there I'd have to nail this bit perfectly.

"Just bad luck, I guess." My southern accent was as over the top, as usual. "We've got some help comin'," I tried to close the deal.

And it worked! The ranger let us off with some pleasantries and was soon on his way. After we were sure he was out of sight we danced around the parking lot, whooping to ourselves.

A few hours later Charlene arrived. We told her of our adventures and she was interested. Blessed soul, she'd been right there before.

Late that afternoon, we sat exhausted on the sidewalk in front of the Inverness store. We sat there eating bread in the sun. It was glorious. All of our thoughts were spent, our fires out of fuel, and yet, somehow, the heart of everything remained. Life stood stripped to its essentials. We were hungry and so we ate. We were friends and so we talked, and laughed, and shared in each other's company. It was all perfectly ordinary, and yet—marvel of marvels—it was enough.

I wish I could remember that better.

❦

I want to be cremated when I die. I want the ashes to be divided up among my loved ones. Then they can bring me wherever they want. I'll be all over this world. I'm pretty sure Stephen will take me to Chimney Rock. I can see him now, sitting there on that bench at the end of the earth with Jung and Masters. I can see my old friend now, sending me soaring over the cliffs like his *Soul* hat. I'll float down to the ocean and be washed up on the beaches.

Point Reyes is my sarcophagus.

2

Inverness Ridge

GREAT GRAY WHALES PASS Point Reyes on their long migrations. It is thought that they make their way in part by memory, by going to the surface to lift up their heads and look around.

There are no lack of landmarks to guide them. The whales must know Tomales Point, the spit of land that separates the Pacific from Tomales Bay and points toward the Bering Sea—toward the whale's summer home—like a long, bony finger. They must know the ten straight miles of white dunes on the Great Beach, and Alamere Falls, near Double Point— at high tide it drops forty feet straight into the ocean. They must know the serpentine white cliffs of Drake's Bay and the fluted sandstone walls of Sculptured Beach, and—without a doubt—the lighthouse beacon on the tip of Point Reyes itself. Perhaps they think it's a star.

What the great gray whales will never know, except perhaps in their unknowable mind's eye, is the shape of Point Reyes as a whole—the shape of it as viewed from above. Do whales know awe? If so, they'd know it then. For it is then, as pointed out by local author Jules Evens, that they'd see that Point Reyes looks, in fact, like a great gray whale. The resemblance is startling. Tomales Point is the head. The westward sweep of the headlands is the pectoral fin. Duxbury Reef and Bolinas Lagoon are the two-lobed fluke. And finally, Inverness Ridge, stretching the length of the peninsula, makes as straight and firm a backbone as ever was.

And the likeness lies not only in form. For the land here is moving, grinding northwestward along the San Andreas Fault at two inches per year. While it is certainly a statelier pace than the whale's four knots, Point Reyes has nevertheless managed to migrate 300 miles in 80 million years. The bedrock here has been linked to the Tehachapi Mountains, near present day Santa Barbara. It seems that Point Reyes is the wayward son of the Southern Sierra.

Like the gray whales, the peninsula dives and surfaces as well. There is evidence of ancient beaches on its hilltops, and wave marks on its ridges. Once dry valleys now lie submerged. True, such change as it happens is imperceptible to us, whose lives, comparatively, are like but one pulse from the lighthouse. Still, it does happen, and continues to happen, regardless of our witnessing it.

∾

Approaching Point Reyes on a foggy morning, when thick mists from the Pacific roll down the mouth of Tomales Bay and hug the flanks of Inverness Ridge, all of the peninsula is obscured save for the crest, and Point Reyes appears to float, an island in the air. Or else, it looks like a great gray whale, coming to the surface for a breath, coming to lift up its head and take a look around.

It was on a day such as this that I first hiked over the ridge.

As usual, I began my morning in Inverness, stopping to photograph the boat behind the store. Named, aptly enough, the *Point Reyes*, the wreck has been there forever, or for at least as long as I've been coming here. I really have shot it a hundred times. A local once told me, as we stood ankle deep in the mud beneath its bow, that the boat is owned by Andrew Romanoff, the grand nephew of Nicolas II, the last Tsar of Russia.

The story goes that after Nicholas and his family were murdered by the Bolsheviks in the wake of the revolution, England's King George the Fifth sent a ship, the HMS *Marlborough*, to rescue the Tsar's sister—Andrew's grandmother—the Duchess Xenia.

Born in London in 1923, Andrew was raised in a guesthouse on the grounds of Windsor Castle. By his own account, it was a strange and idyllic existence. At eighteen, two years after a Nazi bomb killed his mother, Romanoff joined the Royal Navy, and went off to serve in the North Atlantic. In the mid-fifties, he came to America. Working as a farmer and a carpenter he eventually made his way to West Marin, where he ran a smoke shop in Bolinas. From there he sold his handmade hookas and hashpipes. After that he became an artist. Nowadays, the preferred medium of the man who might have been the Emperor of Russia is Shrinky-Dinks, the arts and crafts plastic sheets one bakes in the oven. On them he draws whimsical scenes from his childhood and youth, with titles like, *We Ate Easter Eggs Meant for Princess Elizabeth and Margaret,* and, *Queen Mary Says You Can Call Me Auntie,* and HMS *Shefield Sinks Enemy Ship on the Russian Convoy to Murmansk.*

Andrew Romanoff, the artist prince of Inverness, is quite renowned actually. He's just published a book.

Yes indeed, Walt Whitman—we do contain multitudes!

A while back a photographer friend of mine Louie called me up and said he'd had a dream of the *Point Reyes* all decorated for Christmas. He said now he couldn't think of anything else, and would I help him make the dream true. So one night we went out there with a six-pack of beer and some staple guns and about a million Christmas lights. We even brought a little plastic tree with a plastic star on top. Louie had to buy a generator to power everything. We must have crawled around that boat for hours, until our hands were torn and throbbing with splinters. But she shone like a jewel when we were done. We stood in the reeds just looking at her, rejoicing there like proud parents. People came up to us then and said they'd seen her shining in the dark from all the way across the bay; they said they'd had to come. We took everything down that same night. We wanted it to be a mystery. We wanted it to be a vision. I do wish Romanoff had seen it.

The *Point Reyes* is disintegrating fast. Every time I come I find that something about her has changed; someone has stolen the lantern from the foredeck, someone has broken the windows in the pilothouse, a part of the gunwale is dangling, a railing has vanished, a swath of paint has bubbled. And there, now, high on the prow, a few faded Christmas lights bud from a broken length of green cord.

I try and photograph my boat at least once a month, usually from the same vantage point. I'm making a record of the winter of her life. Sometimes, in my mind, I can see all the pictures bound together in order. And then I flip through them, quickly enough that the stills become fluid, like those old novelty books of horses running, or women

dancing, and I can see then how it all comes together, or rather, how it all falls apart. Compress ten years into a few seconds and the inevitability of everything's end is so clearly revealed.

Someday she'll be gone. Someday I'll come around that bend on Sir Francis Drake Highway—the spot where the trees open up—and I'll look down there and my boat will have disappeared. It is certain. Someday she'll be towed off, or torn apart in a storm, or else, through some destructive urge, reduced to a smoldering heap. And then I'll photograph that too.

Fundamentally, all photographers are memorialists.

On the morning of the day I first climbed over Inverness Ridge, I stood before the Point Reyes and watched a murder of crows gather on her bow pulpit. Perhaps they've come, I thought smiling, to deliver me a sermon on impermanence. Then, as if to prove the point, they flew away and disappeared. This too will pass. This too will pass. This too will pass.

I set up my tripod and folded my hands over its head, leaning there, letting it support me so that I could be as still as the world. The water was so smooth it looked frozen over. Not a single thing was moving as far as I could see. And all was perfectly quiet. It hardly seemed possible that a wild place could be so reposed. The landscape, emptied thus, gained the quality of architecture, of an ancient cosmos of temples and monuments; Thebes or the Taj Mahal. The *Point Reyes* was a weathered limestone sepulcher, a vessel for the next life. Black Mountain lay to the east like a stone fist, like a sphinx paw. And I, I was a statue of a man leaning on his tripod.

Then the fog came down the bay like a living thing, coursing into the grooves on the face of the mountain, rolling up the furrows and meeting at the peak, then lifting off for the sky. The mist soon blotted out the sun, and morning turned to dusk. I was lost at sea.

I don't know how long I stayed there like that,

enraptured with the world. I'd lost all sense of time. Beauty can do that. So can photography.

An orderly line of black loons swam by, and something about the way they split the water made me think of a clock.

I loaded up my gear and drove to the trailhead.

∾

There were no other cars in the parking lot. I'd have been surprised if there were. Point Reyes is mine most days.

Entering the forest was like diving into a cold pool. Everything was wet from the fog. Water dripped down from the canopy, as steady as rain, running down my neck and clouding my glasses. I could hear the murmur of a hidden stream. And a woodpecker's knock, echoing from some faraway place. And then another call, this one more exotic. It might have been a winter wren or a hermit warbler. I couldn't say for sure. I don't know birds the way that some people know birds. But I remember the song and how it made the forest feel ancient, primordial. I imagined that at any moment a dinosaur might come lurching through the sword ferns.

The understory was a tangle of lilac, laurel and blackberry, live oak, madrone and moss-covered bay trees with limbs that twined overhead like huge tentacles. Towering above it all were the Douglas-firs, the great and solemn trees of Point Reyes. Most of them have been on Inverness Ridge your whole life, for the life of your parents, your grandparents, your country. The oldest of these giants, as thick around as a redwood, have stood right there for a thousand years.

After a half an hour or so, I took a branch off the main trail. I took it because I liked the name of it. It was called the Greenpicker Trail.

Almost immediately, the path began to narrow, closing in until I had to stoop to pass through a tunnel of branches.

I burrowed through the forest like an animal. The trail grew so steep I took to the balls of my feet, using roots for footholds to keep from slipping backwards in the mud.

An invisible spider web broke across my face. It made me happy, for I knew then that I was the first person to pass that way that day.

After a time the trail opened up a little and I could see through the mist to the tangled crowns of the firs. They are such sober trees, almost frightful, especially in a fog, when looking skyward each tier of their bare branches grows successively less distinct, so that they seem to go on without end, as if one were standing beneath a thunderhead miles high, watching the lightning come down.

I trudged on.

I've found that hikes precipitate a predictable mental arc. At first, the novelty of new surroundings captures the senses; there are a million fresh things to hold the attention, and I gladly bear them witness. But then, just as surely, the newness fades, and my interior world rises up to reassert itself. It seems my attention always wants to turn inward, back to my own bramble, back to my own thicket of dendrites, those ten million thoughts and desires and well-worn dead ends. I stroll along while the internal discourses are practiced, and the arguments are fought. My memories are indulged, regretted, rearranged, or fitted with alternate endings. Material goods are acquired; how would I look, how would I feel; with that, in that, on that; Royal Blue or Goodwood Green; I'll try them out, now the one, now the other, now back to the first. I stroll along and in my mind, people are possessed—ah, the most tempting flight of all. Of course, they are not really people but only projections of myself.

Still in all, it'd be a pleasant enough way to pass the time, if it weren't for the dangers… For the inevitable price of such idling is that the world begins to retreat. It just fades away, passes by, and one hardly notices—mile after mile, year after year. It is then that though one walks through the world, it is but lightly, as if on stilts. This is how one becomes a ghost.

I can imagine, but only just, that some people don't live this way at all, that their minds and the world are joined together like gears. I imagine that some people manage to remain in focus. But that is not me.

And so I must treat myself. I know some remedies. Ironically, a long hike works wonders. For though at first the condition at hand may worsen, eventually it seems, the body begins to consume the thoughts for fuel. It takes time, but eventually, the musings unconnected to the present begin to peter out. Eventually the junk is purged. The fat is trimmed. But it's not easy. Toward the end, the most stubborn scenes play over and over, perversely, like a song stuck in your head. At last though, even those fade away, and the world returns.

Or else, sometimes it is the case that something from the outside will come forth to shock me from my stupor, like the sudden blow a Zen master gives a student he suspects is faltering in his present-mindedness.

Such is what happened to me on that January day.

I was continuing upward—there and yet not there—when I was met with a sound so loud and strange and close it wrenched me from my slumber. The noise was distinctly mechanical, like a hedge trimmer, or the propeller of a small plane. It was a sound that didn't belong to the place and as such, I couldn't wrap my mind around it. It was as if a desert had dropped down into the middle of my forest. It didn't make sense.

A hummingbird! It was a hummingbird, not three inches from my ear. Before my jaw could even drop, the bird shot straight up, as fast as from a gun, faster than seemed possible, then stopped, all at once, hovering in the air high above me.

The bird made a few strange clicking sounds then dived straight for my head.

I am certain that those who would find humor here have

never been attacked by a hummingbird.

The sheer speed of it was so tremendous I couldn't help but think of those wooden posts found embedded in brick buildings after a tornado. I couldn't help but fear impalement.

And so I ran. I ran as fast as I'd run in a long time, tripping over roots and splashing through puddles as a hundred branches clawed at my face. And all the while, with a terrible relentlessness, that hummingbird continued to strafe me. I quickly discerned a rhythm in the attack. First there'd be the drone, the engine-like humming, growing louder and louder until it passed just overhead (it must have been by only inches) and then, there'd be a moment of silence, followed by the clicking, and then the hum would descend again. I thought it would never end. I thought I'd have to run all the way to the ocean and dive in to escape it.

But after a quarter mile or so, the hummingbird finally, mercifully, called off the assault.

Afterward, I stood there panting, my face bloodied and my glasses fogged, and I grinned like a madman. For all at once, the world had flooded back to me tenfold, so strange and beautiful that I could hardly stand it. I hadn't felt so alive in weeks.

All praise the angry hummingbird!

I am awake.

It was warmer then, and drier. The fog was clearing. And the forest was changing. As I went on, the underbrush began to disappear and the broadleaves grew further and further between. Even the ever-present ferns began to vanish. Everything was opening up and emptying out. After a time, all that was left were the firs, and the litter of their broken limbs.

When I reached the top of Inverness Ridge, I found the path there straight and level—I could see the trees receding to infinity. Their bare branches curved up to meet in the air above my head like crossed swords.

I knew this wood. That is to say, it felt familiar. It was the wood of Hansel and Gretel, of Little Red Riding Hood, of Peter and the Wolf. It was the Black Forest. It was Narnia. It was a boyhood dream, with ogres and elves, hobbits and wraiths, headless horsemen and talking fauns. It was a forest full of wild things. Magic.

I stopped and closed my eyes and listened—searching for something inside–imprinting the moment upon myself. The firs were creaking a little, moaning like old bluesman: Blind Willie Johnson or Son House or Howlin' Wolf—sounds that chill to the bone. I was awed then, and a little lonely, standing there with all those trees, all of them just waiting—just being. I could have been in the Grand Canyon or under a sky full of stars—the effect would have been the same.

We forget how small we are.

I opened my eyes and saw a last, lingering billow of fog, floating toward me down the trail like a breath. I swear it looked lit from within.

I never know what I'm looking for when I'm out photographing, but I always know it when I see it. If something sets me to trembling, the camera comes out. And so it was on Inverness Ridge that with trembling hands I fumbled with my gear (as if I hadn't practiced the ritual a thousand times before), praying all the while that the scene before me wouldn't vanish; *Please, not yet, not yet!*

I tripped the shutter—the photographer's genuflection—and a moment later the fog passed around me. I could feel its coolness on my skin.

Wondrous.

I'm not sure how long I stood there in that spot, transfixed. It's easy to loose track of time in the forest. I'm certain it never crossed my mind that it might be getting late, that perhaps I should turn back. And besides, no one with even a modicum of adventure in their blood could have possibly resisted following that path to its vanishing point and beyond.

And so I did.

The level stretch soon ended, and I found myself descending the far side of the ridge on as steep a grade as I had climbed up before.

Almost at once, the broadleaves returned. I remember a bay tree with branches that arced from its base like water from a sprinkler. And a tremendous old oak, so covered in wooly green moss I couldn't help but stop to pet it.

Ambling through this renewed extravagance, the austerity of the crest began to feel as if it had been long before. Really, it almost seemed as if it had not been a place at all, but rather a state of mind I'd passed through. So much of the landscape comes from within. And yet still it surprises.

I came to a clearing and saw, far below, a sliver of Drake's Bay. The water was a sapphire blue, the color of the Aegean Sea—of Arcadia. And there atop it—the unmistakable green dome of Chimney Rock. How small it looked! I reached out—reached out to this place that looms so large in my self—and carefully laid it along the edge of my finger.

Not long after, I broke from the forest and into the open, into a scene of surpassing beauty—the verdant arms of Point Reyes and Double Point sweeping through a glistering sea, and some twenty-five miles off—set like a star in the crescent—the jagged gray Farallons. The Miwok called them the Islands of the Spirit. It is said they sent their dead there wrapped in tule reeds.

I continued on down the trail, through a low, dense mosaic of coyote bush and sagebrush and vetch. With my only companions an occasional commotion of quail, it was easy to imagine I had the whole place to myself, at least until I reached the overlook high above Wildcat Camp, and saw that the meadow was speckled with same-looking tents. I guessed I'd found a Boy Scout troop.

Fifteen minutes later I was among them, feeling the odd sheepishness that comes after spending the day alone. I marched through the congregation with as much purpose as I could muster, tersely greeting the scouts in a voice that sounded strange—who *is* that?

I remember that each campsite had a barbeque mounted atop a slender pole. Some of the bottoms had rusted out and the grills hung grotesquely on their stands, as if impaled on pikes. The air here is hard on things.

I reached the shore just as the sun was setting. The beach was a flurry of activity: sandpipers flirting and gulls reeling and just offshore, a pair of sea lions play-scuffling in the surf. It reminded me of a bar at last call. I tipped my hat to the gang and continued on south.

The beach was narrow, backed by high, steep cliffs, and I confess, it was a little unsettling to be trapped like that with the light failing. I couldn't help but imagine being dashed against the headwall and dragged out to sea.

I carried on though, comforted with my strange faith—baseless perhaps—that nothing terrible would happen to me. At least not yet.

And then the stars came out, argent and alive, studding the sky clear down to the Pacific.

Ladies and gentlemen, we are floating in space!

Soon it grew so dark I could see only outlines. Double Point had become a void, an empty shape defined by the stars and by the faintest hint of surf.

I remember at one point finding something on the beach. Some thing. I circled it slowly, straining my eyes to determine what it was. It looked like a sleeping sea lion. *Could it be?* My mind made it so. I worked up my courage and gave it a quick pat—cold, wet stone.

I've heard that deep-sea divers can become so enraptured by the beauty around them that they forget they are running out of air; or they *do* know, but no longer mind. They wish only to stay in the presence of beauty, no matter the cost. I think I was a little bit like that that night. Like some mythical siren, Double Point seemed to beckon me on. I knew too, from studying my maps, that somewhere out there in the darkness was Alamere Falls. How could I turn back?

The tide was definitely rising.

I reached a cliff that cut deep into the breadth of the beach. I could hear the waves breaking at its base. As I stood there wavering, trying to discern the rhythm, I remembered hearing somewhere that the seventh wave in a series is the largest—*or was that the smallest?* I couldn't be sure. At last, at what I guessed was the decisive moment, I dashed madly around the point. I hadn't a thought of what I'd find there.

What I found was that the projection I'd rounded was only the first of an indefinite series. The cliffs were scalloped. This would be tricky. I scoured the face of the wall for an escape route but found none. There was nothing to do but stay the course.

And so I began to run, recklessly ignoring the surf. A wave caught me by the ankles but I went on, as if dragging someone behind me. I stumbled over wet stones as cold water swirled around my shins, my knees, my thighs. I cried out. I swore. I condemned myself for having the sort of character that would seek such trials.

And then there came a cliff that invaded the sea more deeply than any of those before it. I was sure the surf there was higher than my waist. I'd never make it past. But what choice did I have but to attempt it?

I let out a yell and charged into the water.

∾

And I was on the other side, standing safely on a wide open beach, with Alamere Falls glowing softly in the starlight. *Alamere Falls.* It looked so incorporeal, floating there in the dark, so much so in fact I would have thought it a phantasm, had I not already known of its existence, nor heard its high whisper from where I stood.

I went to the base and climbed atop a boulder, so close I could feel the spray on my face. The highest waves rushed up the beach and swirled together with the water from the falls. Alamere Creek was leaping straight back into the ocean.

Without a doubt now, the tide was rising. Within minutes I was sure the promontory I'd just come around would be impassable. I was sure my door home had closed.

Again I searched the cliffs for a way up. And remarkably, only yards from the falls, I found a diagonal cut in the bluff. It was steep, and covered in loose talus, but I thought I could climb it.

I began to inch my way up, digging my fingers into the shards to keep from sliding back. It was like climbing through broken glass. Still, I was relieved to be above the surf, and figured in the worst case, I could just cling there until morning.

It wouldn't be necessary. The chute soon delivered me onto a level, open shelf, about the size of a baseball diamond and nearly as sparse. Running through the center of this stone field, empty save for a few clumps of purple dew plants, was Alamere Creek. Here was where it spent its last moments.

I followed the stream to the cliff's edge and put my head over. The sound of the ocean was frightful. I'd be stranded there until the tide turned.

Which was quite alright by me.

Away from the edge, it was an Eden of a place. Quiet. Peaceful. And cold, yes, but I gladly traded the chill for the prospect of being swept to sea. I settled down with an ice plant for a pillow and gazed into space. Within a minute I'd seen half a dozen shooting stars. Their afterglows lingered for a breath.

A pair of rose-colored clouds wafted past. The way they were lit from below looked strange. I thought for a moment that the moon was rising. But then it struck me—*San Francisco.* I was seeing the reflected light of the city of San Francisco. *Amazing.* It hardly seemed possible that this world could exist just miles from that one.

I remembered people then, and I wondered who else had lain there in that same spot. The Miwok must have known Alamere Falls. Had they come there to watch the heavens?

All at once, I wanted to drink from the creek. I wanted to drink like a Miwok. The more I considered it, the stronger and more stubborn this urge became. *Have we really,* I mused, *become so estranged from the world that a perfectly natural act—drinking from a stream—has actually come to seem unnatural? Almost…criminal?* The creek was a forbidden fruit and the prospect of partaking of it made me giddy.

I considered the warnings of intestinal parasites. It is said that the human digestive system can no longer accept this water, that it is dangerous. On that night though, it felt as though breaking the rules was exactly what was required. And so—Giardia be damned—I rose up and went to the river. I knelt there and with cupped hands I brought its icy water to my lips. I brought Point Reyes into myself.

It would have been worth it if I'd gotten sick. But I didn't get sick. In fact, I hadn't felt so good in a long time.

Satisfied, I retook my place. I must have lay there for hours, just listening to the stream and watching the stars. But then the cold began to seep in and I started to shake. My clothes were still soaking wet. I sat up and gathered myself as small as I could, pulling my cap down low and wrapping my arms around my shoulders. I began to rock back and forth.

Across Drake's Bay, over on the headlands, I could see the pulse of the lighthouse. It seemed as distant as a satellite. I peered into the ocean and imagined that somewhere down there in the dark a gray whale might be passing. I thought of the three of us; the keeper, the whale, and me at the top of the waterfall. I thought of the three of us afloat in infinite space. Between each thing there is so much emptiness.

It felt even colder then. I don't think one can get hypothermia on Point Reyes, but one can, short of that, become quite miserable.

Again I put my head over the edge to gauge the surf. It sounded subdued. Deciding that the tide had finally turned, I bode farewell to my sanctuary and scrambled back down to the beach.

The surf had indeed retreated. The swash was now just a whisper, and I strolled along with a light heart, relieved, marveling that such a day could stretch out so long, and be so filled with wonders.

And they did not end.

Sparks! There were sparks shooting out from beneath my feet! At first, I thought it must have been an illusion, my mind playing tricks in the dark. But there they were again, these blue-green sparks, scattering with a drag of my boot. *Glow plankton.* Though I couldn't see them, the sand must have been brimming with tiny bioluminescent creatures. Fireflies aren't the only ones that can make their own light. I experimented by kicking sand into the air. It was as if I had struck the embers of a fire; incandescent particles shot up and then, after a moment, flickered out. I quickly discovered that some patches of the beach were more active than others, and I ran about madly, searching for hot spots. I must have been quite a sight, whirling around like a dervish while sparks flew from my feet. Finally, I dropped to my knees and grabbed fistfuls of the stuff, as much as I could hold, ran to the waters edge and cast stars into the sea.

ॐ

The boy scouts were fast asleep when I arrived back at the campground. Or at least, their tents were dark. I imagined that some of them lay awake in their sleeping bags, wild-eyed, listening for some sound from the wildness outside.

And for good reason. Mountain lions are seen at Wildcat Camp with some regularity.

The thought sent a shiver down my spine. The reality of what I was about to do—something I'd managed until then to hide away in some dark corner of my mind—was now inescapable. I'd be going back the way I'd come, back over Inverness Ridge through the Black Forest—alone and at night.

I considered staying at the camp until morning. It would have been the wise thing to do. But I reasoned that my loved

ones would worry; after all, I'd left that morning for a day hike. I imagined they'd call in a rescue, and when I pictured it—the helicopter rising up over Inverness Ridge at four in the morning, the boy scouts pouring out from their tents to investigate—it was a humiliating scenario. And besides, who would want to shiver all night in a dew-soaked campground like some uninvited ghoul? I'd rather keep moving.

Of course, as persuasive as my arguments were, the real reason I had to summit that ridge was because I was afraid to.

Mountain lions can grow up to seven feet long and weigh a hundred pounds. They can leap eighteen feet in one bound. *Eighteen feet.* Their preferred hunting technique is to silently stalk their prey, then ambush from behind, snapping the neck with a bite to the skull.

It is said that a mountain lion's roar sounds like a woman screaming.

The experts advise, seemingly against good reason, that if one should ever meet a mountain lion, one should make eye contact and speak to it firmly in a loud voice. I wonder though—what should one say in such a case? Above all, they offer, one should stand their ground, fighting back with any means necessary.

Of course, such advice is rendered useless if you can't even see the path you're walking on, let alone a camouflaged lion padding along silently behind you.

I extended my tripod legs to fashion a spear. As I crept through the campground, it struck me that if at that moment a scout had peeked from his tent I would have made a most terrifying specter.

I stormed the hill at a blistering pace, determined to lose myself in action. Mercifully, the time passed quickly, the way it often does when you know where you're going and you're focused on getting there. Soon I was back in the woods.

Not being able to see was actually not a great hindrance, as far as navigation went. The dense undergrowth on either side of the trail let me know when I began to stray. Still of course, it was a ghastly business…

At some point I remembered the flash I had in my camera bag. It was the kind that can be detached from the camera and used by itself. Pleased with myself for having thought of it, I dug it out and switched it on. The capacitors began to whine. After a few seconds, a red light came on, letting me know that it was ready.

I fired it. The forest was filled with a searing white light—then plunged back into total darkness. Afterimages of a hundred mountain lions quivered in my brain. I frantically pushed the flash button again and again but nothing. The batteries were low. At last came another pulse and another mass of gruesome forms—a necropolis of stacked skeletons and a thousand pairs of shining eyes. I decided then I preferred not seeing to seeing and continued on in the dark.

∾

Sometime in the middle of the night I arrived back at the parking lot. My faithful car had waited for me. I collapsed atop the hood, my legs so stiff and sore I wondered if I'd be able to drive at all. But I climbed in, somehow, pulling my legs in after me as if I were paralyzed, bending them to fit. Then I rolled down the windows and just sat there for awhile, savoring everything.

When I started the car, the tape deck sprang to life mid-song—exactly where it had left off that morning. It was as if no time had passed at all.

As I drove down the gravel road toward the highway, I pictured myself from above. In my mind's eye, I saw the swath of my headlights cutting through the woods, saw my little boat bobbing on that big dark sea, saw the smallness of all my endeavors.

And it was all right.

On that night, at least for a moment, having a place in the whole was enough.

A Love Supreme indeed.

3

Tomales Bay

A FEW YEARS AGO I BOUGHT A KAYAK to better explore the peninsula. It's a humble boat, as boats go, but it's served me well. Before its inaugural voyage, I painted a pair of eyes on its bow. I'd read this was a tradition among seafaring people, a way to ensure that their ships always knew where they were going. It made sense to me. I modeled my own boat's eyes on the eyes of a little yellow Lego camel that I borrowed from my son. I wanted my boat to look friendly.

The exact moment that precipitated my buying the kayak was the moment I first saw Hog and Duck islands in Tomales Bay. I was driving up Highway 1, along the bay's eastern shore, when suddenly there they were, sitting still alongside each other like two Zen monks on a temple floor. I immediately pulled to the shoulder, leapt from my car, and scrambled down to the water's edge. *Sanctum sanctorum! But how will I get there?*

A week later I was sailing down the freeway with a bright blue kayak strapped to the roof of my car. I imagine it was quite a sight, what with the eyes and all. I remember that children were laughing and staring and pointing at me. But

I and my boat remained serene, as imperturbable as those islands.

Twelve miles long by a mile wide, Tomales Bay forms the eastern boundary of most of Point Reyes. Its often-tranquil air belies what runs beneath it, for the bay is in fact a submerged rift valley of the San Andreas Fault—the seam where the Pacific and North American plates meet. Study a map and it quickly becomes clear that Point Reyes, riding along on the west side of this divide, belongs at heart to the ocean. And someday may return to it. If only Tomales Bay were to make a final short push into Bolinas Lagoon, the peninsula's tie to the continent would be severed, and Point Reyes would become an island.

It can be difficult to accept the existence of such forces when faced with the bay's supernal calm. One can hardly imagine a more tranquil place. The waters there are often as placid as a pond, a result of the inlet being spared the winds of the peninsula's seaward side by the bulwark of Inverness

Ridge. And when the fog rolls in, the enveloping mist mutes the light and quells the shadows, hiding the evidence of time and change until the bay seems to lay in perfect repose, exempt from the goings-on of the rest of the world, like some watery Shangri-la.

Of course it's an illusion. For whether we witness it or not, change is unceasing. And the bay has its dangers. At its mouth, where it joins the Pacific and Bodega Bay in a volatile triumvirate, high swells, strange currents, and a treacherous bar have claimed the lives of many. The mouth is also ill-famed as a breeding ground for great white sharks. Even paradise has its predators.

∾

My first launch came early on a February morning. I can so clearly recall standing there on the eastern shore, struggling to free my kayak from its car-top restraints, feeling strangely self-conscious, though there wasn't a soul around, save for a pair of feral cats who came up close to investigate. Then again, it *was* my first launch, and as such, I had reason to feel a little uneasy. My kayaking knowledge was really quite limited. The how-to book I'd borrowed from the library had recommended I practice in a swimming pool. Not having a swimming pool, I had to make do with the grass in my backyard. I crammed in and my son sat on my lap. We pretended we were pirates. He wanted to accompany me on my adventure, so I'd be safe. I told him he could come when he was four.

It wasn't as if I'd drown most likely, but a lot of disasters could befall me short of that. The boat could flip over and sink for instance, taking my camera down with it. Or else those strange currents could drag me out to the ocean. I'd have to be rescued. And then there were the sharks. I tried not to think of them much.

With my cat friends watching, I dragged my kayak down to the shoreline and put its nose in the water. I slipped into the cockpit and carefully laid my paddle across the deck. I felt like an old time aviator; I would have donned a pair of goggles if I'd had them. The cats—I guessed they were brothers—came right up to the boat. They were fearless. I think they would have jumped in with me had I wanted them to. I gave them a good farewell pet and began to inch my way forward by vigorously thrusting my upper body. It soon became clear I hadn't put the boat out far enough. I couldn't get loose, and with every thrust my sleek plane began to feel more and more like a fat seal. Frankly it was embarrassing, to be struggling like that in front of the cat gallery. But then, finally, the water lifted me up and I was free, transformed, my boat at home in its element and I with it. And it really was like flying.

I practiced near the shore for a while, turning circles, braking, rocking back and forth, sprinting away from imaginary sharks. Then I tried to go backwards and almost capsized. I wasn't ready for such maneuvers. I knew enough though—just enough.

I went out a bit farther and let myself drift. There was no hurry. I know well the pleasures of delayed gratification. As of then, those two islands held *anything,* and I savored their mystery.

The water was utterly still. It was as if the bay were holding its breath. And in a way, I suppose it was. For right beneath me lay the San Andreas, cocked there like a loaded gun, ready to unleash the most terrible violence imaginable.

In the great quake of 1906, it wasn't San Francisco but Point Reyes that experienced the greatest geologic displacement. In an instant, the area west of the fault lurched northwestward a full twenty feet. Yawning fissures opened up in the land. In Point Reyes Station, a train was thrown clear off its tracks. On Inverness Ridge a lake was drained of its water. The only reason more people weren't killed on the peninsula was that there weren't many people to be killed.

Someday, the power coiled beneath Point Reyes will again be unbound.

Everyone says it's inevitable.
Maybe it will happen today.

∿

I pretended my kayak was the needle of a compass, with I at its hub, turning and turning until my prow pointed east—toward the rising sun. I leaned back and closed my eyes, feeling its warmth upon my face.

The seasons are strange on Point Reyes. That mild February day might have been in June, if I were somewhere else. And if I'd been on the bay in June, most likely it'd have been cloaked in fog. Sir Francis Drake's galleon the *Golden Hind* arrived in June. The ship's chaplain Francis Fletcher noted in the log, "Neither could we at any time, in whole fourteene dayes together, find the aire so cleare as to be able to take the height of sunne or starre." One can imagine that such conditions only exacerbated the Englishmen's disorientation. Strangers in a strange land indeed.

I let myself wheel around in slow circles—or was it the world that circled around me? Features came and went and came again without any sensation of my own moving. It was as if I were at the still center of a slowly spinning cyclorama, a plein-air ribbon of water and rock and light.

And there—*there!* It was a line of low buildings back on shore, just around a bend from where I'd launched. I hadn't noticed them before. The wooden structures were poised above the bay on stilts, strung along the waterfront like a row of sun-bleached tombs in a New Orleans cemetery, noble and somber at once. Even from a distance, I could tell they were ruins.

The islands would wait.

I paddled eagerly toward the buildings. When I was twenty yards away, I stopped to search for signs of life. I half-expected someone would come and yell at me, come tell me I was trespassing. But no one came. It was a ghost town.

I surveyed the scene from my ship. There was a home—and they *were* once homes—whose front pilings had collapsed; it slumped over like a weary animal with its chin in the mud—a vanquished bull on buckled knees. Another house was missing a wall entirely, and with its interior so clearly revealed, it looked like an exhibit, like an architect's model. In places the plaster was rotting away, baring the frame beneath—skin giving way to bone. Electrical wires dangled from the middle of the ceiling, their frayed ends terminating in mid-air—impotent and awful. Around the side I found a porch solid green with algae. A screen-less screen door hung wide open. Had the tide been a little higher, I could have paddled right in.

I went up and down the abandoned row, threading my way through rocks and snags and rusted hulks. A pier ran out from one of the buildings, the wood warped such that the whole span had begun to twist, undulating and dipping down at its end like a tongue lapping at the water. I docked alongside it, tethered my kayak to a piling, then carefully clambered out, crawling across the planks on hands and knees. When I reached the end, I leapt down onto a mat of soft, dried seaweed. The whole beach was covered with it. I padded about like on a thick carpet while a cloud of tiny flies swarmed around my feet.

I found a myriad of treasures: rounded, timeworn boards and empty oyster nets and odd lengths of pipe and rope. I found three squat fishing huts sitting shoulder to shoulder on the ground, foundationless. Their bare slat walls were fraying at the base like old hems—a trio of thickset women in grass skirts. Across the way there was an outhouse, leaning way over—losing its balance. It looked forlorn amidst the weeds. I discovered some train tracks too; they ran straight down the beach and then, in the most whimsical way, disappeared beneath the water.

There was a bar there too. The whole of it was listing seaward. The structure was clearly unsafe but I went in anyway. How could I not? Once inside, I found that large parts of the floor were missing. The bay shone through

where people used to drink and dance and kiss. The patrons probably hadn't thought of it then, the fact that there was water beneath their soles.

There were empty bottles on the counter. Though likely left by latter-day ruin haunters like myself, the bottles still made for a strange scene, as if the customers had just decided one day to get up and walk away.

I set to work, extending my tripod, shimmying its legs back and forth until its feet cleaved holes in the layer of broken glass. I photographed Tomales Point through a window frame the shape of a melting rectangle.

I made a lot of pictures that day. It seemed to me that the town deserved a last testament.

Hours later, when I returned to my boat, my mind was sober with the way of things.

Once upon a time, Miwok Indians lived along the shores of Tomales Bay. They built boats from bundled rushes. The men plastered their skin with mud to keep out the cold. Chaplain Fletcher wrote that they were, "a people of a tractable, free and loving nature, without guile or treachery…" Of course, these were precisely the traits that would prove their undoing.

It is said that the Miwok considered Point Reyes to be the abode of the dead, and they were right. There are no Miwok there now. But no matter the cause, the dissolution was inevitable. Villages, towns, cities, and civilizations; they all rise and fall, rise and fall, as regular as breath. All our homes are future ruins, and shortly thereafter, not even that.

The Buddha was right—this is a phantom world.

I paddled on. The water was so still I almost felt guilty for disturbing it, as if with every stroke I was knocking candles off a shrine. Such quietude seemed to demand a respectful deportment. I shallowed my strokes and glided the best I could.

Together, Hog and Duck Island form the shape of a semi-colon, with Hog the comma and Duck the single point. And their relationship is quite literally close; if a person had a good arm, they could throw a stone from one onto the other. Both of the islands are tiny. From my boat, I estimated that I could circle the perimeter of Hog Island in a matter of fifteen minutes or so. And as for Duck, a modest home could fit there, but only just. In truth, they might best be described as tree-topped pedestals rather than islands. But despite their diminutive stature, the islands have seen their share of human history.

The names Hog and Duck remain somewhat of a mystery. One story goes that in the 1870s, a barge carrying hogs across the bay caught fire and the quick thinking captain landed on the island so that his cargo would survive. An alternate version has the barge sinking and the hogs swimming to the island, whereupon it is said they became wild and thrived for years. The denoting of Duck Island is lost to time and the name is still in fact in some dispute. Area fishermen often call it Piglet. And it is likely that the two were indeed once one. One local used to go around claiming that he actually witnessed the birth of Duck/Piglet Island when it broke from Hog Island during the great quake of 1906. By all accounts, though, his claim was a dubious one.

In any case, the records show that in 1878, President Hayes patented Hog Island for "a few dollars" to a German immigrant named Christian Kushert. In turn, Kushert let Christian Hulbe attempt to ranch the island in the 1890s. Though Hulbe and his wife managed to raise a family in a wood frame home there, their ranching endeavor would prove to be a failure. Hog Island, in the middle of Tomales Bay, has no reliable source of fresh water.

Kushert bequeathed the island to his sister in 1902, who sold it shortly thereafter to Henry and Catherine Siemsen. The Siemsens then sold it to an N.W. Mallery, who promptly lost it in bankruptcy court to Clara Windsor in 1909. It is reported that Mrs. Windsor paid eight-hundred dollars for the property. Fred Windsor (Clara's husband? Clara's son?) built a stone house on the island in the 1940s.

It was the shell of this very same house that I found myself

paddling toward more than a half-century later.

I had read about the ruins, but to actually see them! There they really were—I could hardly believe it. The old house was set back from the narrow beach, nestled in a crook of a low cliff that appeared to encompass the island. Atop the cliff was a dense forest of eucalyptus, and something about it chilled me; I couldn't help but think of Charles Marlow and Benjamin Willard, of Ralph and Jack and Piggy. I half expected a ragged band of Miwok to emerge blinking from the bush. None came, of course. There were only the stone ruins and the eucalyptus and the heavy silence. But as I got closer and looked into the treetops I saw that there were cormorants there, hundreds of them, motionless, their long black necks like hooks. The birds filled the trees like Christmas ornaments.

I wondered what the Windsors would make of their home if they could see it, the roof gone and plants growing out through the windows and all those carefully laid stones streaked white with guano. I wondered how they would feel to see the barrier they'd made between inside and outside so wholly and irrevocably breeched.

And then—a sea lion off my port bow! He was ten yards away, as still as a statue, staring at me with his inscrutable black eyes. I waved hello. He slipped beneath the surface then popped up again, so far away it seemed impossible for him to have swum the distance in that time. We stared some more. His expression remained unchanged. Then all at once he disappeared without a ripple.

I let my kayak drift and turn in a slow arc. I guessed my curious friend would try and sneak up behind me. And sure enough, half a rotation later, there he was, or rather, there *they* were, for there were then not one, but seven sea lions—motionless—all gazing at me with those unreadable eyes. They looked like warriors from Emperor Qin's Terracotta Army, or a conclave of cardinals from another planet. I couldn't tell if the moment was graven or comic. "Take me to your leader," I said, and some of them promptly dove down

as if going to bring him forth, then came up again seconds later in a different place—leaderless.

I wondered what they were thinking. Then I wondered if any such speculation was a fallacy. Perhaps a sea lion is fundamentally unknowable. But then again, were not all species forged in the same fire; are we not all made of the same basic stuff? It would stand to reason then that a sea lion should be as knowable to me as my own right hand.

"Brothers and sisters," I orated, "I've come in peace."

My brethren offered me only more inscrutable staring. And then, as quickly as they'd come, they vanished, for good this time, leaving me to wonder if I'd done something to frighten them off. Or worse, maybe they'd just decided that I was altogether uninteresting. Or else…down there in the dark, at that very moment, there was a great white shark, guiltlessly hungry, looking up at my sea lion shaped boat with the black and white eyes painted on it.

I paddled furiously toward the Windsor's front door. Water splashed my face and streaked my glasses. I could taste the salt. Eel grass wrapped around my paddles and whipped wildly through the air above my head. I flailed on. Momentum was paramount. I'd fling myself up on that beach like a whale. My paddles began to strike bottom and I could feel my hull dragging across the tops of rocks. I ground to a stop. My bow was in the sand. I was safe.

I scrambled out into ankle deep water and strode purposefully up the beach. I was Robinson Crusoe, Long John Silver, and Douglas MacArthur all rolled into one. Giddy with excitement, I let out a whoop and claimed the land for the queen.

Then I stood for a moment looking back the way I'd come. What if I really had encountered a shark? Even if I'd outrun it and made it to the island—well, what then? Knowing you'd have to pass back through such a gauntlet could drive a person mad. But right then the thought didn't much dampen my spirits. Right then I was there, and that was all that mattered.

Lest the tide come up to snatch my ticket home while my back was turned, my first order of business was to secure the boat. I dragged it up onto the berm, onto a broad mat of ice plant, and then tied it to a tree with a rope. I'd always wanted to do that.

Then I set off to explore my island.

The dirt floors of the Windsor ruins were sprouting weeds. The stone walls were hung with ivy. There was a rusty barbeque in a corner of the main room, sheltered by a decaying canvas umbrella. Who'd ever brought the barbeque had a sense of humor; an assortment of rusted cooking implements hung in a careful row above the fireplace. Everything was covered in bird shit. There was so much it looked like snow. The smell was sickening. I could feel it in my lungs and it felt unhealthy, as if I were breathing in bleach.

I didn't linger there long.

Around the back of the house I found a path that led upward through a crease in the cliff wall. The trail was so overgrown that to make my way I had to hack at the tangle with my tripod. It was slow going. When at last I reached the plateau, I found there a scene so startling it was as if I'd just walked into my own surprise party. Beneath the canopy of eucalyptus, spread out as far as I could see—was a carpet of yellow daffodils.

Wondrous.

I picked my way through the bloom, marveling and reverent, as if I were threading my way through a field of tombstones. And in a way I suppose I was. For those daffodils were most likely the descendants of flowers planted long before by Clara Windsor in her garden, freed now to spread across the island and memorialize the dead.

The cormorants were rustling in the trees. I could hear the branches creaking from the weight of them. Still though, there was a certain hush there. Each sound seemed precisely what it should be and not a bit more. Nothing was gratuitous. It was shrine-like.

Until from out of the quiet there came a deep and tremendous sound. It was a sound like cannon fire, like glaciers calving into the sea, or boulders rolling downhill—a colossal sound. I thought at first it was an earthquake; I thought the San Andreas was coming apart like a zipper. Instinctively, I crouched down in the flowers.

Then it struck me that I knew this sound, that I'd heard it before. It was the sound of hoof beats. The elk were running on Tomales Point. There must have been a hundred of them. It seems incredible that the noise carried across the bay that way. Almost...unbelievable.

But I know that it happened. I know that I knelt in a field of yellow daffodils in a forest of eucalyptus on Hog Island, Tomales Bay, atop the San Andreas Fault, on a split between the earth's plates, and heard the beating of a hundred elk's hooves. I know it happened, and I'll keep it forever.

The sound tapered off gradually, like the end of a rain, dividing and dividing until there was nothing.

New sounds floated into my island sanctuary. I could hear music, coming off an unseen fishing boat. It was an old reggae song, Jimmy Cliff's *Miss Jamaica*. It was sweet and haunting at once, in the way that Jamaican music so often is; where dance songs sound like funeral dirges and funeral dirges sound like dance songs—music in spite of everything. I sauntered around under the trees while melodies bloomed invisibly from the air.

I beheld the mighty eucalyptus, an immigrant from down under, planted by human hands but so vilified now that people gather to cheer when they're toppled. They call them weeds, mongrels, dirty and dangerous trash trees. But when I'm down in their shade, under those rustling sickles, amidst their red bark ribbons and their porcelain limbs—I'll forgive them anything. Because down there the light comes through like revelation. And the scent! I tell you no dirty tree ever smelled so pure.

At the edge of the plateau, the soil was eroding away and some of the trees had toppled over the cliff. They were nearly

upside down with their roots in the air and their crowns in the water. There were scores of them like that. They branched off the island like legs from a bug.

I walked to the southern end to get a better view of little Duck. When I reached the edge and peered over, I saw to my amazement that here, at low tide, the two islands were in fact connected.

I quickly sidestepped down a cut in the crumbly cliff and stumbled onto the beach. There it was—a land bridge between the two islands. It was scarcely four feet wide— human scaled. And standing there just then, it really did seem as if the water had parted to allow my passage.

And so I went. I walked to the middle of the causeway and paused, turning to look back at where I'd come from. I turned around again. The two views were remarkably similar; from there each island was almost a mirror of the other. It was like standing in the center of a Libra scale.

Over on Duck Island I discovered a tide pool. It was ringed with black turban snails and bat stars as orange as a pumpkin. There were crabs too; they skittered out from their dark places as I walked over them. I could hear their claws clicking across the rocks.

I found a flat stone and spread out my lunch. The crabs came and watched me as I ate. I toasted them with a bottle of cheap Chianti. Then I smoked some cigarettes (being on an island exempts one from all the usual rules). After lunch I lay on my stone and felt strong in the sun.

I remembered a story I'd read, about a man and his family who'd come to the western shore of Tomales Bay to spend a day at the beach. It was Thanksgiving. The man and his family were doing all the normal sorts of things people do on a beach, when, to their utter amazement, out of the water and onto the sand—came a giant sea turtle. It was an extraordinary occurrence, not only because there aren't supposed to be any giant sea turtles in Tomales Bay, but also because the man who witnessed it was a sea turtle biologist.

The preceding story is perfectly true. It was in all the papers.

I didn't return to Hog Island until the causeway became so thin I had to walk it foot over foot like on a tightrope. Once across, I stood and watched the water meet in the middle like stage curtains closing. The path disappeared and in its place was born a reflection of Duck Island, an onion dome with trees for finials—the Taj Mahal of Tomales Bay.

I untied my kayak and brought it back down to the water. Reluctant to leave, I sat on its deck until the sun was low. I saw a leopard shark in the shallows as big as my forearm. I saw birds of every stripe: cooters, grebes, loons, ducks, and a dozen other sorts I couldn't pretend to name. I saw a long line of pelicans standing on the water. I might have thought it a miracle if I hadn't known that beneath their feet was a breakwater built by Fred Windsor.

On the way back the wind came up and the bay became an altogether different character. The waves were breaking two feet high and at times my bow rose and fell such that my kayak's eyes dipped beneath the water. It was glorious.

Back on shore, with my scratched and muddied and thoroughly baptized boat atop my car, I sat for a spell, just looking at the islands. My satisfaction of having befriended them was tinged with a measure of melancholy. For I knew that they would never again hold the infinite potential of unknown things. I had seen the islands as they were, and so, they could never again be *anything*. They could never again be the place where I would find that larger treasure.

What madness! I wonder—what is it that I think I'll find in all my roaming? I could climb a dozen mountains, could search through a dozen dark forests, could haunt every last ruin, and turn over each and every stone. I could tear the whole damn world apart, but in the end, it'd be nothing more than rearranging the furniture.

Like my friend Wallace Stevens said, God is in me or not at all.

∽

The ruins I found that day on the eastern shore were once called Hamlet. The town was one of the oldest in the area. Schooners carrying butter and cheese from dairies on Tomales Point would sail across the bay to Hamlet, where their cargo was loaded onto a narrow gauge railroad and sent down to the gold rushers in San Francisco.

The bar with the holes in the floor was Jenson's. Henry Jenson, Jr., and his wife Virginia came to Hamlet in the mid-fifties to take over some oyster beds there. Sometime later, they built a restaurant and the bar. It was a hard life. Virginia Jenson remembers a typical workday beginning at six in the morning and ending at ten at night. She shucked the oysters herself. She recalls once shucking 105 dozen oysters in a single day. Over the years, Mrs. Jenson found more than a few pearls, which she kept in a mason jar. They ran an inch deep. Unfortunately, she says, somewhere along the way she misplaced the jar. Jenson's Oyster Beds lasted until 1987. Virginia kept it going as long as she could, raising her five children in Hamlet, continuing on even after Henry drowned in the mouth of the bay.

∽

Recently, I returned to Hamlet with my friend Stephen. We set off early in our kayaks. I didn't tell him where we were going. I just said I had something to show him. I wanted his discovery of Hamlet to be as unexpected as mine had been.

When we rounded the bend where the site was there was nothing. The ruins of Hamlet had disappeared without a trace. As we pulled into shore, Stephen jokingly doubted my sanity. "No really," I said, "there was a village here. There was a bar and some fishing shacks and there were oyster nets and train tracks…" It was almost possible to conclude that the whole thing really *had* been an apparition—there was so little to be found.

We did find something though. Safely above the tide line was a pile of multi-colored glass shards, a rusty plumbing fitting, a coil of wire, a hinge, a fuse, a railroad tie, and above these neatly arranged artifacts, a sign hand painted on driftwood. It read, "Hamlet Museum."

Stephen and I shared a strong ale there, and after some debate, we left the empty bottle at the exhibit. After all, we came to reason, are we not now a part of Hamlet's history? For there we were, late arrivals to be sure, characters from some latter chapter, but still, we were a small piece of the story, a story whose ending will never be known to us.

It turns out it was the park service that razed Hamlet. They said it was falling into the bay. They said it was a safety hazard. No matter—Hamlet is inside me now. Tomales Bay, Hog and Duck Islands, Fred and Clara Windsor, black cormorants and bat stars, the *Golden Hind* and a guano-streaked umbrella, eel grass and elk, eucalyptus and Jimmy Cliff, Miwok Indians and daffodils….they are all inside me now. I took them into myself. I swallow my experiences down like so many of Virginia Jensen's oysters.

I will never wipe away my memories. I swear that both the holy and the baser matters will forever live within the book and volume of my brain.

We are our world.

4

Secret Beach

THERE ARE WORLDS ON POINT REYES—extraordinary worlds—unlocked only when the waters pull back. And so I've come to know the tides a little. I study the tables and I plot my course. I circle the squares on my calendar. I let the moon determine my days. Out here on the edge, one must surrender to the rhythm of things.

The name Secret Beach is a bit of a misnomer. People do know about it. You can even find it on a map. Still, it isn't visited very much. Even on the weekends it's usually abandoned, or at least empty enough that if you saw a stranger there, you'd feel obliged to say hello. Getting to Secret Beach requires a certain diligence. The conditions have to be right. One might wait months for a perfect day.

Mine came in an April. It was windy that afternoon, as it always is in spring. I sat in my car in the Limantour parking lot, biding my time as the air whistled around outside. I knew if I rushed the tide I'd be trapped, pinned against the crumbling cliffs as the surf rolled in. And so I sat and reviewed the plan.

When I finally made my break the wind pulled open the door with such force I feared it would tear from its hinges.

I had to go out and lean against it to get it closed again. I debated leaving my camera behind. Though the tide may have been favorable, the wind was not. But out of habit, or duty, or really because I would have felt naked without it, I strapped on my heavy pack and slung my tripod over my shoulder.

I went south through a blur of dune grass while the wind pushed against my back—urging me forward like a parent with a balky child. Blowing sand stung the back of my neck. The grains showered against my tripod legs with a sound like static on the radio. Strangely though, Drake's Bay was as calm as I'd ever seen it. It was the slack tide, the end of the ebb, and the water was flat and leaden. Stillness comes at the turn of a current.

Presently I came to a little refrigerator, half-buried in the sand with its door wide open. The shine of its white enamel was long since gone, scoured off by the streams of sand that flowed around its contours. Its surface was like an eggshell's. I imagined the appliance had come from a fishing boat, and I had to wonder—*What happened to the boat?* A flock of gulls appeared and wheeled overhead unperturbed. They don't wonder about anything.

As I continued south, the loose dunes on my left gradually began to change, becoming more symmetrical—gathering into distinct humps. They were turning into sterner stuff. After a time, they weren't dunes at all, but a solid wall of sandstone cliffs that towered well above my head. As I went on, the cliffs continued to rise—or was it I who was shrinking? Without the usual references it's easy to lose perspective.

After an hour or so, I reached my first landmark, a huge blue gum eucalyptus set above a gully which cut through the cliff wall. A creek ran down the ravine onto the beach, and desiring a break from the wind, I followed it up toward the tree.

The eucalyptus was a giant by any measure, with a base twenty-five feet around and lower limbs like telephone poles. There was a swing hung from a high branch, fashioned out of thick rope and a wooden plank. It made me happy, that swing. And it made me remember another day on Point Reyes, and another great eucalyptus, this one with a wooden ladder leaning against its trunk. Some determined soul had hiked miles with that ladder, just so he or she could climb a tree.

I understand such compulsion perfectly.

I sat on the swing, poised way up the hill behind the eucalyptus with my heels dug in the dirt. I was scarcely an inch from the ground. Then I took a breath—a few breaths—and let go. The earth fell away, ten, fifteen, twenty feet beneath me and I was flying, and laughing, and praying that the frayed rope would hold for one more ride. And it did.

I could have stayed there all day, suspended under that old eucalyptus, enskyed there at the edge of the continent (as my old friend Jeffers might have said it). But bound by the tides, I left my tree and carried on.

The further south I went, the more fantastic the cliffs became. In one place, the sandstone walls were fluted from where the water ran down, and the remaining relief looked like a row of twist-turned pilasters, like some half-carved coliseum. It made me think of Utah, of Bryce Canyon, of that day above the hoodoos when my brain was everywhere. There was a pipe organ. There was a temple. There was a face in every fin and spire.

I came to a low wall of compacted shale that stretched across the beach like a surfacing submarine. The sand was giving way to bedrock, and the rock was alive: layered, scalloped, spiraling. Form emerged from everywhere. I saw a halved onion, a chambered nautilus, and an ancient bone-yard of vertebra, tusks, beaks, and teeth. *Fantastic*. It almost seemed that the land and sea had switched roles—the water was still and the rocks were roiling.

I disappeared beneath the dark cloth and lost myself, enraptured with the play of light on my ground glass. The sun lit the rock one way and then another. Shadows grew and shrank. Patterns bloomed and vanished. Who knew that stone was capable of such transmutation! I photographed as in a fever, knowing though, that in the end, I'd never capture the essence of the place; I'd never show—to borrow a phrase from my friend Kant—the thing-in-itself. For there *was* no thing-in-itself. There was only this constant *unfolding*. But still I tried. I tried to hold fast to the present. I scooped up the riches as they came.

It all made me wonder—what is it that makes something interesting? I mean to say—why is one pattern more exciting than another? And is the design in the rock or is it in my mind? And if indeed it's in the rock, is it really design, or is it simply in a rock's nature to be the way that it is? And I—was I designed to seek design, or is it simply in my nature to seek?

And so it goes, on and on, as convoluted as the rocks.

I took a break and combed the beach for treasure. My finds: a canvas glove, a milk-blue bottle, some kelp bulbs, a real vertebra (I thought), and everywhere, claws of all shapes and sizes—long detached from their owners. And then, a dead pelican, his blue eyes gone, his fish pouch dried to leather, his long wings bent beneath him—all the grace lost

in the end.

I always encounter death on Point Reyes.

One time I came across the perfectly complete skeleton of a baby seal. It was sitting on a rock, as if staring out to sea, as if it had died just waiting. On another day I found a sea lion I'm sure had died only a moment before. She had such a beautiful face. Serene. It sticks with me. I should have made a picture.

I retrieved my camera and continued on. Soon I came to a steeply sloped wall, about eight feet high, which ran off the cliffs to the sea. There was no choice but to go over it. There were enough footholds though that the ascent was not difficult. And truth be told, it felt good to get my hands on the rock. Some days I don't touch the world at all and no doubt I'm worse off for it.

It was a sheer drop down the far side so I jettisoned my backpack and tripod first, then jumped down after them. At the bottom I found a series of eroded promontories and rock pillars that as a whole formed a sort of maze of high-walled passageways. I felt as if I were roaming through the alleys of an ancient city. And indeed, I rounded a corner and there, in the very center of another rock wall, was a spade-shaped passage, like a mosque's vaulted portal—the gateway to Secret Beach. Well, I know all about pilgrimage. I'd stood there in that same spot a half-dozen times before, but in every case the tide had turned me back. But not on this day. I wouldn't even get my feet wet.

I'll admit though, there was a part of me that didn't want to go through that door. For I knew that once I did, I could never again go back to not having done so—forever after I would know what lay beyond. Sometimes I think there's something to be said for keeping secrets secret.

But I had to go and so I did. I remember I closed my eyes when I walked through, as if to draw a black line between one world and another.

And I was on a broad and sandy beach. It was tranquil there, empty. Offshore, a dense kelp bed covered the ocean like a tatami mat. Glistening bulbs shone from the tangle like eyes.

I searched the kelp for otters. There aren't any otters at Point Reyes, but there were once—a long time ago. There were thousands of them. In 1811 alone, over 10,000 pelts were taken in California. By the early 1900s the otters were so decimated it was thought there were none left to kill. But then, in a near miracle, a small band of survivors was discovered in a cove near Monterey.

It is believed that someday the otters will come home to Point Reyes.

I always look for them.

I continued down the beach. The wind was almost gone then, blocked by the bulwarks I'd passed through. And it really did feel like another world.

Two hundred yards on I came to a ten-foot sea stack shaped like a thumb. Atop it sat a single black cormorant. I greeted him though he regarded me, I thought, indifferently. Just abreast of the thumb was yet another headwall. From a distance, it had looked impassable, but as I came nearer, I saw there was a small crack in its face, a gap just big enough for a person.

I went in. It was obvious that the passage was usually underwater. The walls were covered with orange and purple sea stars. The ground was solid black with goose barnacles. I walked across them as lightly as I could—a fakir across a bed of nails.

Upon exiting the far side I found myself on a level rock shelf embedded with tidepools. Scattered about the pools were perfectly round stones, as smooth as desert slickrock. The wall framing the passage, through which I'd just come, was inlaid with vertical ribbons of white marble—arabesque filaments that curled up through the dark rock like smoke. The design was mirrored in a still, clear pool at the wall's

base. I could hardly tell what was rock and what was light.

I quickly set up my tripod, afraid somehow that the scene might vanish, as if rock could be as ephemeral as a rainbow. Ankle-deep in cold water, I once again ducked beneath my dark cloth, inching forward and backward and then forward again. It was difficult to know what to include in the composition. The forms were marvelous at all scales. And the scale was impossible to discern. Was my ground glass showing an eight-foot cliff or the face of El Capitan?

Exhausted, I surrendered from the looking. I left my camera on its tripod—left my little flag on the summit—and set off to explore the beach. I hadn't gone more than a few yards when I spotted a small opening in the headwall—*a cave!* I had to duck down to enter. A soft light emanated from its end and I went toward it. And then I was there, in the light, standing in a perfectly round, earthen amphitheater, open to the sky. The walls rose eighty feet straight up to frame a circle of clear blue. A smattering of yellow wildflowers clung to the wall's hard-packed soil, making do, blooming somehow in a deep well. I wondered if the sun ever came straight over the top, penetrating to the bottom of the shaft like in some pharaoh's tomb, like it was designed that way.

It was so quiet there, not the open silence of the desert, but rather the muffled hush of earplugs, or of being underwater—a deadening. It felt pressurized. I looked back at the ocean (I could see the water but not hear it) and couldn't help but imagine what would happen if the tide came in.

I packed up my things and began my return.

༄

Back on the open beach, past the shale, the wind was against me and the going was slow. I leaned forward and plodded on, mule-like. I lowered my face and watched the ground. Light colored sand flowed over a dark base beneath and the motion made me think of weather, of atmosphere, of

satellite pictures taken from high above the earth. And then I was a thousand miles up, soaring over a desert of sinuous dunes and deep shaded canyons—my old southbound foot prints! They were already half filled in. I'd be erased in a couple of hours.

It took me three times as long to get back up the beach as it had to come down. It almost seemed as if the wind didn't want me to leave then, that it'd changed its mind.

Near the parking lot I found a little shelter nestled between two dunes. It was made of blue milk crates and driftwood. On a flat board atop the roof, someone had taken tiny shells and spelled out FORT. The proclamation made me smile. "Nice fort," I offered, though of course the builders had long since departed.

The wind intensified just as the sun set, as if it'd been holding something in reserve, as if it'd been waiting its turn. It was so strong then I could hardly stay standing. A contingent of dark clouds had gathered over the ocean. Above the backshore, a huddle of gnarled pines bowed nearly to the ground. The world was an Edo woodblock.

Alone in the lot
My little blue car quivers—
A big storm coming.

I gazed across Drake's Bay, tipped my hat to Chimney Rock, and left.

5

Abbott's Lagoon

I SPED ALONG PIERCE POINT ROAD, past cypress groves and whitewashed farms and telephone poles on barren hills. I sped past stock ponds and cows, water tanks and tractors and lines of birds on lichened fences, and then, past a field of golden grass—chest-high—the whole of it swaying like an enraptured congregation. In the center sat a dark stone, Mecca's Ka'bah, enswirled by circumambulating pilgrims—impossible—but, *ah!*—it moved—a rump—a doe. She lifted her head as I passed by, looked at me, then disappeared—all at once—as if behind a curtain.

The world is full of illusion.

I'd set off that May morning without knowing where to. I do that sometimes. I'll head north up Sir Francis Drake Highway until I reach a split where I'll try and let my subconscious decide, swerving this way or that at the very last moment. Or else I'll look for a sign, a guide, for some auspicious omen. Like the burst of yellow lupine at the trailhead to Abbott's Lagoon, the flowers shining there like little lanterns, or torches—the burning bushes of Point Reyes—ha!

That'll do.

I ditched the car, grabbed my gear, and plunged down the thin, muddy trail into a low thicket of ferns and hemlock and salmonberry bushes. Almost at once, as if to greet me, a rabbit plopped down, not three feet from the tip of my boots. He was about the size of a baseball, just as round, and indeed, my first instinct was to scoop him up and field him, put him in my pocket for safekeeping. But the rabbit, perhaps aware of my whim, promptly retreated into the brush. Only to be replaced by another a few yards on. And then another. And then, suddenly, rabbits were everywhere, gathered together in twos and threes, dotting the path as far as I could see. Extrapolating the potential population (no doubt hidden for the most part beneath the undergrowth), it was clear I'd stumbled into a rabbit metropolis. There must have been thousands of them. I wondered if the locals, as it were, were aware of the extent of their own civilization, if they knew of the outlying boroughs. Do rabbits go journeying?

As I walked along, my new friends scampered before me. And soon, quail came too: plump, haughty-looking quail, waddling along with their farcical, wonderful topknots— Queen Victoria in her mourning dress and miniature crown.

Such odd birds, I thought, *why don't they just dive into the scrub? Or fly away. Can quail fly?* I tested the query by running after them and bellowing. Quail *can* fly, though they do so, it seems, only as a last resort, and then so awkwardly, it is almost embarrassing to watch them. Of course, I was the one bellowing…

At times, a bevy of quail (pursued by me) would bustle past a gang of loitering rabbits, who in turn would coolly watch them pass before fleeing themselves. It made for an absurd spectacle, an unruly little May Day parade—a Beatrix Potter book come to life. I had to laugh. But then I felt mean-spirited for laughing and stopped to apologize.

Overhead, a pair of marsh hawks slowly circled, eyeing up the rabbits no doubt. I wondered what they made of the quail, so unlike them and yet still their brethren. I don't suppose there's any condescension. They each have their strengths. The hawks would be as lost in the underbrush as the quail in the sky.

There were a lot of other birds there too, one that looked like a sparrow, save for a breast as yellow as the lupines. And a group of red-winged blackbirds strung along a barbed wire fence, decking the lines like notes on a score: *Overture to Spring in the Okalee Style.*

The abundance of life really was symphonic: butterflies and frogs, snakes and beetles, poppies and buttercups, and a spiny Venus thistle with a stem as white as bone topped with a blood-red flower that shocked against the greens. The last seemed a thing that belonged in the desert.

But then, I've learned that Point Reyes is full of surprises.

After a mile of earnest bustlings—of enveloping luxuriance—I came to a scene so still, so austere, and so completely different that it stopped me cold. *Can that be true? Can that really be true?*

For there, rising up from behind the lagoon's lily-clothed waters, were sand dunes, sand dunes so formidable I thought at once of the Sahara, the Kalahari, of Arabia's Empty Quarter. Whether such flights were set aloft by the lushness

I'd just come through, or by the sight itself—by this surreal confluence of lilies and sand—I do not know. But it was strange. And the longer I looked, the stranger it became. After a while, the whole thing began to seem almost illusory, a Hollywood backdrop, or a heat-stroke mirage—some chimera of my imagination. And a distinctly exotic one at that. Out there, on a rich green cape off the coast of California, I'd found a desert, and an oasis—I'd found Luxor on the Nile. I'd found a place that seemed to have sprung, as if by magic, out of a dusty, forgotten book filled with old daguerreotypes: *Views of the Ancient World.*

Wondrous.

The two realms were joined by a small wooden footbridge that arched over the pinched middle of the lagoon like the body of a butterfly. Its design, I thought, was humble, proper. Like a bridge in a Japanese garden, it was what was required and hardly a bit more.

I walked to the center and grasped the rails, feeling the sun's warmth in the wood, amazed at the solace a simple touch can bring. I leaned out and looked down at the lilies. Each leaf was connected to another by a slender white stalk, the pattern repeated beyond count to form a vast web that looked every bit like constellations. And indeed, deep down in the water, with the lilies' tangled roots, was a nimbus of decomposing matter like interstellar nebulae—overlaid with an apparition—the reflection of my face!

I backtracked to climb a hill behind the bridge. From there, I could see the lagoon's two wings, with the inverted triangle of dunes in between, and beyond that, the sea. I sat down half-lotus style in rippling waves of purple grass and watched low clouds waft past and cast their shadows on the sand like smoke over blank white paper.

During the 1940s, the military knew Abbott's Lagoon as "Bombing Target Number Two." Army and Navy Pilots would fly in from bases in Santa Rosa and Hamilton and Alameda to rain dummy bombs down on the lagoon's southern lobe. Judging from the ordnance still found on occasion, it seems

they rained some down on the dunes and the lilies and the rabbits as well.

My friend Schopenhauer once said that human existence must be a kind of error.

When the sun reached its peak, I surrendered my lofty position and crossed the bridge into the sand. The dunes were real. And as I trudged up their long, soft slopes, I daydreamed of the desert. I was in the Nefud, the Negev, in Kyzyl Kum. I was Lawrence of Arabia en route to the Seven Pillars.

The expanse, I soon found, was not as empty as it had seemed from above. For here was a snake track, with the sand pushed up at every curve, and here, a scattering of avian calligraphy—pure action transmuted into art—and here, a length of dried white kelp, brought up from the beach by the wind or a bird or a hand. And to this, I added my own footprints, zigzagging so as to confound any subsequent explorers.

When I reached the crest at the end of the dunes, high above the ocean, I sat down to rest. But scarcely had I time to take in the view before my eye caught a glint from something down on the shore—a quick flash like sunlight from a mirror—*what treasure is this?* I hurried down to investigate.

The source, I discovered, was a dead pike; the water wolf—a serpentine nightmare with yellow eyes and spikes for teeth and scales like polished armor. It looked more machine than fish—a fish metamorphosing into a torpedo.

Repulsed and delighted, I retreated a few paces to set up my camera. But before I could even extend the legs of my tripod, a flock of seagulls materialized and attacked the pike in a maelstrom of pecking and tearing. By the time I managed to scare them off, it was already too late. My fellow scavengers had ruined the prize. Its yellow eyes were completely gone, along with half its scales. White pulp

bulged from a two-inch gash in its head.

My picture of a fish had become about something else altogether, something a little grotesque, even for me. I made a half-hearted exposure anyway, all the while trying to shake the thought that if somehow I should falter, those gulls wouldn't hesitate to pick me apart with exactly the same relish they'd afforded a fish.

I packed up my gear and headed south.

Once past the lagoon, I found that most of the breadth of the beach had been roped off by the park service. There were signs on stakes, explaining that the area had been set aside as a refuge for the snowy plover. The signs said that the little birds were sensitive—that they needed their space. Well, I certainly couldn't begrudge them that. The cordoning made for a strange sight though—a length of rope running on without end, dividing one seemingly empty space from another.

Unable to find any plovers, I contented myself by hooking my fingers over the line and walking along with my eyes closed. I wanted to see how far I could go without looking, see how long it took before the sound of the breakers unnerved me. I think I lasted about a minute.

I trudged along the approved corridor without any destination in mind, making up goals as I went: get to that piece of driftwood, that tangle of kelp, that tire, that bottle. Sometimes my guides deceived me. A fat man in an orange slicker turned into a fishing buoy. An elephant seal became a truncated length of tarred telephone pole. Out here, it's easy to lose perspective.

Shortly past the end of the bird sanctuary, I found an old boat up on the backshore. I'd forgotten about that. Years before—lifetimes before—I'd hiked up from the south and discovered this same ship. I'd eaten lunch with my back up against the hull. The *Beachcomber* (surely an apt name for an

old shipwreck) now rests upside down, its wooden skin half rotted off to reveal rusted metal ribs that stretch across its prow in giant V's. From the front it looks like an African war shield.

For a long time the ruin has served as a kind of register. All over it are names and drawings and meditations. Here is a portrait of a girl. Here is a heart. Here is a monkeywrench. "God is love." "None but ourselves can free our minds." "Snowy plover love boat."

When I searched for my own message, penned on that faraway day, I found not a trace. It had been slowly scoured away by the rain and the wind and the sun. The elements, it seems, are unsentimental.

And in the end, even our elegies disappear.

I lingered awhile by the wreck, idly rounding a clump of dune heliotrope, like an airplane rounding an island, waiting for what I did not know. I considered turning back, but the prospect of retracing my steps seemed oddly discouraging. So I compromised. I'd make a circle, head overland around the lagoon's southern end to meet up with the trail.

Of course, it wasn't as simple as that. It usually isn't.

As I turned my back on the ocean and crossed the berm, the sound of the waves faded into silence. The dunes soon turned to a thicket of coyote brush so dense I had to lift my feet up knee-high to get through it. It was as if I were plodding through snow.

I went on, until I reached a place where the roots grew so close together I could go no further. Shackled. *Well, I suppose that's half the point isn't it? One must be bound before one's freed. But how many times?* And I smiled to myself. That's when the bird swooped down on me. It must have passed a foot from my head. "Killy! Killy! Killy!" A flash of a talon and a sharply-hooked beak. This was no snowy plover. I buried my head in my arms and crashed blindly through the scrub while tendrils pulled at me like desperate hands.

My attacker left me alone after a minute or so. Looking back, I think it was a kestrel. Though hardly larger than a robin, kestrels are fearless birds, known even on occasion to attack golden eagles. Their preferred hunting technique is to dive on their prey, sink a talon in its back, then tear off the top of its head with their beaks, precisely so that the brain is exposed. Sort of like a bread bowl. Fierce birds, kestrels.

Although at the time I hardly noticed, it seems my panicked flight had delivered me from the bush, and once again I found myself in open dunes. There was still no sight of the lagoon however, despite the fact that by then I was sure I should have come to it. I crested dune after dune expecting the southern shore but found only sand. I began to have the strangest feeling that the land had inexplicably expanded from the inside, that all its salient features were drifting away from me, like ripples in a pond. It seemed that all the usual laws had been suspended. I'd fallen into a rabbit hole.

And then, as if to confirm my suspicions—

A baby stroller. *A baby stroller,* miles from anywhere— resting at the center of a hollow in the dunes. It lay on its side with its back to me. I remember that its frame was rusted. And that it was blue with white dots. Faced with such a thing, a thing so unexpected, so improbable, and so awfully personal, it seems the mind grasps for simple attributes.

But they're never enough. And as I stood there, I struggled with the idea of it. I felt as if I'd inadvertently wandered into a foreign court, and had been ceremoniously presented with some inscrutable gift. The world had shown its hand, and awaited my response.

Why is this here? You don't come to the beach with a stroller and then forget it. It isn't a thing that slips your mind. Maybe it fell off a Chinese container ship, bobbed along awhile in the North Pacific Gyre, then spun off toward Point Reyes. And

then crossed hundreds of yards of sand and brush to end up precisely before me? Impossible—

I gathered my courage and circled around it, like a hunter around his prey. I looked inside—how could I not? It was empty. Of course it was empty. But the riddle remained—as uncrackable as a Zen koan. *What is the color of the wind?* Thinking about it gets you nothing.

But maybe that's just it; it's the questions themselves that are the problem. No questions, no problem. So there's a stroller on Point Reyes. What of it? Why obfuscate with notions of destiny? It's only personal because I've made it so. There is a stroller. And here am I. I'll make a picture of it, because that is what I do.

To think any more into it could only court madness.

∾

When at last I rediscovered the lagoon, I found to my dismay that its southern end was bounded by an impassible tangle of cordgrass and pickleweed and half-submerged coyote brush. I'd have to head east and attempt a more distant orbit.

No matter. The detour proved to be a fortunate one. For once away from the water, just over a rise, I came upon rolling fields of wildflowers: Indian paintbrush and gold-fields and blue-eyed grass. As individuals they'd have hardly been noticed, but there, gathered together in the thousands, it was marvelous. I strolled along through expanses of pure color: a yellow field, a blue field, a red field. It made me think of the friend in college who habitually re-painted his room to see how the colors would affect his being. I thought of his fatiguing yellows and drunk-tank pinks, and of how red he said the world looked after days spent in a blue room. I thought of the fact that objects in and of themselves possess no color at all, that all those hues are in our heads.

Sometimes I wonder about the benefits of knowledge.

In any case, my flowers didn't last. The land gradually sloped back down, turning to a slough that grew muddier

with every step. Amazing the difference a few feet can make. My boots stuck and slurped through a mire, through pools of oily-sheened water. *Shit.* And sure enough, there were the bovines, just this side of a barbed wire fence, staring at me dispassionately as I picked my way through the muck. "You're cows!" I yelled, figuring no one had ever bothered to tell them that before. They paused for a second and then resumed their serene chewing—as impervious to selfhood as a stone. Disgusted, I fled north for higher ground.

∾

I will never in my life forget the sight of that windbreak—a colonnade of century old eucalyptus, long since fused into a single thing—into a shimmering green wall reaching from horizon to horizon, the whole of it swaying and surging, though I could feel no wind. It looked like a line of thunderstorms. It looked like a tidal wave.

The trees were planted from seedlings by Captain Henry Claussen. Claussen and his wife, Agnetta, had come to Point Reyes from Sweden in 1869 along with Henry's parents, Hinrik and Christiana, in order to steward landowner Charles Howard's alphabet ranches. It was the elder Claussen that was the dairyman; the younger had captained a brig that sailed between Germany and the Orient but gave it up to join his father in America.

By all accounts the stewardship was a success, though not without its costs. Hinrik died in 1872 at the age of fifty-six of blood poisoning from an insect bite. His daughter-in-law, Agnetta, followed five years later.

In 1890, Christiana went to Sweden and returned to Point Reyes with Clara Wallengren, a prospective bride for her son. Henry married her three days later.

The Claussens are best remembered for having brought to the peninsula a certain old world refinement. Clara had a glass conservatory filled with geraniums, tulips, and angel's wing begonias. House guests, Swedish and German

diplomats, and friends from Henry's seafaring days ate off fine French porcelain and slept beneath handmade down comforters.

It seems the conservatory wasn't just for flowers.

∾

I stood before the break, a little loathe to enter. For entering seemed somehow forbidden. No doubt the barrier was intended that way. But there was something else, something in the way that it looked, in this dark, writhing band shot through with dead white branches like lightning in a Jovian storm, that made me afraid. And I couldn't help but feel that such a place just might be haunted a little by some lingering specter roaming within it.

Of course I went anyway.

Inside it smelled of wet earth and camphor. I could hear the sound of the leaves rattling. The ground was covered with bright green grass made greener, it seemed, by the tree's pale trunks. Broken boughs lay everywhere; eucalyptus drop parts of themselves like it was nothing. I bent down and gathered up a handful of dried gum nuts. They looked like little sleigh bells. I brought my hands to my face, inhaled, and the memories of a dozen other days flooded in. The place really was haunted.

And indeed, I soon discovered that people had in fact been there, and not so long before. There was a stack of moldering pallets, a length of plywood nailed between two trees, and a crude hut fashioned from particle board and hunks of crumbling drywall. It struck me that the hut was a fort and that the boards were shields. But why? And who? More mysteries.

I've since read that there was once a little schoolhouse here, not far from the lagoon, at the western end of the break. It was red with white trim. There was a creek that ran behind it where the kids would draw their water. Horses were tied to a white picket fence. The school had about thirty-five pupils, children of the lighthouse keepers and the farmers, and of the Claussens too.

In 1892, Henry and Clara had a son. They named him Henry. Shortly after his birth, they brought him to meet his by then bedridden grandmother Christiana. When her grandson entered the room, the old women is said to have looked at him and whispered, "There is life—here is death," and died.

Shoulders aching from my pack, I stopped to rest on a fallen tree. The breeze had waned, leaving behind an unsettling kind of quiet. I began to rap on my rotten bench with my tripod, just to hear some human sound. Almost at once, rivers of black pill bugs came pouring from every crevice.

∾

On the far side of the break were smooth green hills of closely cropped grass, so different than what had come before that it really did seem that Claussen's wall had divided one world from another.

I started up the first steep slope, reasoning that if I just continued north, I'd eventually run into the road I came in on that morning. But one hill only led to another. Like the dunes before, there seemed to be no end of them. After a while, I began to suspect I was going in circles, but it was hard to tell—the terrain all looked the same.

And then the afternoon fog came in, so dense I'd reach the top of a hill and not be able to see its base below me. It was like traversing a chain of islands. After a long time of seemingly fruitless roaming, I came up against a barbed wire fence. Like the plover rope back on the beach, its purpose seemed only to arbitrarily split one blank area from another. I scaled it anyway.

Not long after I found a hill with a level path cut round its circumference. It made me think of terraced fields—of Myanmar or Yuanyang, of stupas and oxen. The path wrapped around the far side and then went down toward what appeared to be a barn. It was so hard to tell in the fog.

And indeed, as I drew near, the barn changed shape, shrunk down, and became—a water trough!

The trail continued on and I was glad to take it. After all, I reasoned, it must lead to something. And it did. Not far from the trough, sprawled across the width of the path—the shock of a dead cow. She must have been coming for a drink. I wondered about the other cows, about what sort of thoughts they had as they stepped over their fallen sister.

I knelt down to study the carcass. I've no aversion to death. At least those not my own. How could I when confronted with forms of such grace? She was mostly a skeleton by then. Her remaining skin, dried to the color of an old scroll, flowed loosely off her shoulders like an Indian robe. And the bones! A confusion of ribs heaped on the dark soil like firewood, like pickets from a broken fence, and an elegant line of bare white vertebrae, sweeping up to a grinning skull. And then, apart from the rest, afloat in the grass, three ribs and a fibula, freed to fashion a run of eighth notes. Of course, the arrangement wouldn't last. There would be rain and wind and sun. The bones would be dispersed. They would weather, crack, and crumble. Dust to dust, the cow would return to simpler forms of matter; to a sea of subatomic particles—irreducible, indistinguishable, featureless, massless, ineffable points of energy, pulsing through the void like stars. She would become the stuff of rocks and grass, clouds and ships, people and planets. She would become exactly what she was all along.

My friend, there is not a single hairsbreadth between us.

I toasted the cow with my water bottle and took a long drink. Then I wedged my boot beneath her jaw and began to rock it back and forth. I'd take her skull home with me, and hang it over my darkroom door, as a reminder. Despite my efforts though, her head remained firmly affixed to her spine. And so, disappointed (and a little relieved), I left her where she lay.

I'm not sure how long I walked after that. I get lost like that sometimes. I forget myself. The trail led to a farm. I remember there were white chickens milling around outside their coops, and a mound of hay as big as a bus covered over with black plastic and tires. An unseen dog barked at me from a distance.

Not wanting to bother anybody, I gave the place a wide berth by cutting away through a soggy field and over another barbed wire fence. Then, after one last meadow—the road. *Is this the road?* I was almost surprised to find it there. That is to say, I was surprised it still existed. I ambled down the centerline toward the vanishing point, half-blind in the fog. I wasn't worried about cars though. Out here you can hear them coming from miles away. Not that many come.

By the time I reached the parking lot I was spent. Still, I found myself reluctant to leave. I wanted to stretch the day out to its limit. I never lose the feeling that there is some-thing to be found here.

Something.

So I pulled out my camera one last time, setting it up slowly and deliberately, enjoying the ritual. I'd photograph the grass I'd so admired that morning—*could that have really been today?*

The wind was just enough to keep my subject swaying, but I didn't mind. I *wanted* to show the motion. I wanted each blade of grass to trace an arc through my emulsion. I wanted to show the life of it. People think that pictures capture a moment in time, but really, that's not the case at all. All photographs, no matter the shutter speed used to make them, depict a duration. And as nothing in the world is the same from one instant to the next, they depict change. A photograph shows a thing in flux—a thing becoming another thing. It shows a multiple of realities all at once. Put another way, it shows the nature of reality itself.

ↄ

Standing in my darkroom the next day, I laid the negative on the lightbox and found that I'd mistimed the exposure. I'd

left the shutter open too long. I could see the ground
alright, and a little of the stalks, but the heads—all those fine
golden heads—had disappeared completely.

It seems the longer one looks at something the more
clearly it reveals itself.

Captain Henry Claussen died in 1915. He's buried up on
the knoll with his mother and his father and his first wife
Agnetta, not far from the eucalyptus trees he planted.

6

The Great Beach

Solitude, where are the charms that sages have seen in thy face?
Better dwell in the midst of alarms than reign in this horrible place.

–E.G. Chamberlin,
from the Point Reyes lighthouse keeper's log,
September, 21st, 1885

I sat in my car in the Great Beach parking lot, listening to a baseball game on the radio. It was foggy that day, like it always is in July. The announcer's calm, familiar voice wafted lazily through the ether, rising and falling with a sound like the unseen waves outside. The reception was so poor I could hardly tell the fans from the static; at times, the whole game seemed to teeter toward total dissolution—toward a swash of pure white noise. I leaned in close to the dash, as if to a fire for warmth, straining for clues. How the old rituals do comfort.

It was the Giants and the Rockies at Pac Bell Park, bottom of the sixth. The home team was up 4-2. Bonds had hit a homer in the fourth. Torrealba had added to the lead with a solo shot in the fifth—on his birthday. They must have gone crazy down there in Caracas. The announcer said it was sunny in San Francisco. Just over the hill, it was *sunny* in San Francisco. I envisioned a resplendent green field of Kentucky bluegrass—the Platonic ideal of a baseball diamond. From where I sat it seemed impossible.

I surveyed the lot. No one else was there. I'd have been surprised if there were. Hardly anyone comes in July, when the fog rolls in so thick it's like—well, it's not like anything. What qualities does a void possess? It's the lack that defines it. In July the fog rolls in so thick there's nothing. The ocean was but fifty yards away and I couldn't see it. My little blue car floated in a featureless white sea.

I sat awhile longer. There was no hurry. It was the seventh inning stretch. Over at the stadium, people were eating garlic fries and quarter-pound super-dogs. Someone was lining up to buy a cap for their boy. Out on McCovey Cove, guys in kayaks were floating in circles, hoping that when the game resumed they'd get a chance to scoop up another of

Bond's home runs with their fishing nets. Isolated from the action, they listen to the radio too, waiting for the warning shot, for the crack of the bat to tell them a ball might sail over that right field wall—that the game just might spill out—the abstract made real with a splash.

A car materialized in the slot three down from me. A gaggle of tourists spilled out and gaped at each other, stumbling around like cartoon ducks hit on the head. Then after a brief, concerned looking debate, they piled back into their car and evacuated to some more welcoming terrain. I don't think they'd imagined that such a condition was possible. Perhaps they were expecting Waikiki. Well, this is not that. The Great Beach is no place for barbeques or football or romantic interludes in the dunes. The Great Beach is not friendly. When the fog comes in on Point Reyes, it obscures such that there is nothing left for the senses to grab hold of. And then, like a body starving for food, the mind turns in on itself. It's too much for most people to bear.

I turned off the radio. Apart from the distant sound of the surf, there was a certain quiet, like the soft hush of snow. I took a last draw from my coffee mug, cinched my sweatshirt hood tight around my head, and bailed out.

The air was perfectly still, without a trace of the wind that would have surely met me in the winter months. The fog had blotted out the sun and taken all the shadows. I remember thinking how odd my car looked, its blue paint glowing in the strange light like the skin of some giant, phosphorescent sea jelly.

I crested the berm and headed south without much thought. I mean, I might have gone north just the same. There was a scattering of flowers in the dunes: sea rockets and sweet peas and morning glories. Their colors seemed off just a little, drained, their show weary and halfhearted. I trudged on, listening to the sound of the waves. Not being able to see them made for an odd effect. After a while, it was hard to tell if the sound was inside or outside, like putting your ear up to a sea shell. Maybe it was all in my head.

∾

The Great Beach is a dangerous place, arguably the most formidable stretch of coast on the entire continent. The storms that sweep in from the Pacific land here first, their power undiminished. This is the edge of the edge. Down at the lighthouse, winds have been measured at over a hundred and thirty miles-per-hour. Stories abound of the keepers there struggling to their post, prostrating themselves and clinging to the ground to keep from flying away. And then of course there's the fog, the Point Reyes shroud that veils the sea stacks and the precipices and the roiling surf. It's spelled the end for countless vessels. There's hardly a foot of this fourteen-mile beach that hasn't been touched by ruin. The roll call of lost ships goes on and on like the tolling of a buoy bell: *Erin's Star, Copper Queen, Labouchere, Haddingtonshire, Albert, Oregon, Otago, Tai Yin…*

Perhaps this place is like a stage. What defines it most is that which happens here.

I stopped to clear my glasses with a dry corner of my T-shirt. It hardly made a difference. The place was so white it may as well have been black.

The surf on the Great Beach is always fearsome, but especially so when you can't keep your eye on it. As I walked along, I thought of sneaker waves—sudden waves much larger than the rest that curl up out of nowhere, nightmare high, shadowing the beach like a long black cape. If such a wave comes and knocks you down and drags you down the steep slope into that wild, churning maw, the odds are you won't make it back out. And if the currents don't get you, the monsters might. These waters are a favored haunt of the great white shark.

I tried to steer my attention elsewhere, tried to tether my mind to the safety of landward things, but such harbors were hard to find, and often, not what they seemed. The fog plays tricks on the brain. At one point I saw, despite reason, what I was sure was a small white tent. But as I

approached, wondering just what sort of person would camp on the Great Beach, I found the tent had transformed into a bottle of bleach. It had been cut in half and capped at the end—a makeshift bailing tool. I turned it over in my hands, wondering where it'd been, who else had held it, if it had ever had to serve its purpose, if it wasn't enough.

Point Reyes is full of ghosts: *Sea Nymph, Samoa, J. Eppinger, George P. Haub, Norvick, Selma, Tallac, Arakan…*

I remember a story.

On the night of November 28th, 1938, United Airlines Flight 6 left Seattle for San Francisco. The DC-3 had a crew of three onboard, along with four passengers. After stops in Portland and Medford, the plane continued south along the coast, where it met with wind and rain. The crew began having trouble with the radio. At 4:09 am on the morning of the 29th, Captain Charles Stead radioed Oakland, "There is something wrong with this course."

An hour and a half later, hopelessly lost and out of fuel, Stead ditched his plane into the Pacific. It came down off Point Reyes.

In a near miracle, all seven persons survived the crash.

Then, fearing that the plane would sink, and perhaps grateful to God for living, they climbed out of an overhead hatch and clung to the wings, waiting for their rescue.

Then the sea came up and pulled them off and drowned five of them.

One female passenger and Captain Stead managed to swim ashore. It was later determined that it was he who bore the brunt of the blame for the disaster.

I wonder what the rest of his life was like.

The plane itself eventually washed up in a rocky cove near the lighthouse. When it was found, it was discovered that the passenger cabin had remained largely intact. It was, in fact, almost completely dry.

∾

The fog had seeped through my clothes to the skin. I didn't have a patch of dry shirt left. I muddled on.

Presently (and in such a fog, everything happens presently), I came upon a sprinkling of little jellies. They were a translucent blue, each about the size of a quarter. It seemed that the whole beach was covered with them. Kneeling down for a closer look, I discovered the creatures had a triangular comb attached to their base at a right angle. They looked like little glass sailboats. And in a way I guess they were. For these were Velella Velella, by-the-wind sailors, cousins of the Portuguese Man-O-War. Subject to the will of the elements, they spend their lives roaming the sea as an armada of tiny, organic prisms.

Once, on Drake's Beach, I found a group of moon jellies as big around as dinner plates. They must have been two inches thick, and yet, so clear and colorless I might not have seen them at all, if it weren't for a dusting of sand on their tops. They looked like giant magnifying glasses, like lenses, like the condensers in my enlarger's lamphouse.

I plodded on through the mist. I've read that our eyes use the horizon to measure the sky—that it is our minds that build our ceilings. When there are mountains, the sky appears to vault up over them. Conversely, when there is no horizon, the sky drops to a spot just above your head. Walking down the Great Beach in the fog is like walking down a long, empty hallway. It can have an odd effect on a person. I've found that it's difficult to resist carrying on indefinitely, even though there's really nothing to carry on *towards.* The emptiness is hypnotic. Left with only a thin ribbon of sand beneath your feet, what else is there to do but go onward? And so you trudge on in the hope that eventually, something will come forth, as if from an invisible door, to shatter the blankness. And something always does.

I found a water heater there once, standing upright in the middle of nowhere. I set up my camera and imagined I was an archeologist from another planet. After a while, the water heater wasn't a water heater but an artifact, a capsule,

a monolith, an enigma. Sometimes what things are depends on where they're put. In a basement, or a junkyard, in any peopled place, a water heater is a water heater. But stick that same object in the sand at the edge of the continent and it becomes something else entirely. At first it was a pun; an old water heater poised there with infinite gallons of frigid water behind it—it made me laugh. But then, the appliance seemed to deepen. It became stranger, a riddle, "Why *is* there a water heater on the Great Beach?" And then, finally, all its past purposes irrelevant in its current condition, "Just what *is* this thing, anyway?" I've found that if you look at any object long and hard enough, things get a bit slippery.

Almost a year to the day after the water heater, and in nearly the same spot, I found an airplane wheel. It must have weighed hundreds of pounds, and yet, it stood there perfectly upright, as grave and mysterious as Stonehenge. Just another Point Reyes mystery I suppose: why is there an airplane wheel on the Great Beach? And what happened to the airplane?

I continued on. I walked miles. It was impossible to tell what time it was, for the light looked the same throughout the day. At twilight there, in such a fog, it can get pitch dark as suddenly as if a switch had been flipped. And if you're caught out there then, you're in real trouble. One time I lost the light coming back down Kehoe Beach to the north and for the life of me I couldn't find the trail I'd come in on. I wandered all the way to the South Beach parking lot, a full four miles off course, before I even realized my mistake. By then, the thought of struggling all the way back through the sand was unbearable, so I headed overland for the road. I must have walked half the night in the dark. Eventually, a ranger found me and brought me back to my car. He didn't ask what happened. I guess he didn't need to.

I could hardly walk the next day, my shins hurt so bad.

There were purple bruises on my shoulder blades from carrying my tripod.

Why do I do this?

What is it about this place?

On the Great Beach on another day, as alone as one can be, I heard my name called aloud. It was quite clear. I spun around and found of course nothing but a mirror view of the one I had been looking at before—just sand and fog. Was the voice real? Who can say? For how does one distinguish an objective fact from the constant chimera of an idling mind?

Still, I can't help but wonder if I missed something that day—if I was called and should have answered.

It's never happened again.

I went on. I considered turning back, for I had no destination, but the prospect of returning to my car disheartened me somehow. It seemed that such a retreat would amount to cowardice—just why I did not know.

Suddenly shadows materialized in the fog: a dozen silhouettes, all frightful hard angles: claws and fangs and swords and crowns. The forms jerked about as if on rods, a mechanical nightmare behind a white screen. It was a Balinese puppet show! I dropped to my knees, terrified, as kings and gods and demons danced and fought and shook before me in perfect silence.

I couldn't wrap my mind around it.

Could it be that the beings were born in my brain and projected out my eyes?

They're pelicans!

I laughed out loud.

Of course they were pelicans.

Relieved but wary, I gave the birds a wide berth. I'm an ardent admirer of the pelican, but even I must confess that sometimes they can seem a little sinister.

I headed up to the backshore for a late lunch.

While searching for a good spot, I found a shoe and a rope, a tire and a float, some Styrofoam—the accumulated detritus of past lives. It struck me then that everything on that beach, down to the last grain of sand, was once something else. But I suppose that all in this world is like that. I sat down on an old log and wondered about its history. It had floated down a river, no doubt, a long time ago when I was a boy. It might have been the Russian or the Noyo or the Eel. Or further up—the Rogue, the Umqua, or the Colombia. And now it was my bench. I retrieved my lunch from a soggy paper bag: peanut butter and jelly on wheat, an apple, some almonds, and a miniature bottle of wine. My meal looked strange out there, different than it had that morning, though of course it hadn't changed at all. I found myself overcome with the sort of feeling one gets returning to their old room after four years away at college, or in the military, when everything old is seen with new eyes, when one witnesses oneself from the outside. *Is this me? Is this who I am? Is that really what my hands look like?*

A few more fallen ships: *Warrior Queen, Francois Coppee, Quinault, Gaspar, Nahumkeag, Ayacucho, El Dorado, Bengal…*

∾

Once upon a time, people lived and worked on the Great Beach. The U.S. Life-Saving Service (the precursor of today's Coast Guard) erected a station there in 1888, after it was determined that the lighthouse wasn't enough to stop the shipwrecks. A crew of eight surfmen and a keeper in charge lived in a wood-slat, two-story building set back above the cliffs. It had dormer windows and a covered porch and a 125-foot flagpole for signaling ships at sea. There was a bell in the yard to warn vessels away in bad weather.

The men patrolled the beach on four-hour shifts, day and night. A pair would set off together, and then, after some words of commiseration, no doubt, one of them would head north while the other went south. Each man wore a heavy punch clock around his neck. The keys to the clocks were set in shacks along the way, where the men could take a moment's shelter from the wind before punching in to prove they'd completed their patrol.

If a distressed vessel was spotted on one of the rounds, flares were set off and a surfboat was launched. The keeper would steer while the others rowed. If the men determined that they couldn't reach the ship, they'd shoot a line from shore with a Lyle gun, and then send a ring buoy over to extract the endangered crew one at a time.

It was perilous work, a fact reflected in the surfmen's motto, "Ye have to go out, but ye don't have to come in." And, in fact, some of them didn't, three drowning in the first few years alone.

Even after the Great Beach station was abandoned in 1927 for the relative calm of Drake's Bay, the duty remained exceedingly dangerous.

In 1960, on the night before Thanksgiving, two coast-guardsmen secured a disabled boat up north in Bodega Bay. They then radioed their projected arrival time back to the lifeboat station. The men were never heard from again. In the morning, their empty boat was found on the Great Beach. Its propellers were still turning.

∾

The dunes on my left turned to cliffs that continued to rise as I carried on south. At the end of the beach, those same cliffs buttress a headland three hundred feet high. From up there, on a clear day, you can look back down the way you've come, at fourteen miles of scalloped surf—row after row of combers backed into the Pacific like pews. From there, you can see the white sand beach, far-stretched to the horizon like a desert road, or a river from the air. From there, you can look back down on the rolling fields and the wide green

pastures laced with thin black roads and thin black wires and the tiny dots of whitewashed ranches. From up there, atop the cliffs, you can finally see this place in its entirety, and know why it is Great.

It's a god's eye view if you can get it.

∽

I scrambled up a break in the cliffs to a place I know.

There, on a level shelf overlooking the ocean, sits the sole remnant of the old lifeboat station. It is a little boot-shaped building, with peaked roofs and white shingles and so many windows they nearly cover the lower level solid. It looks like a wayside chapel. In fact though, the structure once served as a Navy compass station, receiving and transmitting signals from ships at sea. It's been abandoned for a long time. A side porch with half its supports collapsed droops down onto a mat of ice plant. In places the white shingles are beginning to slough off, and the dark, bare wood beneath wraps one corner like a spreading stain, or a slow, consuming fire. All the window glass is frosted from years of weather and neglect, laced now with sea salt filigrees and streaks of guano.

I hopped a barbwire fence and crept up to the building, then stood on tiptoes to peer through a broken pane. The place was filled with soft light, dusky and church like. There was a curled, faded map of Point Reyes on one wall, and just below the sill on which I hung, a dusty green couch. At once I considered breaking in. How I'd love to spend the night in there! I'd lie on that old, moldering couch in my sleeping bag with a bottle of red wine. I'd watch the sun set through the milky windows.

And I would do it too, if only I were younger, and less concerned with consequence…

It seems sometimes that such an experience would consummate my relationship with Point Reyes—would bring it further into myself. But why should it be necessary?

I've roamed over almost every square foot of this land. That first night on Chimney Rock became every weekend and then every chance I've had for years—more than ten years now. What is it about *this* place? And for what?

It's been said that people go to the coast to leave things behind—that here, at the edge of the continent, you can turn your back on your country, on your past, on your whole life, and gaze instead over the ocean of infinite, unalloyed potential. Of course it's a delusion. The truth is you can't leave anything behind. For anywhere you go it all comes with you—every last bit. The truth is that everything you've felt and done and thought, is always with you, in you, *is* you. And the ocean? Riptides and monsters—a cold, dark void. You'll find no quarter in the cradle of life. No, to stand on an empty beach is to stand—denuded and inescapably—toe to toe with your life.

I come here to put my back against the wall.
This is where I'll make my stand. Point Reyes is my desert.
Who am I?

I stumbled back down to the sand and lurched about in the fog, a red hot iron ball in my head. I was sure it was in me to know everything. If all things sprang from the same source, isn't it true then that each thing must hold within it, like a latent seed, the potential to know the whole?

So who am I?

And there I was again, in that very same spot, sure that something was required but knowing not what. I didn't know how to answer. I feared I hadn't the strength. I wanted to retreat.

And then, as if I'd subconsciously timed the whole hike so that my inner arc would collide with the world at just that moment, I saw the lighthouse beacon—a single pulse through a thousand pieces of hand-ground glass. They say you can see it from twenty-four miles away, but on that day it looked feeble, so distant through the fog. No matter, I'd

grab any line I could get. I'd lose myself in the details. Yes, the lens is a first order Fresnel, made in Paris in 1867. They brought it around the horn by steamer ship. From Drake's Bay, it had to be hauled to the point with an oxcart. It took three years to put it together.

The Lighthouse keepers had a hard job. The log entry for January 30th, 1889 reads, "The second assistant went crazy and was handed over to the constable in Olema."

The detached tone tells more than the words ever could.

∾

I stood for a while, waiting for the beacon, as alone in the fog as a ship at sea. The light came every five seconds. That's a lot of time in-between. Wet and cold and aching, I turned my back, and went for home.

∾

…City of Topeka, Munleon, Charles R. Wilson, Annie E. Smale, Valentine Alviso, Hartwood, Yosemite, Sonoma…

7

Drake's Estero

Though still the subject of exhaustive, perhaps fruitless debate, it is most generally thought that Point Reyes is the Plymouth Rock of the West—the place where the English first landed on the Pacific shore of what is currently called the United States of America.

June of 1579 found Sir Francis Drake and his crew sailing down the California coast in their galleon, the *Golden Hind*. The men had already endured a harrowing trip around Cape Horn, as well as a subsequent failure to find the famed Northwest Passage, and morale was low. To make matters worse, they were also fleeing the Spaniards, who considered them pirates for having left behind them a long line of plundered Spanish ships.

Thus, it was with undoubtedly no small measure of relief that Drake and his crew discovered a "faire and good baye," one whose white, undulating cliffs reminded them of Dover, of the English Channel, and home; a bay where they could tend to their battered ship, and prepare for the long voyage across the Pacific.

When the *Golden Hind* entered what is now known as Drake's Bay, a lone Miwok Indian paddled up to meet it. He sided up to the galleon in his tule canoe—one can scarcely imagine what he was thinking—and delivered the Englishmen a long oration, which of course they found completely unintelligible. The Miwok then departed, only to return shortly afterwards with a gift of feathers. In exchange, Drake's men offered him an assortment of objects, all of which he refused save for a British naval hat, which he gleefully put on his head before once again paddling away.

Satisfied that the natives were of no immediate threat, Drake brought his ship nearer to shore and careened her in a small cove near the mouth of Limantour Estero, the "thumb" of Point Reyes's hand-shaped estuary. He then ordered his men to build a stone fort on the beach, a base from which they'd repair the *Hind* and explore their surroundings.

During their six-week stay on Point Reyes, the Englishmen found the land to be grim and inhospitable. Chaplain Francis Fletcher wrote, "…How unhandsome and deformed appeared the face of the earth it selfe, shewing trees without leaves, and the ground without greenes…" On the weather, Fletcher frequently complained of the "nipping cold" and the "thicke mists" and the "stynkinge fogges."

He also recorded that the Miwok often visited the fort, asking the men to sing or play their violin. He said that though most were generally friendly, sometimes the natives' behavior took on a darker cast. He recalled the women once rolling on the ground and repeatedly striking themselves and scratching their cheeks with their fingernails until blood ran down their faces. He called them, "hysterical." Archaeologists say it is quite possible that the Miwok thought that the Europeans were ghosts.

Before he left, Drake erected a large wooden post, affixed with a brass plaque that christened the land Nova Albion and claimed it for the Queen.

It is doubtful that the Miwok ever came to discern the extent of the European's presumption—at least one hopes not. Better that they puzzled over Drake's plaque for years, perhaps thinking it a directive from beyond. Anything but the truth. Who would wish to know their future if their future was ruin?

By the early 1800s, most of the Miwok had been converted by the Franciscan Fathers, and had abandoned their villages for the mission in San Rafael. When the Mexican government secularized the mission in 1834, the Miwok were left largely to fend for themselves. Having by then already forgotten their culture, and with it their self-reliance, they found they couldn't go home, and within a short time, most died of starvation or disease.

For many years after, the Point Reyes peninsula lay virtually empty; a ghost ship like the *Golden Hind*, slowly sailing north towards some new world—a world that I would be a part of.

∾

And so it was that early on a September morning, I strapped the kayak atop my car and headed for Johnson's Oyster Farm. I'd launch from there, from the northern end of Schooner Bay, and explore Drake's Estero like its freebooter

namesake, like some modern-day Miwok.

Well, one can pretend.

∾

I turned off my music as I rolled into the lot. There's something about Johnson's that seems to call for a cautious approach. One comes as if to a village, with all the deference so implied. One comes as a guest.

I relate with no small measure of affection that the place looks like a shanty-town. It is not clearly a farm, nor a business, nor a settlement, but an indistinct amalgamation of the three. Function reigns supreme. The whole thing seems to have grown organically, exponentially, with structures thrown up whenever and wherever they were needed. Buildings appear to lean on one another for support. Small squares squat atop large squares buttressing even larger squares. Everything is painted white—white washed over plywood and concrete and corrugated aluminum alike. It looks like a cliffside village in Greece. It looks like art—like M.C. Escher or Jasper Johns—it's *White Flag*.

When I stepped from the car I was immediately confronted by a pair of huge black dogs. They looked wild, their fur matted and caked with froth and mud. They brushed against my legs and sniffed at my boots. I feared them, as if I were sure I'd fail a test the nature of which I'd no idea. In vain I searched for someone to call them off. But no one was around. I'd be torn to pieces. But then, as if beckoned by a command I could not hear, the dogs bolted off.

I stood there with my heart racing, berating myself for my fear. *They wouldn't have let them loose if they were really wild—would they?* I retrieved my tripod from the trunk and flipped the legs spike side out, just in case. As an extra measure, I left my kayak on the roof of the car should a quick getaway be required.

Brandishing my makeshift spear, I entered into the

compound under a frayed American flag, its sun-drained colors still vibrant against the whites. I threaded my way down the crooked central alley, passing rows of weathered shacks, their fronts opened up like carnival booths at a county fair—an apt resemblance, no doubt. For the defining impression in either case is of being beset by a vertiginous array of disparate sensations all at once. The last oyster cannery in California is stacks of wooden pallets and plastic barrels and mesh bags, the clatter and hum of machines, the smell of fish, shouts in Spanish, swells of laughter, and a thousand other things one can scarcely apprehend, washing over you as they do like a flood. And a sign that made me smile, "Please keep your dogs on a leash. Thank you."

A soccer ball flew in from a side alley, ricocheting off a wall before scudding toward me through the dirt. A group of boys rounded the corner after it, then pulled up short when they saw me. I sidled up to the ball and offered them an exaggerated windup with my tripod before teeing it back. The boys laughed at me and I was glad.

I continued on until I was behind the buildings, out on the bay's shore. There I found scores of empty oyster shells, heaped up in piles like cherry blossom drifts. And a rusty, one-eyed truck, so decrepit it appeared to be a prop. But it isn't. The truck works—I've seen it work. I remember I made a picture of it that day, hoping no one saw me. I've found that some people don't understand an interest in ugly things. It makes them uncomfortable somehow. They'll come up to me and say, "Why would you want to take a picture of *that*?" They'll almost sound indignant. Well I never know what to tell them. It's not really about the dump truck.

I packed up my gear and returned to the car. It was time to put to sea. I wrestled down the kayak and dragged it across a shell-covered beach to the water. The resultant noise was awful, and it made me self-conscious, to be announcing myself that way. *What a spectacle I must be,* I thought, *with my blue boat and my blue lifejacket and my orange paddles. What a sideshow. Better I should be shucking oysters with the workers. At least then I'd be connected.* But

no matter. It was all forgotten once I slipped into the water, like an ungainly bird taking flight.

The wind was strong and the waves were high. My bow was coming out of the water at the crests, then plunging down—hitting the troughs with a slap. I was soon soaked from the spindrift. My glasses were all fogged up. But I couldn't have been happier. I did wonder though what conditions would be like nearer the mouth of the bay, closer to the open ocean. I am not a good kayaker. Nor a great swimmer. I supposed I could always turn back. Though of course I knew I wouldn't.

And then—*there!* An undulating line of brown pelicans, flying low, just above the water. I leaned back as they passed, so close over I could hear their wings cut the air, could see a flash of crazy grin and a lone yellow eye—*that one surely took me in!* There's something wonderful about pelicans. They're so serene, so at ease, so content in their own pelican-ness. And the intelligence! That was no flock of birds, but a group of friends—individuals. I confess the closest I ever come to something like patriotism is when I'm watching pelicans.

I struggled on through the chop, push–pull–push–pull, through light and air and spray. I watched the sun's reflection, keeping pace alongside my boat, shatter into a thousand swirling spangles; into a galaxy of stars, before collapsing back in on itself, returning for a moment to a single point, before exploding again. The rhythm of it was like breathing, or music, like the quivering beat of a big band—Count Basie and his crew—bang after bang billowing out from silence—from nothing. Magic.

Onshore, a cast of marsh hawks circled gracefully over parched downs. I wondered what it was they were looking at. Just over that hill is a stand of Monterey pines, long ago emancipated from a failed Christmas tree farm. The trees are so close together that when the wind comes up, their limbs rub together, and the whole forest starts to creaking. Sometimes it almost seems like they're trying to tell you something.

I reached the start of the oyster racks; rows and rows of thin wooden rails hung with wires on which the mollusks are grown. It was near high tide and most of the structures were underwater. The crop glided by beneath me, the strands of white shells trailing down into the dark like long garlands of garlic flowers.

Charlie Johnson learned how to cultivate oysters in Japan after World War II. Before that he'd been an Oklahoma wheat farmer. He came to the estero in the '50s with his Japanese wife Makiko. He said that the water here was clean and the location was good. The Johnsons were the first to bring Japanese oyster farming techniques to California. Their business stayed in the family for generations.

It'll all be gone in a couple of years. The park service says it won't renew the farm's lease when it expires in 2012. They say that the estero should be returned to its native state, that it should become a "full wilderness area."

As I glided down the middle of two racks, like over the aisle of an old sunken vineyard, I considered the fact that local archeologists report that people have been pulling oysters from Drake's Estero for thousands of years, and it struck me that as well-intentioned as the Park Service's efforts may be, attempting to extricate humans from nature can only serve to further our own estrangement. Nature is not outside of us. Fundamentally, we are all, and will always be, in our native state. There is not one place in this world that is not wilderness.

And yet, still I come to Point Reyes…

∾

Shortly past the oyster beds, back in open water, a sea lion surfaced off my starboard bow. I stopped and stared at him and he stared right back. I read somewhere once that sea lions and dogs share a common progenitor, a tree-climbing carnivore called Miacis. That seems about right to me. Sea lions have such earnest faces.

My new friend and I continued our mutual evaluation. I suspected that others of his troop were already gathering behind me. That seems to be their habit. "I know you're there," I said over my shoulder, in precisely the same way I'd say it playing hide and seek with my son. Then I turned my head and sure enough, there they were—seven sea lions, still and impassive, and yet, I dared hope, not wholly unkind. It was a less than ideal audience perhaps, but better than nothing.

"Brothers and sisters," I offered, half dreading they'd respond, "Thank you for coming." I wondered what the sea lions made of my boat. It does have the eyes after all. Perhaps they thought I was riding on the back of one of their brethren. I'll bet they're smarter than that though.

"Brothers and sisters," I continued, St. Francis to the birds, "much bounden are ye unto God, your Creator, and always in every place ought ye to praise him. For that He hath given you liberty to swim about…" But then, all at once, spurred by some unknown cue (perhaps a whiff of charlatanism), the sea lions disappeared. They came up again a ways off some seconds later, still looking in my direction but seemingly not so interested then. How I wished they would stay! But I supposed they had their own endeavors. I waved goodbye and they vanished for good.

About a mile from Johnson's I reached the mouth of Home Bay. I considered heading into it for a respite from the waves, but decided instead to carry on. I'd need to conserve my strength to make it to the mouth.

The nearer I came to the open waters of Drake's Bay and the Pacific, the stronger the wind became. By then the waves were the worst I'd ever tried. My descents into the troughs had grown steep and unnerving, and for the first time I began to fear capsizing. In such a case I probably wouldn't drown, but my open kayak would surely sink, taking my camera down with it.

I don't much like the sensation of plunging. Once, when I was in the Navy, I ventured out onto one of the ship's

catwalks during a ferocious storm despite being forbidden from doing so. I'll never forget the seconds I spent clinging to that rail, watching with my heart in my throat as we slowly ascended the face of a mountain so high it made an aircraft carrier seem insignificant, smaller than my kayak on those swells—a bath toy. We reached the crest of the wave and for one terrible moment we paused—a 100,000-ton ship teetering on a point…and then the bottom dropped out.

I still wish I hadn't looked down in that hole.

∾

The currents are strange in Drake's Estero, an effect of the meandering shoreline and the shallowness of the water. Sometimes I had the feeling of being jerked backwards as if yanked by a rope. Series of swells rolled in from one side and then the other. Moments of calm were dashed by my being suddenly lifted straight up and then dropped back down, as if my boat were astride a whale. Waves seemed to rear up from nowhere, atop me before I saw them forming. I had to frantically turn this way and that to keep from being broadsided.

After awhile, I actually got a little paranoid. I had the oddest feeling that the waves were somehow conscious of my existence, and moreover, that they resented all my floundering. And so I attacked them. I paddled into their faces as strongly as I could. I would be belligerent and fearless and the waves would respect me. They would respect my assuredness.

Of course it was a bluff.

But it passed the time, and soon enough I could see the mouth of the estero, the thin land there parted into two lobes with an opening in the middle unto Drake's Bay and the ocean beyond. The eastern side of the passage is Limantour Spit, named for the French trader who stranded his ship there in 1841. After the wreck, unaware he'd overshot the Golden Gate, Limantour roamed Point Reyes searching for San Francisco, still hoping to sell his cargo of perfumes and sweetmeats and silk brocades.

On the western side of the gap, just inside the mouth, lays a sheltered cove near where Drake is believed to have careened the *Golden Hind*. It is there where I was bound.

The wind was fierce and the landing would be difficult, but from out there struggling in the waves, that little beach looked like paradise.

I charged the shore in my usual fashion, a blur of orange paddles, trying to generate enough momentum to hurl myself up on the sand. The technique rarely works as well as I'd like. The kayak hit bottom and ground to a stop, and I bailed out—cold water to my knees. I was still in my hiking boots. I didn't much mind though. I was just glad to be there, alone in a new world.

I quickly dragged my boat up past the berm, up into the dune grass. The beach was calm and empty, with not a soul around. I was a castaway. And glad of it. I sat on the nose of my kayak, pulled off my waterlogged boots (they must have weighed ten pounds apiece), wrung out my socks and laughed. I'm the sort of person that keeps their shoes on at the beach. On this day though, I set my pale feet free and it felt good. The sand was soft and warm.

The thought of having to paddle back up the estero through those waves was a daunting one. *But never mind that.* I'd be all right there for a while, there on my beach at the end of the earth. I celebrated with a sandy bottle of Belgian ale, brewed by monks. They've been making it the same since Drake's day. The beer was warm and flat and wholly glorious. I raised a toast to my ascetic brothers over the ocean *(Not yet for me friends…)* and thanked them for the fruit of their labors.

If the world ends, I'm coming here. I'll live like the Miwok, right here on this beach. I'll live off the land. Somehow.

Across the mouth, I could see a herd of elephant seals lounging on Limantour Spit. It seemed a marvel that such creatures could ever look so small.

Once, in a cove near Chimney Rock, I came across a lone bull sleeping, and desiring to make his portrait, I gathered up my courage and crept closer. And closer. It can be comforting to look through a camera's viewfinder. So removed, one feels almost immune to danger. I was about three feet from his head when his eye opened, when that giant red eye snapped open. There was a terrible noise; a roar that seemed to shake the very ground beneath my feet. I bolted down the beach as fast as I could, that two-ton bull right behind me all the way. I couldn't believe his speed. I'd be crushed. When I reached the cliff face, I flew up it with an agility I'd never known before. I was monkey-like. When I was sure I'd reached a safe height, I turned and looked back down, at a monster as frightful as any there ever was.

I haven't bothered any elephant seals since.

I finished my beer and set off lightly down the beach. When I rounded the horn to its seaward side the wind returned. The land there was scoured and stark, a rock strewn plain that reminded me of Mars. But I found evidence of civilization there: tangled ropes and nets, an orphaned sandal, a neon-colored fishing float, and bottles splashed with Japanese Kanji.
I dug out a half-buried lawn chair and claimed the throne.

I abandoned my seat when I saw the ladder. A wooden ladder on the beach certainly deserves a photograph. So I trekked back to the boat and retrieved my gear. When I returned, I made my photograph, then righted the ladder and climbed to its top step. From there I waved to the elephant seals. They seemed disinterested.

I continued on towards Drake's Beach. It was there, in September of 1966, that Ladybird Johnson officially dedicated Point Reyes National Seashore. There's a picture of her made that day. It was taken from behind her as she strode along the surf. There's no one else visible in the image; it's just a lone woman walking down a beach in a skirt and a hat and in shoes inappropriate for walking down a beach. It's a slightly melancholy photograph, surreal even. But I suppose pictures of people walking away are usually like that. I wonder what Ladybird Johnson was thinking about that day.

President Kennedy had established the seashore four years earlier. It is said that he considered the peninsula the Nantucket of the West Coast. Kennedy had planned to visit Point Reyes in 1963 as part of a tour of conservation projects. At the last minute though, for reasons unclear, Point Reyes was removed from his itinerary. He went to Dallas instead.

I scaled a short sandstone ledge and dropped down the other side onto Drake's Beach. I was appalled to find that there were people there. There were hordes of them—maybe a dozen. They were doing the sort of things that people usually do on a beach. They were having a pleasant day.

I stood there gaping at them, half-drunk on Trappist tripel, still wearing my blue life jacket. I felt ridiculous and indignant. I felt like a stranger.

Fuming, I retreated to my vessel.

Who the hell are these people and why are they on my beach? Don't they know how I've bled here and wept here, how I've taken this place into me? Don't they know this is Holy Ground? For God's sake you fuckers, don't you know that this is no place to fly kites?

Despite my efforts, I had to laugh a little. It's hard to take oneself too seriously, in light of everything. Lord knows I try though.

The sun and the beer were beginning to make my head hurt. I was sure I was getting sunburned. I sat on the prow of my boat and stared at the water. It looked cold and

hostile. The wind had shifted against me. It would be hard going on the way back.

But what choice did I have? So I put in, and immediately felt myself being pulled out toward the mouth. The tide was turning. I struggled against the current, fighting for every forward inch. I gauged my progress by the shore, making up small goals for myself; *just make it to that rock, just make it to that curve.* I knew if I stopped to consider the whole thing I'd surely be defeated.

And then I saw an egret standing on the water—a silent town crier. The mud was a foot beneath my hull. I could feel it with my paddles. The estero was emptying. I had to cross the width of it just to keep from grounding. And then I had to do it again. The whole place was draining to a morass of branching, looping channels. And down low in my kayak, it was so hard to see the way. I zigzagged about, chasing one lead and then another, only to find myself right back where I started. All my shallow strokes were bringing me nowhere. It was all dead ends.

And I was lost.

I made for the eastern shore.

~

The shore was rocky and the landing was rough. Once again I had to clamber out into the water. And my feet had just begun to get dry. No matter—I was glad to be back on solid ground. My refuge was a tiny cove about a quarter of the way up the estero. It seemed as good a place as any to plant a flag and wait awhile. And anyway, I needed to gather my strength. As the first order of business, I scaled a boulder to gain the long view.

I'll never forget the sight.

In just a few hours, Drake's Estero had lost nearly all its water. It had become a hedge maze, a halved cabbage, a labyrinth written in mud. Stupefied, I searched for a way out, tracing a line in the channels with my mind. It made me think of a cereal box puzzle; "Benjamin Bunny needs your help to get back home." But this one was impossible. The game was too complex.

I was stranded.

I took some comfort in the knowledge that sailors infinitely more adept than I had also been stuck on Point Reyes. In the autumn of 1579, Sebastian Cermeño and his Spanish galleon *San Agustín* were bound for Mexico with Asian treasure. The passage across the North Pacific had been an arduous one, and the galleon was battered and leaking. Moreover, the crew had become so discontent with Cermeño's leadership they'd nearly mutinied.

Thus it was under protest that the men followed their captain's order to anchor at the entrance to the estero. They wanted to go home. But Cermeño wouldn't waver. As part of his mission, he'd been directed by the Spanish authorities to explore the California coast and that is what he would do.

The men grudgingly prepared the launch, and that afternoon Cermeño and most of the crew went ashore.

They were on the beach when the wind came up. They stood there and watched as their ship was torn from its moorings and blown into the surf. They watched it get smashed to pieces.

In a desperate attempt to save their passage home, some of the men dove into the sea, into a maelstrom of surf and timbers. For several, including the ship's chaplain, it was to be their last act.

When it was all over, Cermeño and his surviving crew stood on the beach, their world having just dissolved before their eyes, and we cannot possibly know the state of their being. It's not often one sees one's whole life so vividly dashed.

Compared with that, I had it pretty easy.

Still, my situation was a little disconcerting. I mean— what then? The prospect of heading overland with thirty pounds of camera gear was a disheartening one, to say the least. And what would become of my boat? I decided

instead to wait for the tide. I placed a few stones at the water's edge in order to gauge its movement. When I checked on them a few minutes later I found them ringed with mud. The estero was turning to desert. The half-moon cliffs I had paddled past only hours before now loomed over an empty plain. They looked odd like that, monolithic. I thought of Shiprock, of Uluru and Half Dome. My beached boat had become absurd, poignant, like those orphaned ships in the Aral Sea. The estero's metamorphosis seemed impossible, almost biblical. I was overcome with a conviction that the transformation was not in keeping with the usual rhythm of things but was rather a sign that something extraordinary was happening. I imagined a tsunami soaring over the ocean…

I have dreams like that sometimes.

I imagine most people do nowadays.

The cliffs were beginning to glow red. The sun was getting low.

The water, however, was not forthcoming. So I made up ways to pass the time. I built rock cairns. Before I knew it, I had half the beach covered with little stone towers. I imagined in a few days someone might come along to be impressed by my metropolis. I thought of her while I worked. When I tired of the cairns I switched to a search for shells. I found one the size and shape of an eye, with a pattern on it that looked like a pupil. I wedged it under my glasses and strutted around like a pirate. I made some self-portraits.

Further on I discovered a boulder completely covered with aggregating anemones. Their tentacles were retracted from the sun and air. They looked like sleeping sunflowers. Or open mouths. I've read that such creatures beget their offspring by tearing themselves in half.

I strolled along a wide rock shelf that ringed the base of the cliffs like the brim of a hat. When I rounded the bend at the end of the beach, I found a cove quite unlike the one I'd come from. Here was a lush green marsh, backed by softly rounded, chaparral-covered hills. When I went into the rushes, an army of tiny frogs began popping up from beneath my feet. I went slowly to give them warning. Near the center of the marsh, as if it'd been arranged that way, there was a thick length of gnarled driftwood. The old white log was alive with associations, the wood layered and folded like the shale on Sculptured Beach, shot through with raised patterns like an illuminated print—relief etched flames of furious desires. William Blake would have loved Point Reyes.

I doubled back to explore the other end of my sanctuary. In contrast to the marsh, it was rocky and severe, and the air there was rent with the alarm of death. Startled by my arrival, a pair of vultures alighted to reveal the deceased. It was a cow, a calf. She lay bloated and broken beneath forty-foot cliffs.

I wondered about when she fell, what I was doing in that moment, what I was thinking. I wondered what kind of thought a cow has when she's falling through space.

I came to know my refuge well. I made up a regular route, sauntering back and forth between my landmarks (Dead Cow, Anemone Rock, Tortured Wood) until I began to feel like a part of the landscape. I was the caretaker, the curator of these curiosities. I checked my stone clock as regularly as a watchman. Near sunset the tide seemed to reach its nadir. My shift was up. Though undoubtedly it was my mind making it so, it seemed that the water was coming back quickly.

My spirits were buoyed.

I climbed up onto my lookout stone and saw that the little rivulet I had ridden in on had returned. Though still quite narrow, it appeared to follow the shore as far as I could see. It just might be enough. And anyway, I figured in the worst case, should I get stuck, the waters would soon come to lift me up and deliver me north.

Sometimes my mother says I "push it." But how, I bluster, can one experience the joy of surmounting troubles if one doesn't get into the troubles in the first place? Of course such troubles are always a little more than you asked for.

Things went all right until I reached the entrance to Home Bay, where once again I was forced into a tangle of circuitous

channels. Each passage was indistinguishable from the next—all of an identical width with turns of identical angles.

And then the sun set. And with the shore darkened, I could no longer tell the direction I was going. The stars came out, but I don't know the stars the way a sailor should. Stars are just stars for me. They offer no guidance. Soon all was so black I couldn't even see the deck of my kayak or even my orange paddles. I was afloat in a void—entombed in a cheap plastic sarcophagus.

My objective became more humble—to try to stay afloat. I used my paddles like a blind man's cane, probing ahead with wide arcs, striking at the water, listening for the mud's hard whack. I'd run aground, reverse course, and begin anew, only to run aground again. It was an absurd task, Sisyphus rolling his rock uphill. How long I went on like that I've no idea. Without the senses, who can tell a minute from an hour? I began to have dark thoughts—*when the tide returns, how will I know which way to go? What if I'm pulled to sea? Is that a wave?* I tried to cage my fear, lest it run wild, choosing instead to hold fast to the old faith that nothing terrible would happen to me.

And then (as if reward for my certitude) I saw a light! It was too low for a star, separated from the stars by a black border. At first I thought it might be another boat. *But who in their right mind would be out here?* I studied it carefully. It wasn't moving. And the vague shapes of the things around it did not conform to those of a ship. I could see it was pulsing a little.

Johnson's!

I nearly shouted with joy, but didn't for fear that someone might hear me.

A moment later, in a way that seemed to prove a turn of luck, I was siphoned into a canal much broader than the others. I reached out as far as I could with my canes but could feel no bank. I'd found an artery. Now I had a light

and a way and I'd follow them to victory. How could I have ever doubted it? Giddy with success, I began to sing softly to myself.

> *Row, row, row your boat*
> *Gently down the stream.*
> *Merrily, merrily, merrily, merrily,*
> *Life is but a dream...*

I recounted the day's adventures in my head. It was a good story and I was looking forward to telling it. I'd emphasize the darker parts.

But then, in the cruelest way, my Grand Canal began to peter out. I could feel the sides closing in with my paddles. Soon the passage became so narrow, it was as if I were slicing through earth itself. Then the mud squeezed against my hull and held me still. I'd reached the end of the line.

You can't do this to me. You can't do this to me.

I was a hundred yards from Johnson's, a hundred yards from my car, a hundred yards from a happy ending. I was so close I could hear the murmur of idling machines, so close I could see that the guide I'd been following was just a light bulb—just a little light bulb.

I sat there feeling stupid, waiting for the tide. But the tide didn't come, and just then, I wasn't sure if it ever would. I wanted to cry out to the light for help, but when I imagined myself doing so I found that I could not. The people on shore would surely hear my voice. But then what? Would they train a spotlight on me? Throw me a rope? Call in a helicopter? All the outcomes seemed equally humiliating. Though I was in a desperate way, I wasn't so desperate as to want to be rescued.

My father has a framed quote on his wall. He and my mother found it when they moved into my childhood home. The outgoing tenants had left it hanging in the empty living room. My father has kept it all these years. It reads,

You gotta pay the price.

I climbed out of my boat and into the mud. I sank to my ankles, my knees, my thighs. I couldn't stop sinking. I had to grab the boat to keep from going under. When with all my strength I finally managed to haul myself back out, my boots were sucked right off my feet. They'll probably be down there forever.

I attempted a different tack. I straddled the top of the kayak with my head out over the bow, like the figurehead of an old sailing ship. Then I reached down with my hands and tried to drag my way forward. But it was no use. The mud was too soft and the weight was too much. Pushing off with my feet proved equally futile. I was stuck.

I lay there for a long time, neither fighting nor surrendering, just lying there atop my boat in the dark, feeling the mud between my fingers. I remember it had the consistency of wet clay. It smelled like soil and butter, like a newborn baby.

I had to do something.

Finally, impulsively, I slid headfirst into the mud, like a seal off a pier. I'd guessed I wouldn't sink with my weight distributed. Lucky for me I was right. I carefully rolled over and began to inch my way backwards with a kind of inverted breast stroke. I was frog-like. After a few such iterations, I hauled my boat after me by its bowline. By then I was half sunk in the mud and had to extract myself and begin all over. It took a tremendous effort to advance even a short distance and I was soon exhausted.

I imagined myself being discovered in the morning, or more precisely, I imagined my kayak being discovered, and alongside it one up-stretched arm jutting from the mud—the stiff hand still clinging to the bow line.

But I went on. What choice did I have? Though it meant more slithering, I avoided heading straight for Johnson's. The possibility of being seen in such a condition, so thoroughly beaten, was too much to bear. Even then I was vain. I aimed

instead for a spot to the left of the light. I imagined it was near where I'd launched that morning. *Was that really today?* It hardly seemed possible.

At last the mud began to grow firmer, and I was able to turn over and crawl along on my hands and knees. I was evolving. Near the shore the mud was embedded with rocks and oyster shells. It was like crawling over broken glass, and never have I been so glad. When I finally reached the beach, I collapsed atop a bed of broken shards and grinned up at the stars. They were my friends again.

I stopped in Point Reyes Station to use the payphone and what a sight I must have made, strutting shoeless down the street, covered in dark, smelly mud. I was the creature from the black lagoon. I stood in the phone booth, stinking up the phone booth, the most ridiculous thing in the world. It made me laugh.

I looked at the Old Western Saloon across the street and it looked so warm and inviting. I wanted to walk in there and collapse extravagantly on the floor. "You won't believe what happened to me today!" I'd say, and then I'd share my tale of peril with the enraptured patrons. But I knew it wouldn't go down that way. I knew most likely, they'd take one look at me and already know what happened.

Point Reyes happened.

Still in all, I thought to myself as I climbed in my car, *it's been a good day.*

I put the windows down and headed for home.

Cermeño made it home too. After the disintegration of the *San Agustín*, the captain and his men were essentially left with three choices. They could live out the rest of their lives with the Miwok on Point Reyes, walk hundreds of miles

through unknown territory back to Mexico, or finally, they could cram back into their tiny launch, and return to the sea. Being sailors, they chose the latter course. Seventy men and a dog piled into the open boat for what should have been a hopeless journey. But luck was with the sailors of the *San Agustín*, for in a near miracle, all survived—well, all except the dog, who was eaten by the men en route.

As for the *San Agustín's* treasure, it remained back on Point Reyes. On occasion, remnants of it still wash up on Drake's Beach. Local archeologists surmise that after Cermeño left, the Miwok may have taken to sleeping on silk sheets and eating off of fine Chinese porcelain.

8

Tomales Point

Tomales Point is the prow of a ship, the head of a whale, the ear of a coyote, a long, bony finger, a spear. It is a memory, a muse, a dream, a sign. Like everything I suppose, Tomales Point is exactly what you think it is.

Early on a morning in October, I set off for the Tomales Point trail out by the old Pierce Point Ranch. It was still before dawn when I rolled into the lot. I was the only one around. The park service recently restored the ranch to create what they've termed an interpretive site. To me it looks a little like a stage set, or else, on that morning, a cemetery—all those white-washed buildings looming in the half-light like marble tombs. Or at least that was my interpretation. In the daylight the buildings are so bright you can hardly look at them. There's a hill nearby, and from up there all the white clapboard beams back at you like the sun from a broken mirror. It almost looks like it's on fire.

The name Pierce Point comes from Solomon Pierce, who started the ranch in 1858. He cleared 400 acres for 300 cows, and built a dock down on Tomales Bay to ship butter and hogs to San Francisco. By all accounts it was a prosperous operation. By the 1880s, under his son Abram's control, Solomon's ranch boasted a blacksmith shop, a carpentry building, and a school. The business had grown so much that the local press began likening it to a village. They called it Pierceville.

I stepped into the hay barn and paused, waiting for my eyes to adjust. I thought back to a rainy day in December, years before, when I'd spent a whole afternoon there—just me and an old tufted owl. I'd photographed the light seeping through the cracks of a closed door. I remembered setting my camera on its tripod and opening up the shutter, letting the exposure build—letting incalculable quanta of light pour in through the aperture to silently bombard the silver-halide salts in their gelatin bed—while I wandered around listening to the rain on the roof.

Photography is at once both commonplace and utterly miraculous.

My exposures were long that day. I wanted the light to look brilliant. That is how it felt. From there in the dark it almost seemed like the light was *trying* to get in; as if at any moment the door, the wall, the barn, the whole world might dissolve in one last flash of white heat. That is how it felt, so that is how I made it. It seems to me that the truth of a thing must include our feelings for it. How could it not?

I made another picture from inside the barn on that December day, of a building across the yard through a rain-smeared window. I composed it so that the window was a tiny rectangle floating in the ground of the barn's interior wall. In the darkroom I burned down the wall until it was black. I wanted the building outside to look like it was up on a movie screen, like you were parked at the back of an old drive-in. I wanted it to look like a memory—unreachable.

When I walked over to the same window, all those years later, ducking a little to try and find my old vantage point, I found that aside from the weather, the scene looked much the same. And indeed, standing there, filling that same space, looking at the very same thing, it really did seem as if I'd never left. And yet, because I myself had changed, the scene did feel somehow different, and I knew that if I were to make another picture of the same subject, I would make a different picture. I wonder then—which of the images would come nearer to the subject? No doubt the question is wrongly put. Subjects are practically incidental. All photographs are of the photographer. Or more rightly put, all photographs are of the viewer. They are all portraits of you.

∾

I needed to get moving. Other people would be showing up soon and I was in no mood to meet them. I like people, at least from a distance, but photography is best left a solitary pursuit. And anyway, it was cold and I wasn't dressed for cold. Strangely enough, in a couple of hours it would probably be balmy. October is Indian summer on Point Reyes.

And so I started down the dusty ranch road toward the point, passing beneath a cluster of gnarled cypress. The trees were the last I'd see for a long time. Tomales Point is an open and solemn land. It looks a little like the Shetlands. There are plants there: coyote brush and hemlock, lupine and poison oak, wild radish and mustard. But most of it lies low, prostrated by the wind from birth.

The scrub was alive that morning with the bustlings of innumerable creatures: a tiny, long-tailed mouse, a fat black beetle, a pair of lightly hopping sparrows, and many other birds I did not know, humble birds a birder might call, with affection, *LGB's*—let us now praise the Little Gray Bird! And there were rabbits too, so small they looked like half-scale models—rabbits in miniature. I wanted to pluck them up and warn them of what would soon be overhead, tell them of the peregrine falcon and the red-tailed hawk, the rough-legged hawk and the sharp-shinned hawk, the harrier, the kestrel, and the merlin. I've heard that there are osprey here too, the great sea hawk, cousin of the eagle. They say that osprey build a nest as wide as a man's outstretched arms.

But I carried on, saying nothing, leaving my rabbit friends to fend for themselves. After all, everyone's got to eat.

∾

I reached the inlet of White Gulch just as the sun was rising. I watched it crest the horizon across Tomales Bay and cast its reflection down on the water as if it'd split itself in two. The light was so bright I could hardly keep my eyes open; so bright it brought the awe right back—why *wouldn't* one worship such a thing? And those hills! Everything was gleaming with dew, the sun in every drop, and each blade of backlit grass rendered wholly translucent, silver-veined and edged with fire. A mercury world.

There were buildings once in White Gulch, an outpost of the Pierce Point Ranch. From there a schooner went back and forth over to the rail stop in Hamlet. Sailors lived in those hills.

There's nothing left of any of it now.

Squinting against the sun, I sought out Hog and Duck Islands way down on the bay, and what a strange feeling it was to find them—like spotting one's house from an airplane. When I thought back on all the days I'd spent there—those diamond days in my little boat—on the eucalyptus and the daffodils, the stone ruins and the starfish, the cormorants and the crabs and the hundred other wonders…it made me a little sad. For I knew that those days would forever after be colored by that day. Even then I could feel the moment (as I feel this moment) settling over my memories like yellow over blue, and from there on I would know only green.

How odd it is that we think of the past as something completed! The past is not fixed. It is not done. No, the past is forever in flux, changing in light of our every subsequent experience, evolving in light of our selves. Even if we could go home we'd never recognize it.

And then—elk! How had I not seen them before? Two-dozen tule elk in the hills right below me. They were bent over grazing, steeped knee-high in the lingering mist, silently nibbling silver dew beads from the chaparral. All of them were facing the sun. The scene seemed almost sacramental, as if I'd stumbled onto a meeting of Quakers, as if each elk was gathered there to bow down in his own private devotion.

And I was an interloper.

There were once over a half a million elk in California. It is said that in the Central Valley the herds sometimes darkened the land as far as the horizon. But with the Gold Rush came California's transformation, and if the elk were regarded at all, it was not as God's creatures but as fuel for the fire; something had to sustain all those golden dreams.

Aided by the peninsula's remoteness, the herd on Point Reyes outlasted their brethren on the mainland, holding out until the 1860s. Exactly what happened to the last of the elk here remains a mystery. One tale has them fleeing out to the tip of Tomales Point and then, half-mad from persecution and starvation, plunging into the frigid waters and swimming across Tomales Bay. One can only imagine the sight of it—all those wild eyes and gaping mouths, the bulls' racks swaying above the surf…

It's an affecting picture no doubt, but likely a false one. They were probably just slaughtered on the point. In any event there would be no refuge, and the California elk went extinct. At least it was thought so until a few were found hiding in a swamp near present-day Buttonwillow.

It is almost certain that the animals before me that morning were descendants of that same small group.

Tule elk were returned to Point Reyes in 1978 with the introduction of two bulls and eight cows. The settlers took readily to their ancestral homeland, thriving such that within two decades there were nearly 500 of them roaming Tomales Point. The reintroduction was so successful, in fact, that the park service had to go in and cull the herd.

I set up my camera as quietly as I could, performing each task with careful deliberation. As I extended the legs of my tripod, it occurred to me that from a distance, they might look a little like antlers, or at least they might to a jealous, half-crazed bull. It was the rutting season, and though the elk didn't seem to mind (or even notice) my being there, some deference was certainly prudent. The bulls can be quite aggressive that time of year.

I busied up my mind with facts. The rack on a mature male elk can weigh more than fifty pounds, heavier than the gear I lug on my back. The points that branch up from the main part of each antler are called tines. The first is the brow tine, the second the bey tine, the third the trey tine, and the

forth the royal point. Continuing upward and outward, the fifth and sixth points are known as sur-royals.

It turned out I needn't have worried. I was the only bull around and the cows were aloof. I took my picture and carried on.

∾

It's about four and a half miles from Pierce Point Ranch to the trail's end at Tomales Bluff. You can walk the distance in a little more than an hour, or, if so inclined, you can stretch it out all day. John Muir used to call it sauntering. I'm pretty good for a beginner. Good enough to wile away a morning at least.

∾

I crested a swell and a group of huge stones came into view. They were startling and poignant in all the open, rearing over the land like the upturned prows of a sinking fleet. Or like Stonehenge. I've learned though that the outcrops are in fact slabs of the peninsula's granite basement, probably surfaced since long before Stonehenge, since before even there were people to perceive them. And I imagine they'll be there long after.

The grass was swaying a little with the wind, and the movement seemed to accentuate both the stillness of the stones and the movement of the grass. It almost looked intentional, as if the two things, simply by way of their own nature, were each offering a silent eulogy on the other.

How I love this place! Sometimes I'll be photographing one of the rocks here when suddenly I'm struck with the realization that I've photographed it before. *But how*, I then wonder, *did it seem so different then? Was it that it was bathed in a different light, that it lay under a different sky, or was it different because it was seen by a different me? What would these rocks look like without my looking at them? When*

a tree falls in the forest and there's no one around…

But enough! It's all obfuscation. Indulging in such idle rooting only ensures my own estrangement, ensures that I'll forever remain trapped in the rock of myself. These old stones needn't be strangers. After all, are we not made of the same stuff?

∾

I scaled the largest boulder to its top. From there, I could see the ocean on my left, the bay on my right, and before me, narrowing like a sword to its tip—Tomales Point. *Punta de los Reyes indeed!* I sat there for a long time, surveying my kingdom, as rooted as the stones. I watched a procession of elk pass by. They seemed to know where they were going. Overhead, two hawks spiraled around on invisible currents. They watched me as I watched them. I wondered—*If I sit here long enough, and still enough, will they come down to meet me?* Way off down the trail, I could hear some hikers talking. They were looking for birds.

Everyone comes to Point Reyes looking for something.

I took out my lunch: my warm salami sandwich on wheat, my carrots and cookies. I drank my little bottle of wine. When I was done I made a pillow of my backpack and lay down on the rock. I closed my eyes and felt the sun on my face, rubbed the lichen with my fingertips, and listened to the ocean way down below. I was on the bridge of a great granite ship, slowly steaming northward with my elk friends. I wondered if my little son would come there someday and sit on that very same rock. Maybe he'd bring his own children, his grandchildren…

∾

I awoke to the saddest sound on earth. It was a scream, a moan, a whistle—it was all of those at once. The first time you ever hear an elk bugle, you'll brood over it long after.

You'll turn it over and over in your mind, hearing it there, trying to understand just why it makes your hair stand on end. I've thought of it a lot myself. For me, it's the sound of a horn, a trumpet, of Miles Davis. It's *Saeta*, from *Sketches of Spain*.

The Saeta is a song performed during the Holy Week processions in Seville, when the religious brotherhoods make their slow march through the alleys, barefoot in lined gowns and pointed hoods, carrying an image of the crucified Christ. The Saeta singer waits for them on a balcony overlooking the route. When the brothers reach her, they stop, and she sings down to them, unaccompanied. She sings to Jesus:

> *¿Quién te ha clavao en esa cruz?*
> Who nailed you to the cross?
> *¿Quién te ha puesto espinas?*
> Who crowned you with thorns?
> *¿Quién te ha herio ese costao?*
> Who wounded your body?
> *Está tu Mare Divina con el corazón traspasao.*
> Your divine mother's heart has been pierced.

And that's the connection between the Saeta in Seville, Miles Davis, and a bugling elk on Tomales Point, Point Reyes. They are all, each of them, the exact sound of a heart pierced by grief.

ॐ

I rolled over onto my stomach and saw before me a scene so unexpected, I gripped the rock as if to confirm that it was real. Two bull elk stood a stone's throw away, so close I could smell their musk; so close I could swear I heard them breathing. Not ten yards apart, they faced one another with their heads bowed down, as bound to ritual as ancient samurai.

The right-hand bull lifted his head and bugled. It started off low, quickly climbed to a metallic shriek, then faded away with a series of what sounded like wracking sobs.

It seems that elk enter battle with heavy hearts.

The left-hand bull returned the call, then dipped his head and began swinging it back and forth, raking at the brush with his rack. The right-hand bull mirrored the movement and for many minutes the two of them swept together like that, like reapers bent over a field of wheat.

The sun was directly overhead then, the fog burnt away, and all at once it was hot. Sweat was rolling down my forehead and into my eyes but I was afraid to wipe it off. I was afraid if I blinked, it would all disappear.

Left-hand elk started forward then stopped. A bluff. Right-hand elk advanced an equal distance. They were only a few feet apart then.

Seconds passed—an eternity.

Then, finally, the bulls came together—not with a lunge, but slowly, gingerly, almost tenderly. The meeting of their antlers brought not a crack but a soft sound, yes, like the clicking of castanets. Further off, a harem of cows (I hadn't even noticed them) began to skitter off in all directions.

Oblivious, the bulls wrestled on, their heads bent nearly to the ground. With dust rising from their hoofs, they began to circle, faster and faster, until they were whirling around their tethered antlers like planets around the sun. And the elk's twined racks did then seem a sun-like thing, separate from them—a fire floating up from between their heads. The elk slowed to a stop. Stasis. Canted forward, they leaned on one another like tired boxers.

I've read that bulls can sometimes become so entangled they die together of starvation. But not on that day. The elk shook themselves loose with a motion that was brutal and wild and bracing.

Left-hand elk took a few steps back and lowered his head. Right-hand elk gave a victory bugle, and the vanquished turned and fled. It was over.

The winner peered about a moment as if confused, as if he were waking from a dream. He began to search for his harem. As he bolted off to round up the runaways, it struck me that his was a desperate, sad task, sad that is to say, to be so enslaved to your own nature.

I waited until he was gone before coming down from my perch. As I continued along the trail, I extended the legs of my tripod, just in case. It's easy to be valiant when you're sure nothing will happen.

∾

I arrived at the site of lower Pierce Point ranch at mid-afternoon. A half-circle of ragged cypress showed me where the buildings once stood. Such loyal trees—still sheltering the empty space from the wind! And what fantastic forms: tortured trunks and wide flat crowns like the acacia trees of an African savanna; bare husks twisting skyward to end in jagged tears; spindly limbs reaching up like pleading arms. I swear those trees are braided through with all the ruin they've seen.

Abram Pierce died in 1893, bequeathing his estate to his only son William. William preferred to run the family business from Petaluma, where he lived—some say scandalously—with his stepmother, Abram's second wife Mary.

In any case, the younger Pierce didn't live long past his father, committing suicide in 1895. He willed the ranch to Mary.

∾

A line of elk streamed across my path, as silent and fluid as a school of fish, then disappeared behind the trees. They seemed more ghosts than elk.

Did that just really happen?

I carried on. The twin wheel ruts of the old ranch road soon disappeared, replaced by a single footpath. Strange,

how the change made me feel more alone. Before long I came to an unmarked spur that led out toward the ocean, and I followed it there, as I had so many times before. The branch ends right at the cliff's edge, high above a huge, guano-streaked sea stack called Bird Rock. The last time I'd been there was in a winter storm, and the wind was so strong I'd had to kneel in the mud for fear of flying away. When I'd crawled up to the edge and looked over, the power of it almost made me sick. Two hundred feet up, I could feel the sea spray on my face.

But how different it was that later day! A few feathery clouds hung high and still over a sea so calm it seemed impossible, chimerical, so lacking in qualities it was almost like air, and indeed, Bird Rock looked then suspended—afloat—a halcyon nest on a halcyon day.

Once more I dared myself to the precipice, putting the tips of my toes at the very edge, as precisely as if at a starting line. A trio of pelicans glided by beneath me. I watched their shadows cross the rocks. And there I was again, in that very same spot, higher than the birds, cradling the thought that with only the slightest effort, everything could be resolved at once. It would take but a shrug. How rare it is we wield such world smashing power—a choice of the most perfect simplicity.

Out here, right now, it is either this—or that.

I read somewhere once that murre eggs are shaped like pears. That way, instead of rolling off the ledges, they just go round in circles.

This.

∾

I retreated to the main trail and turned toward the point. Soon the footpath disappeared entirely, and I plodded along through loose, sandy soil, threading my way among the bushes. If it were spring, I'd have been wading chest high through yellow lupine. But it isn't spring anymore, not even

summer, and everything is growing indistinct—all muted browns on muted browns. I could hear a buoy bell tolling. I was getting close. And then at last I summited the final hill and there below me was land's end, the prow of the ship, Tomales Bluff.

The point was alive with birds, each contingent gathered in their own way: bickering gulls and imperturbable pelicans and offshore on the sea stacks, somber black cormorants crowded together like pilgrims. And indeed, even without people, there was an unmistakable air of destination there— an air of pageantry.

I addressed the throng from above—*Hell, if it's a coronation, I might as well be king*—but the birds paid me no notice, going about their business as I went about mine. Laughing a little, I scrambled down a sandstone furrow toward the water, headlong into my wayward congregation. Right down near the point I found an elk skull. I'd nearly tripped over it. The skull was ringed with white coyote brush roots like a halo. Where once was an ear, there was a round brass tag, about the size of a half dollar. In a script that was strangely, unnecessarily elegant, it read, *"3215."* I set up my camera to make a picture. It seemed the least I could do. And besides, it was a delightful find. I lost my revulsion toward death a long time ago. To me, bone is as beautiful as lupine. I studied the skull, searching for the best perspective, bringing round my full attention to bear on it, and after a while, like always, everything extra began to fall away. After a while, it was just me and the elk and the buoy bell, ringing on and on and on…

Last rites performed, I returned to my perch to watch the waves. I sat there for a long time, just waiting and looking. I'm patient that way. I'm not easily bored. How can one be bored when everything is bottomless?

Look there—those seas stacks are testaments to rapid cutback. The ocean is turning rocks to sand. Over time, Point Reyes may just disappear. Or else, should the forces at work take a different tack (for in truth such forces are far too complex to predict the fruits of their labor), the peninsula

may instead become an island—an island far to the north. Imagine polar bears instead of elk! Of course, such flights can't help but be weighted down with a little melancholy. We want our loves to be eternal. But don't fret. By the time anything happens we'll have all been dead for centuries.

I sat there on the bluff for the rest of the day, watching my bird friends come and go, until my shadow on the sea foam stretched a hundred feet long. I waved down to myself, once again a figurehead, the soul of a ship that has no need of one. I read once that the ancients sacrificed people for that, that they'd kill a maiden and impale her head on the prow. And to think, these days we settle for a broken bottle of champagne.

I rose up, tipped my cap to the setting sun, and then strolled back under a hallowed autumn sky colored with purples and reds. Twilight woke the stars and turned the brown grass gold. And then—*look!*—a half moon so clear I could see its seas: Serenity, Tranquility, Vapors, and Crises. Somewhere out there, the elk were still dueling. I could hear their bugle trills, could see their racks against the sky. Or was that a bush? It was hard to tell. No matter. Walking along the granite crest of this wayward peninsula, my mind had finally stilled. And I could feel it in my heart—we are not just in the world but *of* the world—same as the birds, the grass, the moon, the sea, and everything.

My friends! I can feel it in my bones—it's all of one piece!

I felt safe then. Relieved. Thankful. And at long last, like myself again.

∽

I leaned against my car in the parking lot, marveling at the Cypress trees, at their crooked silhouettes sweeping across the stars—effortless and artless and perfect. From far away in the dark I heard a lone elk cry and the sound seemed so familiar, as if I'd known it for all my life. It made me reminiscent somehow, of just what I wasn't sure. But I felt I

was supposed to remember something—and in that moment, with that very thought, the wedge was driven, and the joy from the ridge began to slip. I scrambled around to retrieve it, but it already seemed so long before.

What am I supposed to think? What am I supposed to remember? That's it's all of one piece? Yes, but it feels differently now—fallen from something known to something thought. The spirit's all drained out. How am I supposed to think it? What am I supposed to remember? Why must life forever be this finding and losing, losing and finding? I don't understand what it is I'm supposed to do.

What am I supposed to do?

9

The Unknown Coast

I REMEMBER TALKING ABOUT POINT REYES with a woman once, at a gallery opening for some of my pictures. We stood in the corner and spoke close in hushed tones, as if we were sharing a secret. And I suppose we were. "What *is* it about that place," I asked her, hoping for a thought that would grasp its essence. She considered a moment, then smiled and said; *"It's medieval."* It was an odd thing to say and yet, I knew just what she meant. And I knew that it was true.

It was another gray day in December, with the stinking mist and the chill that cuts right through. A few miles inland was a world away. *I'll bet the sun is even out,* I mused as I hiked down the twisting ravine toward McClure's Beach, the taste of coffee still in my mouth, my mind still clamoring with that other life's ten thousand things. *Well, let them have it. A solemn land deserves grave weather. Besides, I make my own light. And who would wish this place was different?*

McClure's is a cove unlike any other on Point Reyes, a

revelation made all the more startling by the fact that one does not so much draw nearer as enter into it, all at once, as if entering into a room. Blindered by the ravine's high sides on the way down, one arrives at the trail's end, rounds a sandstone bluff and there it is—the whole thing—the whole scene revealed like a curtain had been parted. I've been there a million times and still it shocks like something new. Here one finds not the soft, white chalk cliffs of Drake's, or the straight empty plane of the Great Beach, but instead a massive gray range of tortured granite, all right angles and listing spires. Brutal and forbidding, McClure's looks like a ruined city, like a row of shattered cathedrals. It looks in fact, medieval.

Reaching the shore, I made for the southern tip of the crescent-shaped cove, down to where the cliffs turn to the ocean and then curl back to parallel the beach as a thirty-foot high seawall. Once, in the worst of a winter storm, I set up my camera there, on the landward side of the wall, daring myself to hold fast as the waves rumbled in like trains, like battalions. *Don't fire till you see the whites of their eyes…*and then, after a concussion that sucked the air from my lungs, a wave would

crest the top of that granite horizon, rearing into the sky like some colossal, winged demon—pausing mid-air as if to size me up—before finally collapsing under its own weight, half in front and half behind the bulwark.

My camera got half-wrecked from the sea spray, but it was worth it for the memory.

At the highest of tides, the waves can inundate all of McClure's, riding clear across the sand to the base of the cliffs. If anyone were down there then they'd be swept off the beach like chess pieces after the end game.

But this was a different sort of day.

It was the low low tide and the ocean had retreated to a distant whisper, pulled back to reveal a field of black rocks bristling with mussels and sea wrack. Some of the stones were branched through with spidery white lines—gneiss, or schist, or quartz perhaps. I couldn't pretend to know, but the veins made them seem almost alive. And in their way I suppose they are. After all, were those rocks not formed, and then transformed by their experience? Have they not roamed? Have they not, like each of us, been subjected to forces beyond their control, to trials of friction and fire and happenstance? Have those stones not been made by the world around them?

Fantastic.

But I hadn't the time to linger. It wasn't by chance that I was there on that day, at that hour. I'd planned the trip for months. For McClure's has a treasure, if you know when to reach for it.

Though from a distance the promontory at the end of the beach appears impassable, upon closer inspection one finds there is a crack between the cliffs and the seawall. The first time I discovered it I couldn't have been more excited if I were an archaeologist who'd found a forgotten tomb. I can so vividly remember entering into the cut that day, how dim and cool and damp it was. There was a driftwood log wedged into the slot, and I climbed atop it, walking along its length with my arms outstretched, trailing my fingers along the rock. It reminded me of Zion.

And then…a bend…white light…a beach! I stumbled out onto the sand, lurching about like a blind man given sight, stunned that the world could so unexpectedly open up from the inside. The discovery was simply so startling, so unbidden, and the beach so different than McClure's that it seemed less a continuation than a whole new place. It was like I'd passed through a portal into another day entirely. And the contrast! Where McClure's had been shadowed and brooding, there it was brilliant, everything ablaze under a hard white light like the desert. I could barely open my eyes.

Giddy, I raced back and forth between the two worlds to experience again the transition. I could scarcely believe the difference, in the attributes of each place yes, but even more how I felt in one and then the other, first somber, then exultant, then somber again. Could my moods really be so malleable?

I mean to say—how much of this was written by the weather?

No matter. That day, I was sure I'd found a great secret.

Not long after, my father sent me a dog-eared box full of old negatives. I'd never even seen most of them. I headed straight away into the darkroom and began making memories from my childhood: an unknown tabby cat curled around a bottle of Italian table wine; "Uncle" Ron with his cowboy boots and a handlebar mustache; the burned up apartment from where the Navy jet went down; my friend Kevin who grew up and went to jail; my father in a hard hat surrounded by cylinders; my mother on the porch without her ring; and then, on a roll marked plainly "1973," I found that very same passage, those same cliffs—McClure's Beach. It was unmistakable. I never knew my father had roamed there. When he made those pictures he was thirty and I was three. I wonder what he was thinking about that day. I have a three-year-old son myself. And McClure's carries on through generations, through epochs, wholly indifferent to you, or me, or anything, save, I suppose, its own nature, its own slow, slow unfolding.

And that's all right by me.

I came here on the morning after September 11th. I wasn't the only one. There were people all over McClure's that day, sitting quietly by themselves, as still as statues, seeking sanctuary from the ephemerality of those 110 story towers amid 110 million year old rocks. No one said a word—what could be said? There were no eulogies or debates, no tirades, no feelings so base as patriotism. Not then. But I'll never forget the looks we shared. There was a palpable empathy there, a tenderheartedness that was wholly transcendent of our individual life experience or even of the circumstance itself. It was as if each person had become perfectly transparent, and each could see in the other the same taproot, the very same suffering. We were not strangers after all.

I've only felt such a thing once before, in that damned operating room, with those doctors ringed around us like magi, or mourning elephants—noble like that, their eyes shining in the dark, their hearts ablaze with sorrow. I didn't even know them and yet, I *loved* them. I loved them like I was on fire. I loved them like I loved our own dead son.

I passed through the notch and found the second beach gray and still, muted under a leaden sky. The sand was thoroughly blank, all traces of yesterday having been expunged by last night's tide. It made me almost sentimental to see it that way, as if I were standing in an empty house one last time. I thought of the day I brought my mother there. It was sunny then. My grandmother had just died and we took a stick and wrote her name across the beach in letters five feet high. *Ruth Ashworth Southwick*. It was there. It was right *there*. I made a picture of it.

The stretch of coast around McClure's, as pictured from above, is shaped roughly like a W. The right half of the W is McClure's proper, the left half is the second beach, and the middle peak is the massive rock (of which the seawall is a part) that splits the two. From the second beach side, one can scale the center mass to its top. The ascent, however, is not without danger, a fact made clear by a small plaque one passes on the way up:

CAUTION
DANGEROUS AREA
6 KNOWN DEATHS

The reward for ignoring this warning is a grand view of the whole coast, as well as a chance to peer down over the far wall, and watch the waves roll in mountain high beneath you. I imagine it's like being on the rim of an active volcano. For in either case, if some outsized monster should come, there won't be a thing you can do about it but try and dig your fingers into the rock, and wait for your end. The pools of water up there tell you all you need to know. You're playing the odds—if you stay long enough, you'll certainly be killed. But a few minutes is probably alright. The key is to stay until you're sure your luck's run out, until you're sure that the next wave will be the big one. Then, just to prove your courage (to your friends, to yourself, to your god), maybe you stay for one more. And then you flee madly back down the rock, laughing and shouting and trembling, feeling thankful and alive—*really* alive—for the rest of the day.

There would be none of that on this morning though. I was on a mission. In an hour the tide would be at its lowest in months, and the two and a half mile stretch from McClure's south to Kehoe Beach would be unlocked. Point Reyes rewards the patient. As McClure's Beach opens to reveal Second Beach, so too, on occasion, does Second Beach open to reveal a land beyond—the Unknown Coast. The peninsula is like a Russian nested doll: worlds within worlds within worlds. I'd waited a long time to go further.

I advanced to the end of the cove, to a rock protrusion which jutted out into the ocean and blocked my view of the

far side. Even then, near low tide, the water was three feet high around its base. I checked the watch I never wear and found I was a little early. Withdrawing higher up the beach, I sat on a stone and bided my time, reminding myself that once I made my break, no matter what marvels lay around that corner, I couldn't dawdle. I couldn't ever forget the time. If I didn't cover the two and a half miles to Kehoe Beach before the tide came back, I'd be trapped, or worse. As if to punctuate the thought, a fist-sized crab skittered out from beneath a nearby rock to look at me (I'm quite sure of it) then retreated back, darting in and out at me like a dog from his doghouse.

Keeping a wary eye on my crustacean friend, I took off my hiking boots, tied the laces together, and draped them around my neck. Then I put on an old pair of tennis shoes (well worth the sacrifice) and rolled my pants to the knee.

"Catch you on the flip side, sucka!"

I charged around the corner and immediately a huge boulder forced me inland, into a sort of narrow-walled alley honeycombed with tide pools—of what depth I'd no idea. With a wave rushing in behind me, I leapt up onto the left-side wall, hoping my momentum would keep me up. But the bank was too steep and the rock was too slick and I began to slide down, clawing at the wall on my way, like some beast caught in a tar pit. I hit the bottom with water to my waist. *Shocking* cold. The wave rushed around me—like wind around a sapling—and in a strange way I was relieved. At least I wouldn't have to worry about getting wet. More though, I knew that the immersion would ensure my full engagement with the day. For thus baptized, I was no longer an observer, but a participant. Sometimes it takes a shock to rouse the soul.

As I hauled myself out of the pool, my boots swung wildly around my neck, kicking at my head. A tripod foot jabbed me in the ear.

I'd never make the two and a half miles like this. I considered turning back. But then, as if to shore me up,

memories of boot camp came (no doubt precipitated as much by my being cold and wet as my needing them): memories of marching through the snow into sweltering barracks; of my glasses fogging up like the windows; of gray, steel-frame beds and blue linoleum; of the smell of shoe polish and leather, wet wool and sweat; and of the sound of my instructor's stentorian rasp. *Where are you now Senior Chief?* I intoned the old mantras to the rocks: *No pain, no gain. Nobody rides for free. There's no such thing as I can't. You either can—or—you won't.*

I went on. The tide pools soon gave way to more solid ground and I threaded my way along a rugged shore.

About seventy yards on I came to another promontory, in the center of which was the mouth of a huge cave. The entrance must have been thirty feet high, spanned with peaked arches of banded granite like some ornate gothic portal. And to my eyes, just as holy. I went in. Water dripped down onto my head and onto a floor of little stones as smooth and round as marbles.

I'm here. I'm here. This is really happening.

The cave was actually a tunnel that ran diagonally through the promontory, with another, smaller opening located near the headwall of cliffs. There was an alcove off the main chamber, from which two secondary tunnels wound their way toward the sea. I remember they were shaped like butterfly wings. And that the light came through them like from a distant train, wavering like that, rising and falling as the ocean rushed in to fill them up, and then fell back. The tunnel walls were alive with anemones, side-lit such that it looked as if they themselves held light—little green glass lamps in a long dark hall. When I set up my camera to make a picture, I became so transfixed that I forgot to trip the shutter. Sometimes I get stuck like that, like a deep-sea-diver drunk off the rapture of the deep, throwing away his mask. Or offering his air to a fish. Or just deciding to stay down a little longer, just a little bit longer, until it's too late. But maybe those divers don't mind much then.

And I understand that perfectly. But not yet. Not yet for me.

I reluctantly packed up my gear and continued to the cave's eastern outlet. Though it was obvious that the ground sloped upward to the far side exit, the view from there still startled—I was twenty feet above the beach. I rested my elbows on the opening and leaned way out, as if I were leaning out on the sill of a second story window.

I'd been told I'd find a rope there, attached to a metal stake, but I could find no sign of it. It was probably removed by the park service—they're always looking out for our safety. Of course, by taking away the rope, they ensured only that I'd have to descend the cliff unaided. But no matter, I'm agile as a mountain goat by now. I've got big arms and skinny legs. I'm well adapted.

I turned in and carefully backed out the window, descending laterally, crab-like, along a seam in the wall. When I neared the bottom I leapt down, and found myself on a long, rocky beach, the end of which I couldn't see through the fog. It was completely deserted. I'd have been shocked if it weren't. This part of Point Reyes is so seldom traveled I might as well have been roaming the ends of the earth, Kamchatka or Tierra del Fuego.

Just offshore was the sea stack known as Elephant Rock, and from there, for the very first time, I could finally see where it got its name. In fact, the rock looked so much like an elephant I laughed out loud. I waved at my new friend and set off down the beach, happily strutting along in my soggy old sneakers.

I hadn't gone more than a few yards when the sea roaches showed up. There must have been hundreds of them, scurrying out from beneath my feet as I walked. They looked like giant pill bugs. It seemed the whole beach was covered with them, and I couldn't help but become inordinately aware of my bare legs, my low top shoes, and my sock-less feet. What if I was hurt somehow, and had to lie down…I shuddered to think.

But then (as unexpectedly as this) I came upon a pile of clothes. *A pile of clothes.* I cautiously circled the discovery as if it were evidence of a crime. And I actually thought it might have been. For the existence of the clothes simply didn't jibe at all with any innocuous explanations I could conjure. I mean, it's not as if anyone would want to go nude there, not on *that* beach. It was obvious that the items had been consciously placed: a red sweatshirt neatly folded atop blue jeans, next to a pair of boots with the socks inside, and a black canvas duffle bag. *Lord knows what's in there…*I peered about befuddled, wondering what to do. *Should I open the bag? Should I go back? Where's a damn ranger when you need one?*

And then, as I stood there, dumbly staring into the ocean, a rubbery black head bobbed up from the surf—a sea lion—no, a man. Or something like that, some *thing* rising stiffly from the water with its arms outstretched, some cthulian, sci-fi, fish-man—the creature from the black lagoon.

I've come to expect that anything can happen on Point Reyes, but this, this took the cake. The man flopped towards me in oversized flippers. It was comical really—absurd. I stood there and waited—what else could I do? And then he was before me, his ruddy face bulging out from a tight black hood. He truly was as red as a crab, with an enormous mustache and a vaguely maniacal grin, and a snorkel that cocked up beside his head like an oversized cigarette holder. He looked like a representative from the British East India Company. All that was missing was a monocle, a pith helmet, and an elephant gun. It was that sort of look.

My face must have betrayed me, for the stranger thrust out a mesh bag, as if it were a peace offering.

"Abalone!" he shouted cheerfully.

"Oh…" I said, the sense of it slowly dawning. "I'm um, exploring—a photographer."

"Ah, well, you picked quite a spot."

"Yeah…I did."

The Gill Man and I turned toward the sea then, and had

a conversation. I wish I could say that something profound was exchanged, but out there, on that day, nothing seemed needed. I do remember having the strange sensation while we talked that our two identities—fisherman and photographer—were but like loose fitting suits, wholly interchangeable under different circumstances. It could have just as easily been me wearing the wetsuit, and he with the sheet film.

We wished each other luck with our endeavors before parting ways.

Looking back, I do wish I'd made his picture. But I didn't. I'm not sure just why. Perhaps I feared he'd think such enthusiasm evidence I wasn't really present, and that my amicable sincerity was but a net I used to catch him. Or maybe it's just that sometimes I find photographing people a little too much, like looking into the sun.

I glanced at my watch to check my progress. Though I guessed I had but a little over a mile to go, not knowing what lay ahead made it difficult to judge just how hurried I should be. And so I opted for caution, for once, and adopted a purposeful stride. I let the sights skirt my senses as if it were not I but they that were parts of a passing procession.

But what do I remember? My sea roach friends of course. And a hundred foot high waterfall—just a wisp of a fall really; most of the water turned to mist and floated off before it even hit the ground.

And I remember a pair of boulders as white as eggs, so bright that even in the fog I could hardly look at them. That was worth a stop. I found though, that when I tried to take their picture, I couldn't focus. Focusing requires lines, texture, and contrast, but the stones were so nearly featureless it was like trying to focus on a blank piece of paper—impossible. Inspired, I fished out my driver's license and placed it square atop one of the rocks. I focused on the text. The method worked, but it was strange to read my

attributes like that, detached from them under the dark cloth. It made me almost forget what I was doing.

Just who is that, anyway?

I glanced at my watch to check my progress. Though I

The beach ended at another promontory. At first it looked impassable, but as I got nearer I found a slit in the mass of rock and followed it back toward the headwall, into a sort of natural chamber, with the cliffs on one side and a line of enormous sea-stacks on the other. The stacks were so evenly spaced they looked purposefully arranged, like the columns of a ruined temple. And indeed, with the bedrock revealed for a floor, I felt as if I were in some half-sunken catacomb, or else Atlantis; it was clear that all of this was normally underwater. Long tendrils of green and purple kelp draped down from the top of the stacks, and every surface was covered with life: purple starfish laced with fine white lines like a seine-net, like a celestial map, stacked one atop the other in grotesque, orgiastic heaps, and tiny, webbed bat stars a hallucinogenic red, the color of blood beneath florescent lights, and high, high above, giant twenty-rayed stars, glowing against the granite like sunflowers under a stormy sky, or like lamps in a Spanish mosque—Mezquita de Cordoba. And more: black turban snails and sea palms and a chiton with a string of white diamonds down its back. I hear you'd need a knife to pry him off.

Wondrous.

The place was so full of life it might as well have been one thing. In spots, I was forced to wade through tide pools, and there, even the ground beneath my feet was soft with little creatures. I was Jonah in the fish. Water was slowly flowing in and out of the temple, rising and falling through the base of the columns. It was a tranquil, almost lulling movement, and yet of course unsettling, for I knew that such a swelling could consume me in an instant. I was a trespasser there, and so I didn't linger.

Near the end of the passage, an especially deep tide pool forced me toward the cliff wall, to a chest-high rock ledge I'd have to traverse to continue. The ledge was covered solid with giant sea anemones. I remember their tentacles were the most extraordinary green, an opalescent, milky green that reminded me of antique drawer pulls, or absinthe mixed with sugar. A full participant indeed, I closed my eyes and dug my hands in—and another memory came, as forcefully as if it'd grabbed me by the shirt.

I'm in Yokosuka, Japan, upstairs in our little bar. The place is so small it only holds our group of four. We sit on the floor by the fire on woven tatami mats. We sit and drink absinthe—how did *we* come to know the green fairy? I can't recall. But I remember we liked the fire ritual best—a flaming sugar cube on a slotted silver spoon.

Then later, much later, we stumble down a flight of narrow wooden stairs, through a frosted glass door, into the freezing night. Snow! We shuffle back to base, back to our cold gray ship, through empty, snow-muffled streets, passing pachinko parlors lit up like aquariums.

Yes, and then—there I am—a decade later, a second later, standing at the edge of another continent, just knee-deep in Turkish towels, shaking hands with sea anemones.

The wonder of life, with its relentless and bewildering transience, is that we can carry on at all.

I passed onto a broad and sandy beach. A green marsh had replaced the headwall of cliffs. There was a tangled line of white driftwood strung along the backshore, and I slowed to admire the forms, perfectly alone but not lonely, disheartened only a little by the knowledge that ahead lay my last obstacle, and the end of the Unknown Coast.

The final promontory was different again than the last, shrouded so completely with mussels it was nearly solid black. Set high up in this void was a tiny white gash, a window to the sky—my way out. I climbed toward the keyhole over heart-shaped goose barnacles and mussels so sharp I could feel them through the soles of my shoes. When I came to the opening I discovered it was perfectly human scaled, so small in fact, I had to take off my backpack and push it through ahead of me, letting it drop down onto the far side.

I took a long look back, gave silent thanks, and squeezed through—

—borne onto the sands of Kehoe Beach.

Kehoe is a pretty beach, a place where people go, and sure enough, before I'd even had the time to decompress, I was approached by two women and a dog, all of them clearly puzzled by the manner in which I'd materialized from what they'd thought was a dead end.

"What's that way?" one of them asked, pointing.

"Amazing things," I answered, my smile telling more, "but you wouldn't make it—the tide's coming in."

The women and I talked there for a while. I told them I was a photographer, and gave them my card. In return they made my picture, and sent it to me a few days later on my computer. Yes, there I was, on Kehoe Beach, wet and smiling with my white legs, looking more awkward than I'd felt. I was thankful to have the image though. It let me know that the day really happened. It did happen—didn't it? And does it not, in some way, continue to happen, informing all of my subsequent actions? I mean to say, is that day on the Unknown Coast not inside me, even now, as I sit here in my dining room, at my grandmother's old table, thinking and drinking and writing?

I used to play under this table when I was a boy. I'd float a sheet over the top to make a fort, then sit down below, and drive my cars along the grooves of its curved legs. But I remember the occasions most: birthday parties, with the table crowned with balloons and spiraling streamers, covered

with paper plates and bright napkins and turned down dixie cups with surprises inside; Thanksgivings with the table stretched out long with its leaves like arms to embrace us, bejeweled with silver and crystal, a spread fit, in the eyes of a boy, for royalty. And in my mind, I guess we were. That was all a long time ago. But not so far away. For isn't that all here now? Haven't all those conversations and carols, those laughs and shouts, all those myriad vibrations somehow tempered this wood, imbued it with spirit, if only in my mind? But what is the world, my world, if not my mind?

There's the bouquet from when the twins were born (mysterious indeed, that life taketh, then giveth back, and then giveth back again two-fold). It makes me think of the sea stack temple on the unknown coast: red daisies and salal tips and bear grass—sea stars and mussels and kelp. The flowers are starting to wilt a little now, the water's getting milky, louched with bacterial blooms, full of floating detritus like interstellar dust. There's a world in there. And in here too, in this little bare room. There's a Japanese maple outside my window; it filters the sun in these summer months like a forest of kelp. And a teardrop shaped prism, hung from a nail on fishing line. My grandfather probably tied that knot. He spent some time in the Merchant Marines. The prism is one of the few things I took from my grandmother's apartment when she died. In the afternoon this room's full of rainbows. My friends, it's worlds within worlds within worlds, up and down to infinity, and in every last one, in each and every thing—the whole.

My little boy Myers says that Mr. Ree made all the flowers.

I raise my glass and toast the dead, bring the absinthe to my lips, and swallow down bitter green sea anemones.

CODA

Chimney Rock

New Year's Day, 2005

I STAGGER ABOUT IN THE WIND, exaggerating a little for a trio of pelicans just now materialized from somewhere below the cliff's edge. Suspended on some invisible current, they hang in the air right before me, perfectly still, seeming to transcend the bonds of gravity. And judging from their grins they know it. *Look at what we can do!*

Well I'm game. I unzip my parka, unfold my makeshift wings and lean—and the wind once again holds me up.

As if satisfied they've taught me something, all at once my bird friends bank left and fall away, sliding from view like a corner of the sky had been lifted.

And then, for a moment, the wind stops, and in the calm, I remember why I came.

Today's the day.

If only these clouds would part. Actually, it seems they have, everywhere but here—to the north, above Drake's Beach, all the green fields are alight, and out on the ocean too, the sun is shining. It's almost as if the stragglers from last night's storm were drawn together around Chimney Rock to plead for a stay—*Not yet, not yet! We still have rain to drop!*

Well I'm sorry my friends, but the time has come for you to go. Can you not feel the change? The air of anticipation? This shadow cannot last. Something must give.

Shouldering my pack, I trek back up to my perch above the hump, back to the very same spot where my friend Stephen and I sat all those years ago. Holy ground.

Why? Because I've made it so.

With a flourish, I spread my tripod above the path and plant it deep—hard-rock sugar maple re-rooted in the soil.

Now let me bear fruit!

I've been coming here for so long, roaming here for so long, through the forests and the fields, over the hills and along the bluffs, down beaches and bays and valleys, all the while reaping for lights and keepsakes.

I've photographed the grass and the lilies, the lupine and the firs. I've photographed moss and ferns, stone-crop and limpets, urchins and sea stars. And birds, so many birds! I've photographed rabbits, and cows, sea lions and elk. I've photographed rocks, and shells, sea foam and sand. I've photographed mud, and rot, and guano—why not?

Things are only lesser if we make them so.

I've photographed barns and roads, beacons and bridges, hay bales and barbwire and rope. I've photographed cobwebs and dewdrops, rainbows and sunsets, moons and stars, sunbeams and waterfalls. I've photographed shadows.

And then I've brought it all back, back to my little hovel in the yard, back to my little dark room, where I work, sifting and sorting and shaping—transmuting the treasures I've found, trying to do them justice, trying to do justice to the memory of our meeting, and to the wellspring that lies beneath us both. Fueled on coffee and bread and beer, I seal myself in, and like some half-crazed alchemist, I mix my magic potions, esoteric formulas out of musty, spiral-ringed books: metol, bromide, glycine, selenium...What strange recipes for a heartfelt testimonial! Then, with the chemical trays at the ready, I sit at the enlarger and shine a light through my negative, projecting an incorporeal double onto a sensitized piece of paper—so much like that subject was projected onto me! Taking the paper, pregnant now with latent form, I slip it gently—as gently as if it were thousand year old parchment—into the baths that I have made. And then I rock them, carefully lifting one corner of the tray and then another, inducing tiny currents in miniature seas. Finally, I pull them out, give them a quick rinse in the laundry tub, then turn on the lights, to see just what has come.

What a wonder, that a neophyte like me can make things bloom!

What a wonder, that I could make a thing to bridge the gap, meet a stranger in the middle, and connect, truly connect.

I will not be forever stranded on this island.

Do you see?

I've built a little boat.

It's made of paper of course, of pictures and words, but more...it's made of that which made those things—that is to say, of everything. It's made of trees and rain and sun, of salt and shale, wind and fog, of hidden coves and secret glades and a hundred diamond days. It's made of books, and maps, and signs, of leather and wool, muscle and sweat, and of my camera's aluminum and mahogany. And of course it's made of people too: of rangers and ranchers and scouts, of baseball players and oystermen, of teachers and tourists and friends. Yes, and of you too. For you will bring yourself to it—you will bring to it all of those things that make you. And in doing so, you will help make it.

So push on back! There's room for more. There's still room for more. My ark can hold the cosmos and still fit in the palm of your hands. And I welcome it all, every last bit—how can I not when it's all of one piece? No, I declare this vessel to be most thoroughly and unapologetically egalitarian. It's a ferry. It's a carnival float. It's one of those Filipino jeepneys I used to ride around on in the Navy—too much could never be enough. And my friends, the time has long since passed for restraint!

Come then, let us mount chrome horses on our hood, festoon the prow with fighting cocks and pin-up girls, with reflectors and flags and icons. Let us adorn our ship with altars and antennae, with mirrors and mottos and blessings, and Christmas lights. Ho! We'll work in the Pinoy high baroque style! Here is a wedding dress. Here is a kiss. Here is a bedtime story. Here are all the things of our life: a bicycle, a birthday cake, our childhood home, our mother's face, our father's hands, a failure, a heartbreak, the darkness and despair...Yes, those things are here too. They must be. And I think we should not shun them. For are they not also who we are? And would not disparaging them then be disparaging ourselves, and, by extension, be an affront to the very universe itself? No my friends, such sacrilege is not for us! No, we must look upon it all with a steady heart—and embrace it. We must ring it *all* aboard. And sing its praises.

So sound the horn! Gather the birdsongs and the buoy bells, the elk bugles and hoof beats, a cricket's chirp, a fire's crackle, the clatter of dishes, the rustling of leaves, the swash

of the surf, an engine's rumble, the turn of a key, a voice, a laugh, a sigh, a shout, and music, of course—we'll need music. Anything you want—there is no high or low. Ludwig van Beethoven or Woodie Guthrie—I tell you it's all the sound of heaven! I myself have a mind to bring aboard the Beatles, yeah, yeah, yeah, the whole damn sweep, and Bob Dylan, well, just because. Because it strikes me just now that I might not get another chance. So make way! Clear a space, clear a line for the old song and dance man.

Hey hey, Bob Dylan, I'm not ashamed to say; I'm gonna cry like a baby when you go away.

Do I overreach?

Without a doubt, but I'd much rather overreach than not to have reached at all. And besides, how can a book *not* be about everything? What we do, and how we do it, is a result of everything we are—and everything we are is a result of everything that we have done, and seen, and thought, and felt. Point Reyes is surely in me, but so is everything else—and it is the everything else that colors the way I know Point Reyes. Do you see? All those walls are in our head. Like John Muir said, everything is hitched to everything else. And the sea before us stretches unbroken all the way to the Bay of Bengal, up to the river Ganges, to the mighty Himalayas, and, the Hindus say, to heaven itself, and then back down to the holy city of Varanasi, to the stepped banks where the pilgrims go to cleanse their sins and cure their ills and burn their dead on the charnel grounds.

Aye, dim the lights.

For this is a funeral boat, a sepulcher of wrecked ships and ruins, of sea-wrack and spoil, of hollowed shells and haunted grounds, of dissolution and remembrances. Here is the Pierce Point Ranch. Here is the Grandi building. Here is Hamlet and old Petaluma. Here is the last Miwok village. This thing is full of ghosts: the ghosts of poets and pirates, of lighthouse keepers and conquistadors, of philosophers and kings. Here is Brion Gysin, and Bill Evans, John F. Kennedy and Francis Fletcher. Here is the good Captain Claussen, and Tsar Nicholas, Lyman Bryce and Lawrence of Arabia. Here is Fred Windsor and Ansel Adams, Lao Tzu and El Greco. Here is Sebastian Cermeño and Saint Francis, Son House and Walt Whitman, and my friends from the bench, Burbank Jung and Stephen Ernest Masters—we hope you have found peace. This is your Elegy. And an elegy for your ancestors, their ancestors, our ancestors—they are all here now. And so too, it must be said, are the ghosts of our own younger selves; those selves from whom we have descended—can you not feel the changing of the season, this new chill? My friends—our summers—they're waning. So let us acknowledge, without pity or regret, the loss of our green youth, and along with it, its unformed twin, that empty mold we left behind when our lives were carved—ah, those things we'll never do, those loves we'll never know, those paths untaken, those lives not lived... So much like the life of a beautiful baby boy, who died just before he was born. My son, I built this boat for you, to remember you by, and to hold you safe.

Come then, let us be solemn. Let us paint our ship in the colors of India, in gold and vermillion, saffron and indigo. Let us string the bridge with carnations and marigolds, and smear the hull with holy ash and incense. We'll walk down these stepped cliffs to the shore, and float out our boat like a little oil lamp. We'll let go with both hands.

And then what? What will become of it? My nights are filled with welling dread—*it is not worthy*. For is it not sullied with pride and pretension, weighted down with heavy hand-edness and flights of fancy, with derivatives and desperation, and just maybe, with outright delusion? Surely it's an odd thing, this handmade curio, in all as full of flaws as its maker. Surely it cannot be seaworthy. Well then, I say let it sink. Or else get trapped in some swirling eddy, in some forgotten backwater like me in my kayak. It will have served me right. And I'd only have myself to blame.

I'd like to think though, that I've done my best, under the circumstances. I'd like to think that I've done my best with the things I had at hand. And I have to believe there are a

few good parts, a few amusements, a scattering of sparks, a certain earnestness, some love. I have to believe. I have to try. It's the only raft I've got.

And it's time to put it out. That's why I've come here—out here to the edge of the continent—out here to this wild, lonesome shore—to finally put it out. What's the point of a ship that never leaves harbor? No, I will not be stuck in the mud like the old *Point Reyes*. And it's time.

I need but one last thing; a New Year's sun from Chimney Rock, a New Year's sun from where it all began. I'll hang it off the bow like a little lantern. I'll hang it from the hook of this blessed, blessed peninsula.

And pray that you will see it, and pull me in.

And I'll have it too, if only these clouds would part. *My dear little lambs! Would you move just a little, and share the sun with me? It is cold down here and I need some light. I ask only for a moment. Well then, I'll wait. This I can do.*

And so I set up my camera and I sit down beside it, cross-legged on the wet ground. I will be as vigilant as a watchman, as Buddha beneath his Bodhi tree. Ha! No doubt the Sage of the Shakyas could tend this wayward flock. But as I possess no such powers, save patience, I can only wait...

...and watch as the clouds slowly roll about, casting their columns of rain on the bay like fishing boats with their nets. One of the squalls is coming right toward me—sweeping right toward me. *But it'll peter out*...I think, trying my best to be detached. Only it doesn't. It just keeps coming, closer and closer. I can feel the air change, a mass of cold before the curtain, and then, a subtle smell—some molecular liberation. And then, it's upon me, the rain pounding the swell of Chimney Rock with a sound like a thousand skin drums, like Jajoukan thunder. I can see the grass bow down. Everything is alive.

Without thinking, I tear off my jacket and throw it over my camera, then dive down under, into the tiny shelter of my tripod, into a little green teepee. But I don't really fit—my back is out, so I grip the legs on either side, white-knuckled, like a flagellant readying to receive his blows, and they do come. Freezing rain lashes at my back, courses down my neck. It feels like electricity. And the sound! A roar, an unrelenting tear, so loud it feels like it's inside of me. I am dissolving into rain. And yet I am laughing, and laughing, I can't stop laughing... Until it all relents—and I'm laughing in silence, or something like it—I can still hear the sound of rain in the distance, receding like a train that's passed.

And the walls of my green room are glowing.

I leap out, into the sun, into light like burning magnesium, so pure and hard and white I can hardly stand it. Everything is crystalline.

I throw my parka to the ground and grab the shutter release. The sun is coming down between two clouds, right down the middle, right down to me like a ladder. *Yes.* I close my eyes and breathe in, freely, consciously, acknowledging the man that I am, and I give thanks—I know not to who or what, but just now it doesn't seem to matter. It simply feels good and right to thank.

Thank you.

I pull the dark slide, open my eyes, and trip the shutter...

"Zzzt..."

I've caught my tail!

I've caught my tail!

I've caught my tail and everything's come back, luminous and perfect, exactly as it is!

I am in focus with myself.

What joy! What bliss!

What have I been thinking?

My friends, we are not in a house looking outside. We are outside. We are in the world, of the world, are the world, just

are, same as the clouds, the sun, a tree, an elk. There is no window to look through.

*As an eye cannot see itself, we cannot know the truth because we **are** the truth.*

No, there is nothing to know.

There is nothing to know.

There is nothing to become.

There is nowhere to go. Do you see? We've already arrived! We are, always and everywhere, at home. And it is paradise.

It's all so simple!

The key is right there in your pocket. It is already within you.

How do I know? Because I look inside myself and see.

And so can you.

To remember your true nature is your birthright.

It's all so simple.

Just remember where you come from.

And do what is right.

And you know what is right.

Like the sun shining above the clouds, there is a light that never goes out. And that light is in your heart. It's been there all along.

Now come close love, put your forehead to mine. I'll whisper to you.

Listen.

Do not be afraid.

In all the whole world there is nothing to fear.

In all the whole world there is nothing but this:

this.

And not even that.

No, not even that.

But it's alright love.

It's all right.

Love.

Now let us set sail.

Photographs

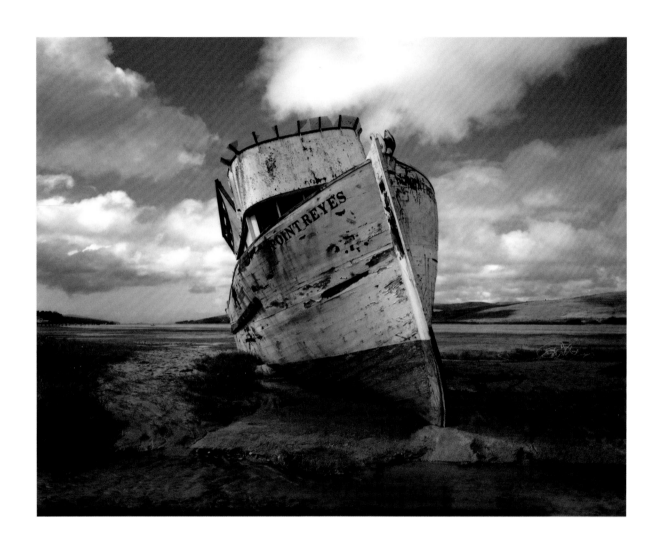

THE POINT REYES, TOMALES BAY

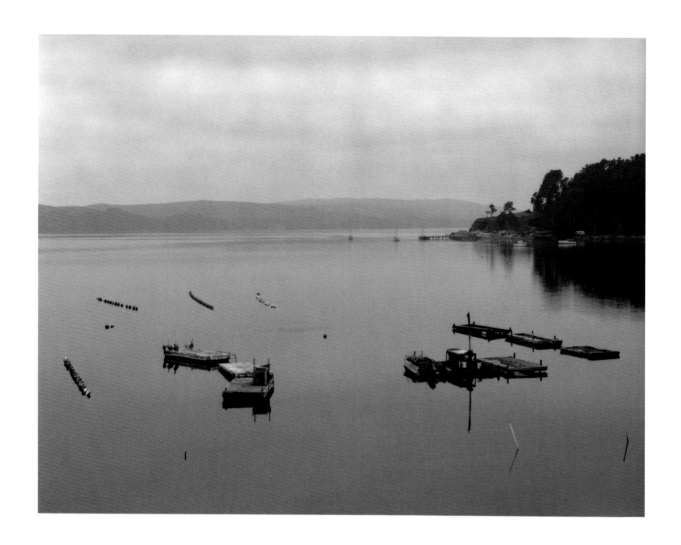

TOMALES BAY

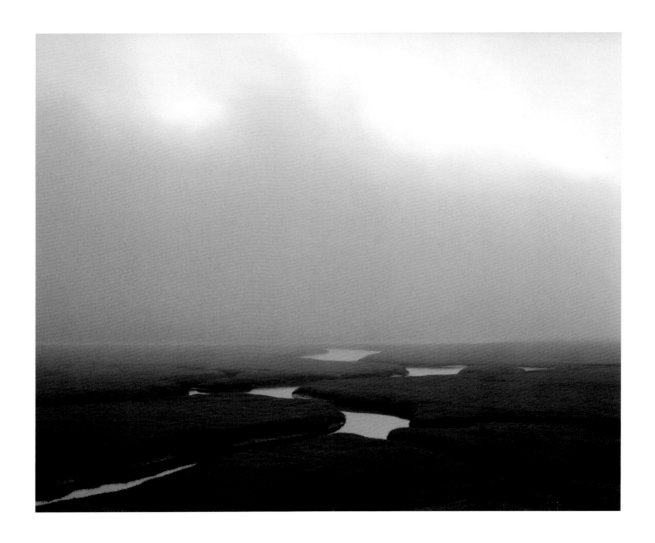

UPPER SCHOONER BAY

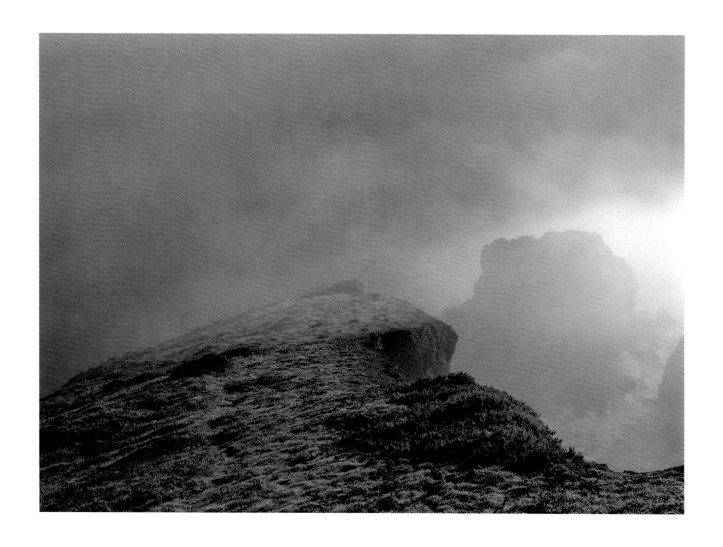

FOG, CHIMNEY ROCK

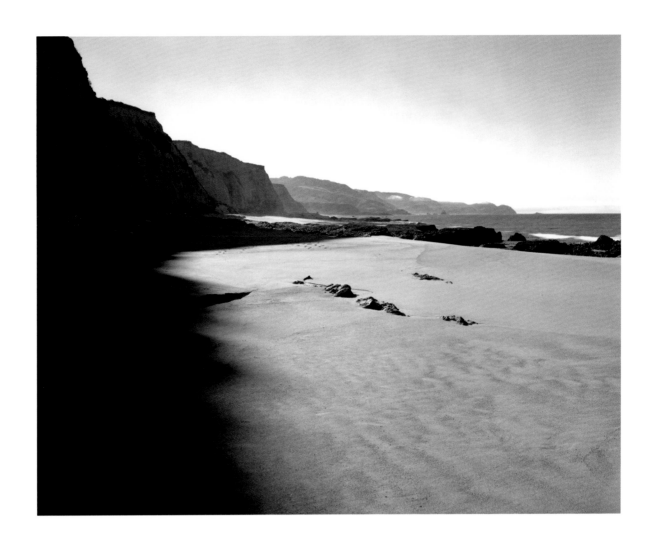

EARLY MORNING, SCULPTURED BEACH

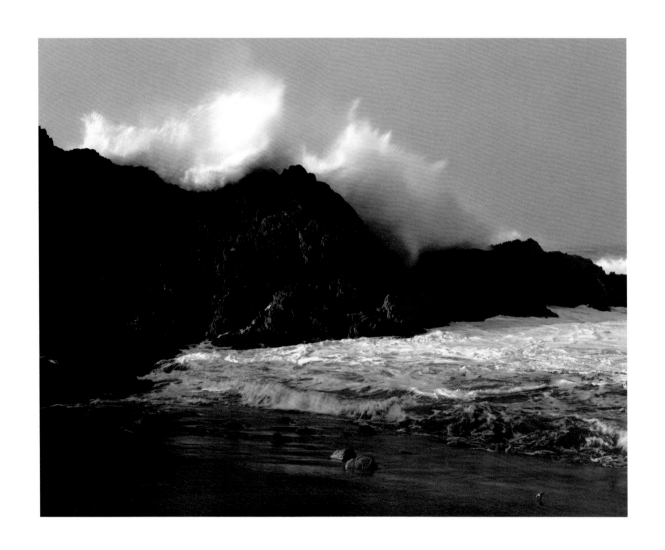

LARGE WAVE, LITTLE BIRD, MCCLURE'S BEACH

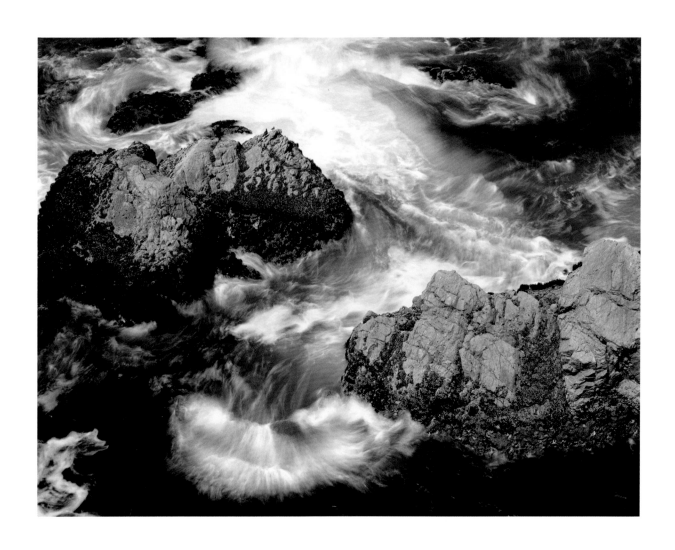

ROCKS AND SURF, MCCLURE'S BEACH

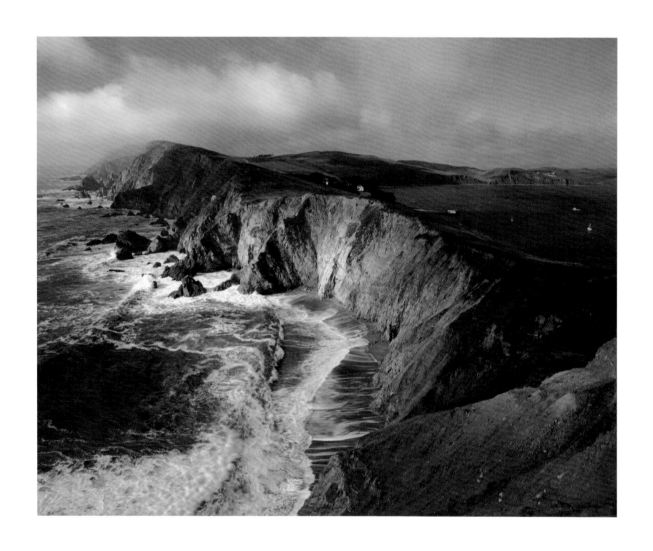

CLEARING STORM, DRAKE'S BAY

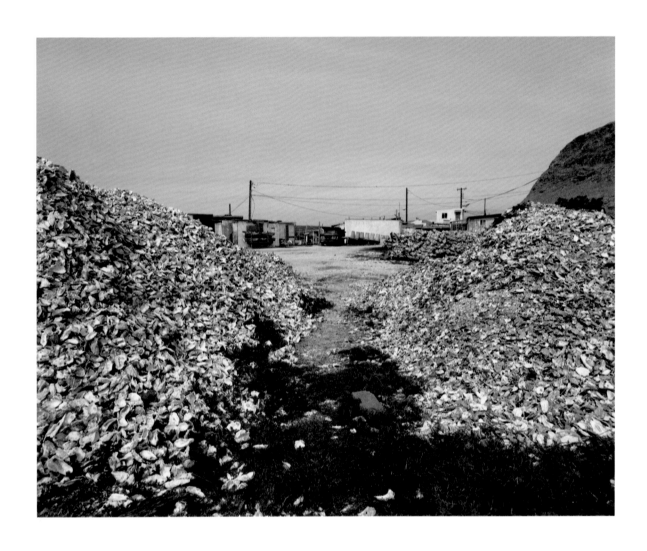

JOHNSON'S OYSTER FARM, DRAKE'S ESTERO

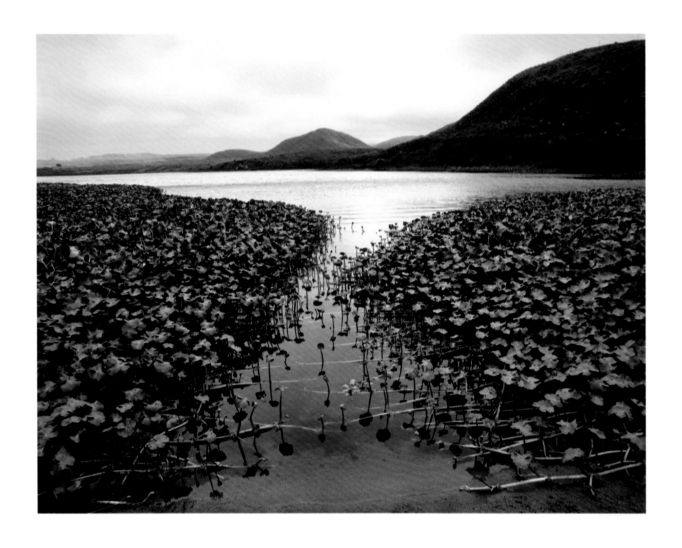

ABBOTT'S LAGOON

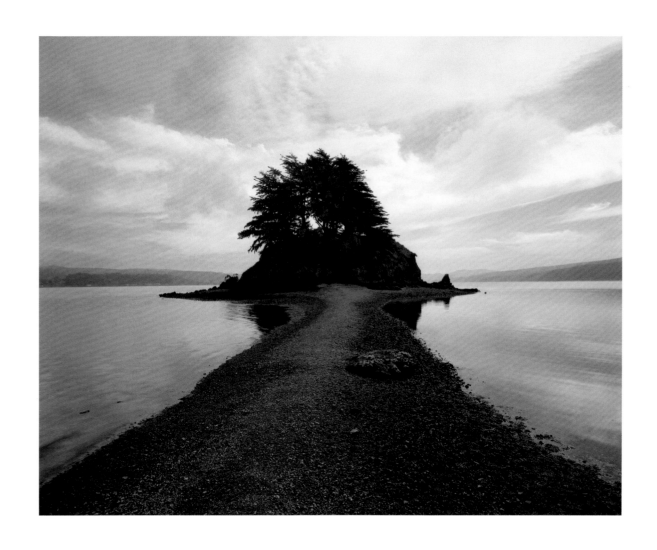

DUCK ISLAND FROM HOG ISLAND AT LOW TIDE, TOMALES BAY

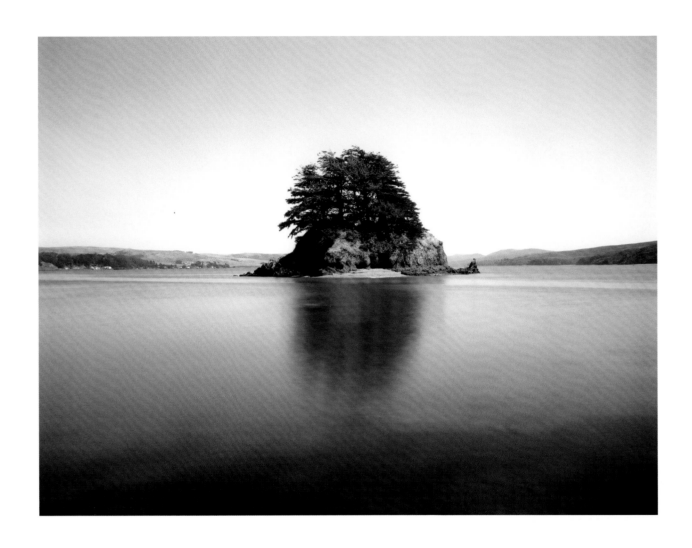

DUCK ISLAND FROM HOG ISLAND AT HIGH TIDE, TOMALES BAY

HAMLET, TOMALES BAY

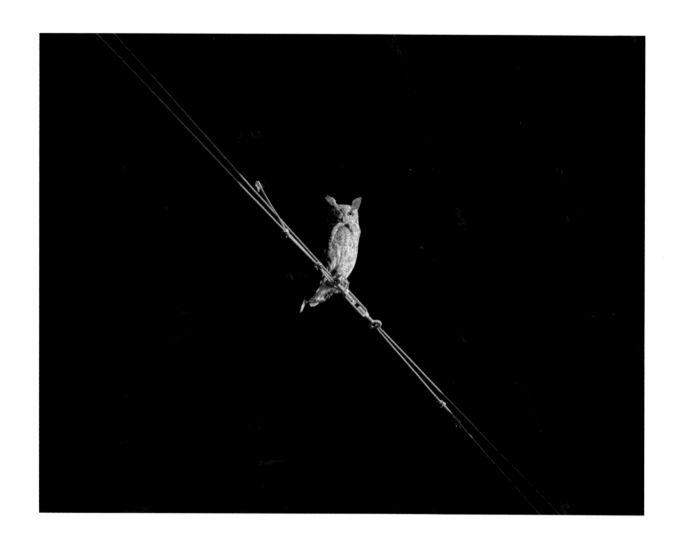

OWL, 'D' RANCH

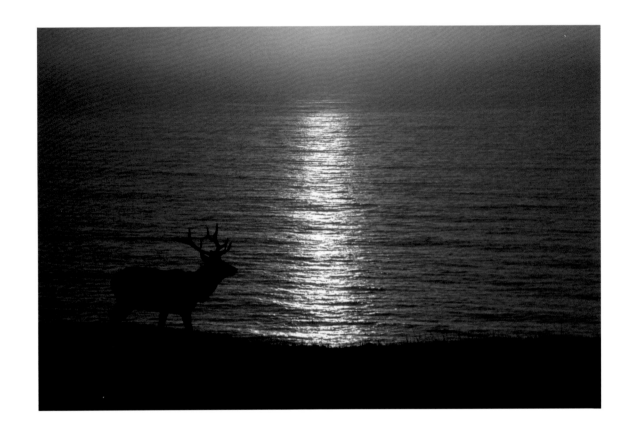

ELK AND SETTING SUN, TOMALES POINT

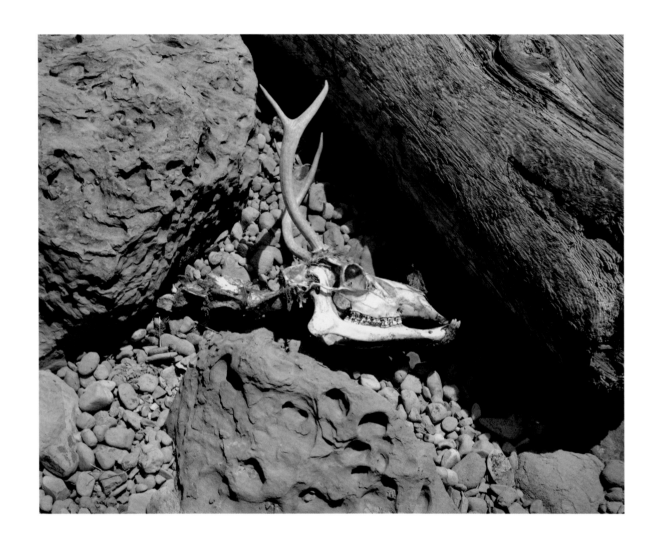

BUCK SKULL, DRAKE'S ESTERO

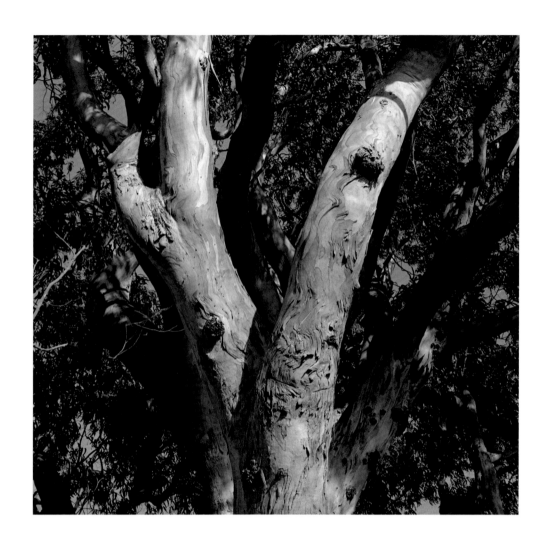

EUCALYPTUS, NEAR SCULPTURED BEACH

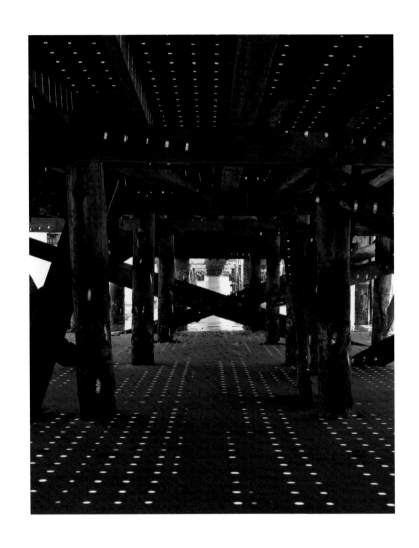

BENEATH THE PIER OF THE OLD LIFEBOAT STATION, DRAKE'S BAY

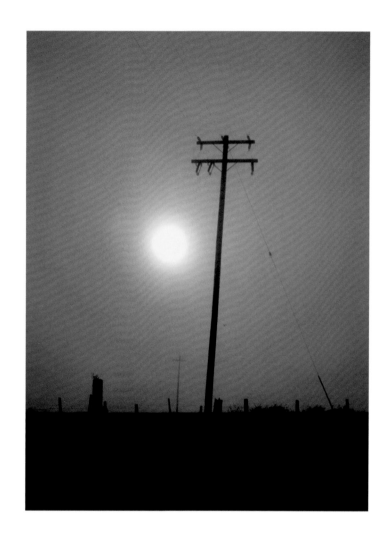

FOG AND POLES, NEAR CHIMNEY ROCK

EMPTY PARKING LOT, THE GREAT BEACH

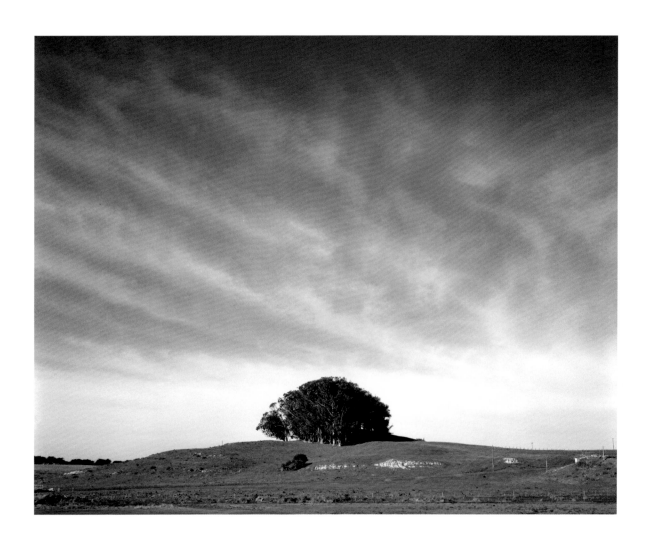

CEMETERY, ABOVE SCHOONER BAY

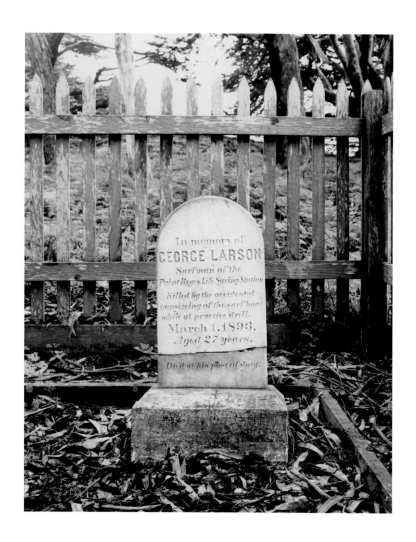

GEORGE LARSON'S HEADSTONE

FACE, THE GREAT BEACH

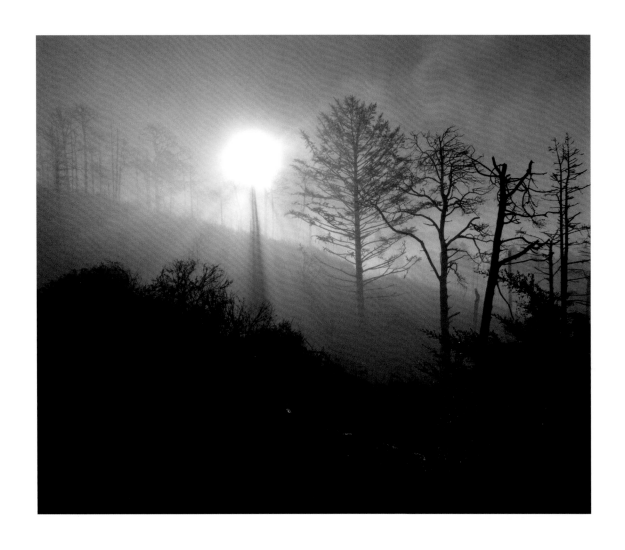

SUNRISE, INVERNESS RIDGE

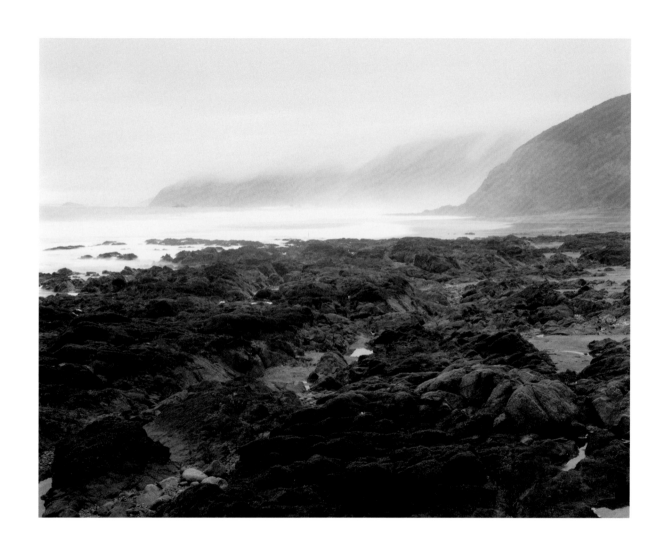

EARLY MORNING, MCCLURE'S BEACH

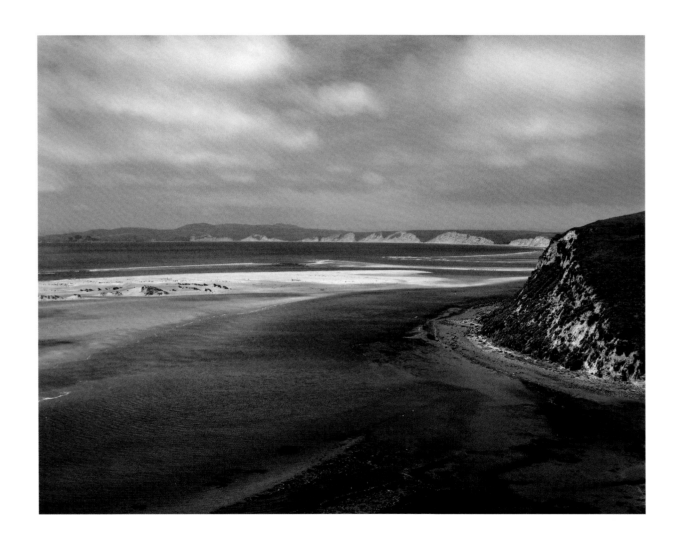

POSSIBLE LANDING SITE OF SIR FRANCIS DRAKE, LIMANTOUR ESTERO

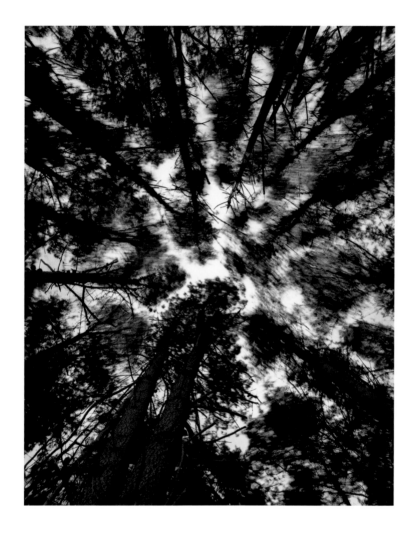

IN THE PINES

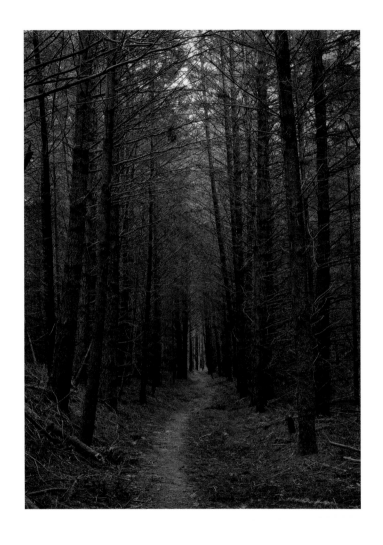

PATH, INVERNESS RIDGE

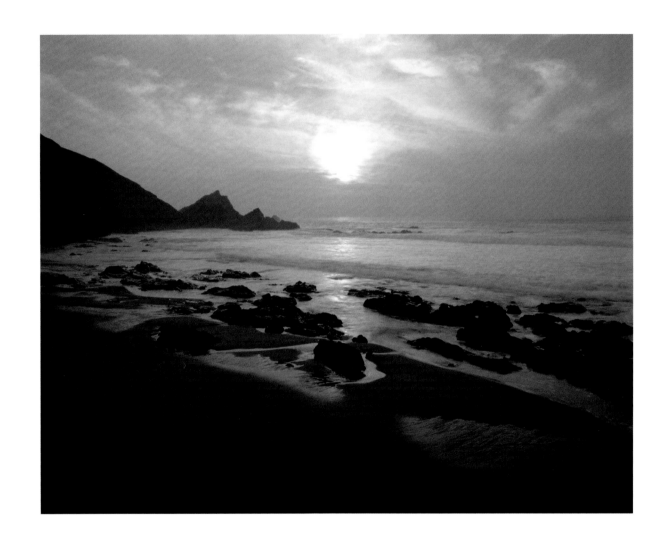

SUNSET, MCCLURE'S BEACH

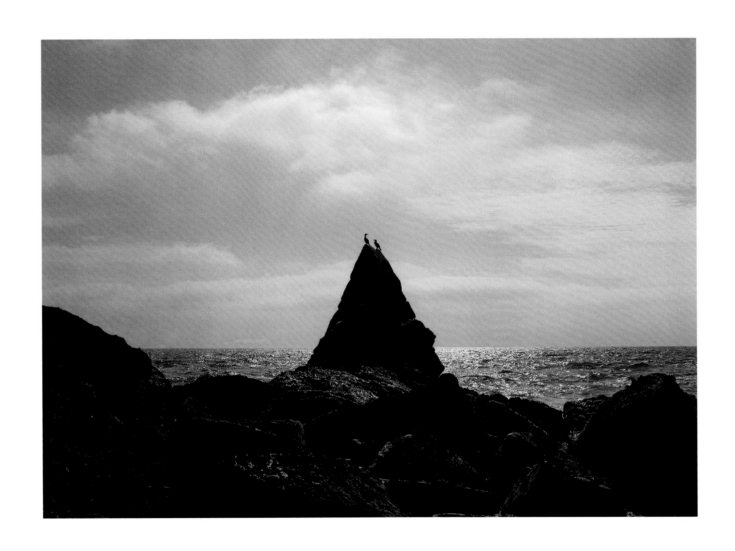

CORMORANTS, THE UNKNOWN COAST

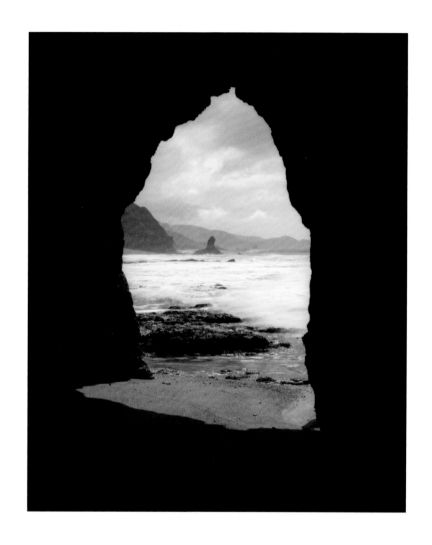

THE GATEWAY TO SECRET BEACH

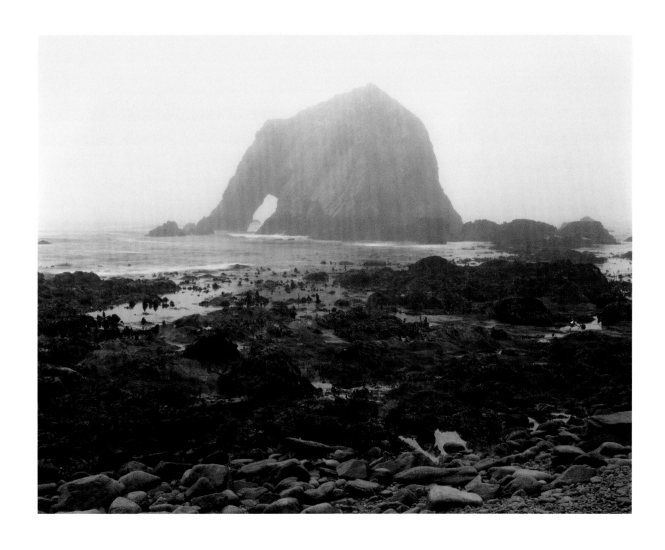

ELEPHANT ROCK FROM THE UNKNOWN COAST

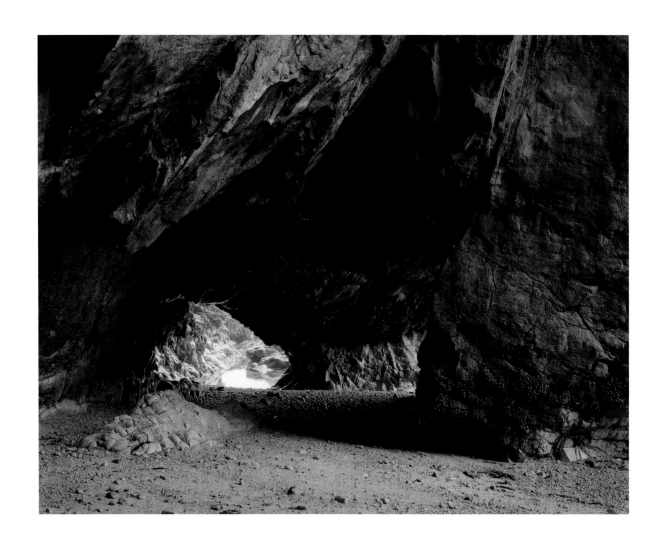

ELEPHANT CAVE, THE UNKNOWN COAST

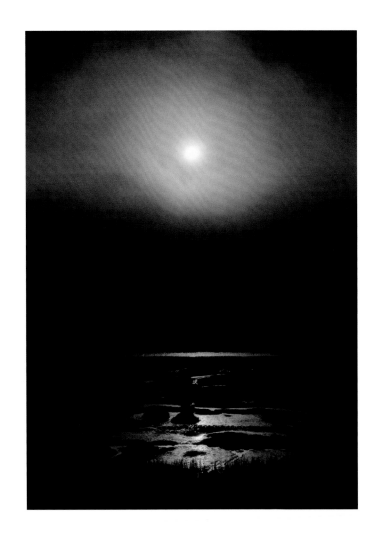

FOG AND SUN, UPPER SCHOONER BAY

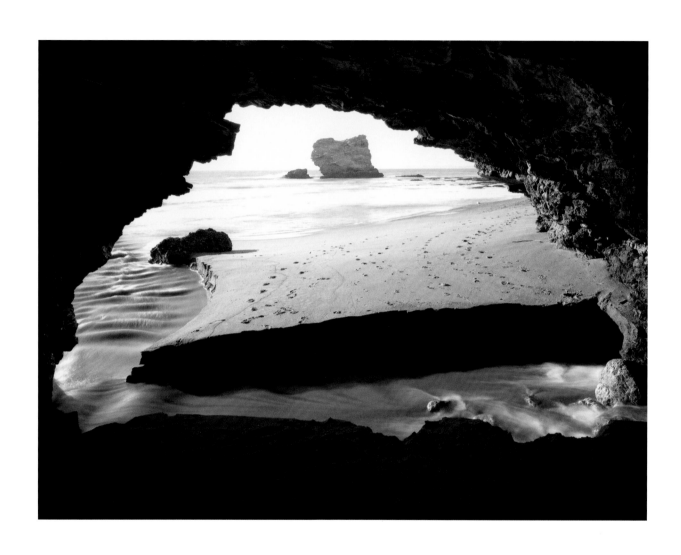

FROM INSIDE THE SEA TUNNEL, NEAR ARCH ROCK

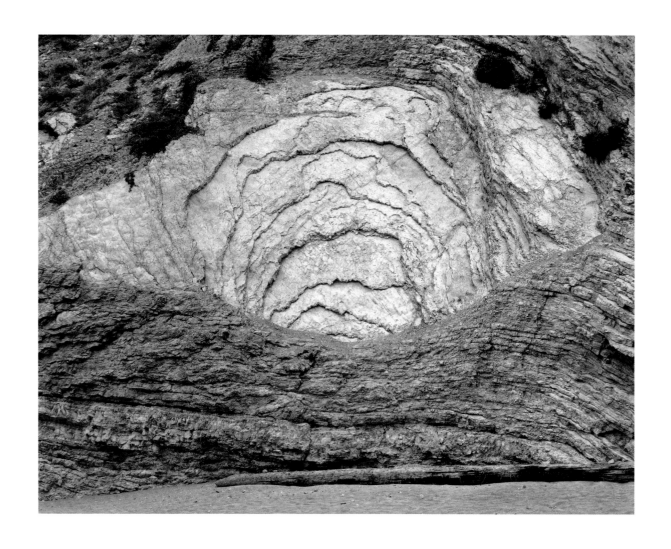

CLIFF, WILDCAT BEACH

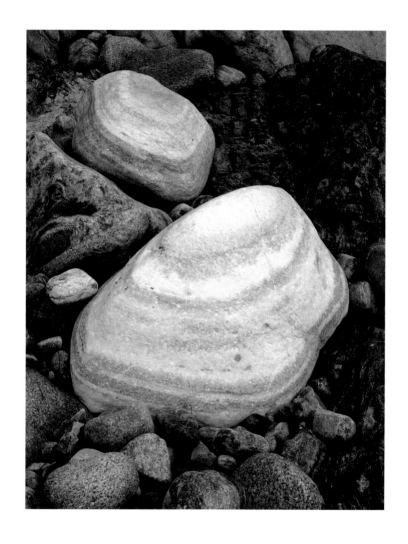

WHITE STONES, THE UNKNOWN COAST

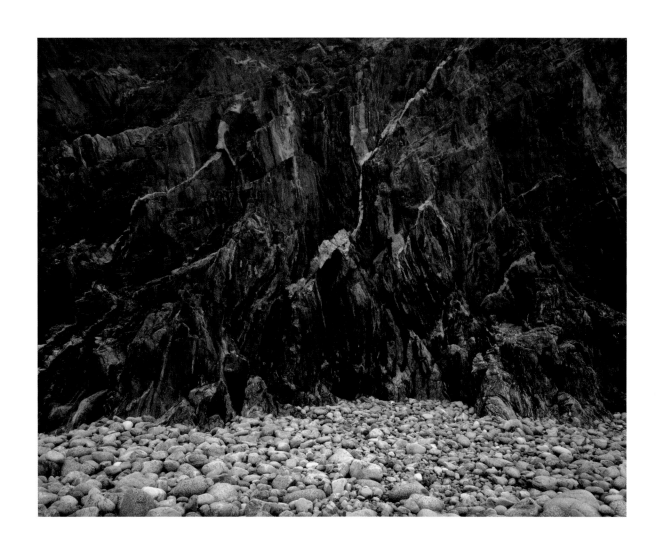

CLIFF WITH STONES, THE UNKNOWN COAST

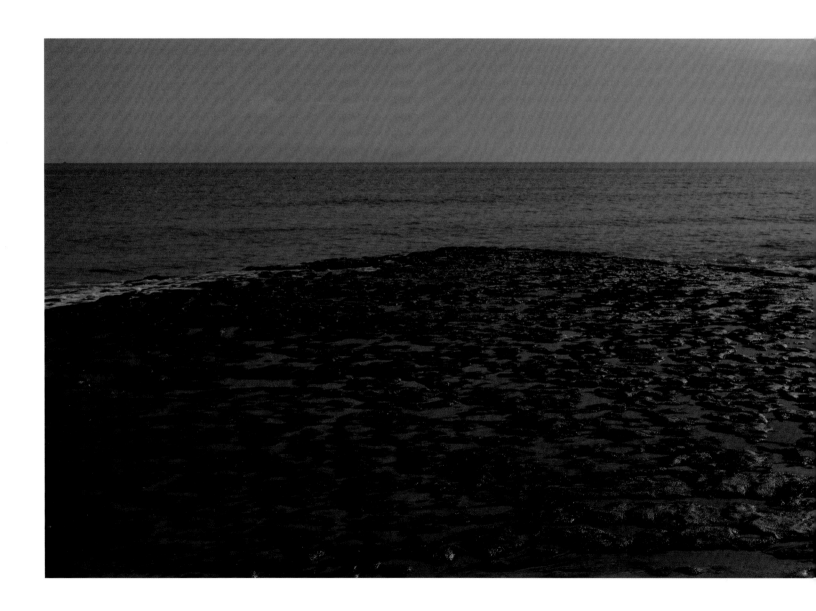

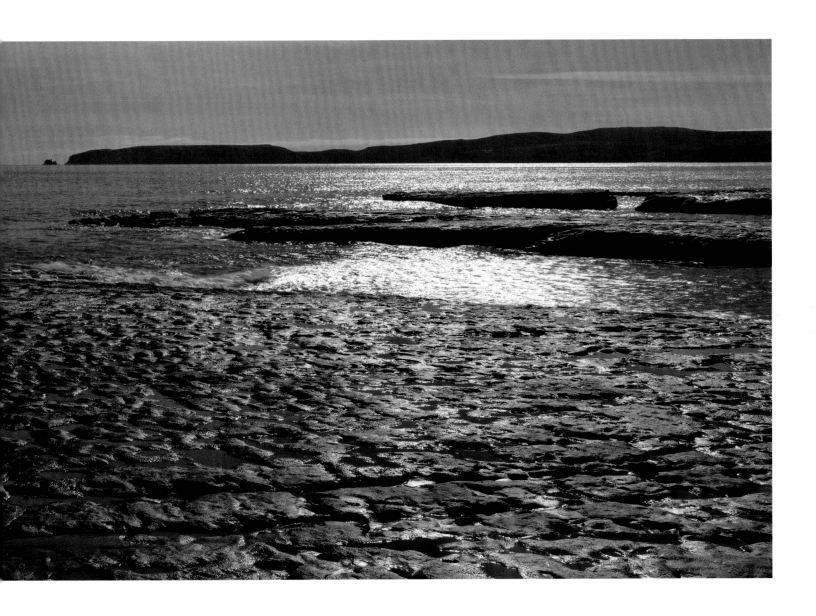

LOOKING TOWARD CHIMNEY ROCK FROM DRAKE'S BEACH

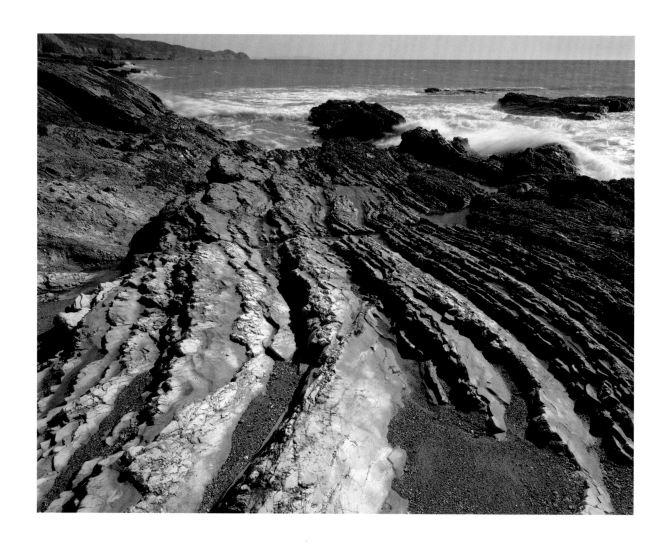

SCULPTURED BEACH

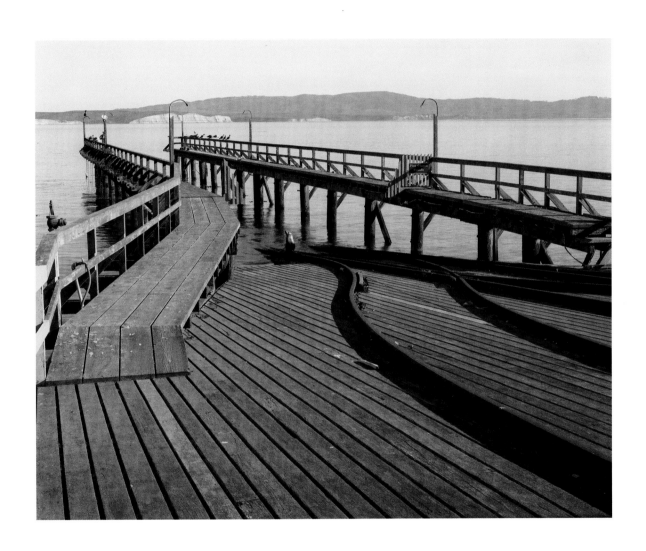

SEA LION, OLD LIFEBOAT STATION, DRAKE'S BAY

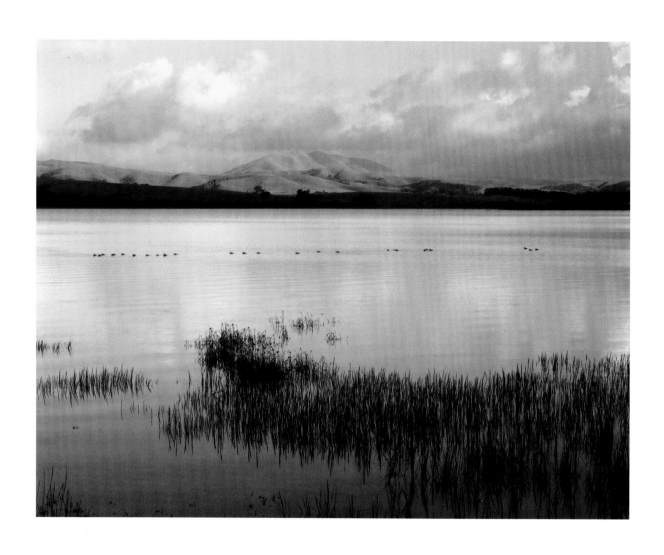

BLACK MOUNTAIN, TOMALES BAY

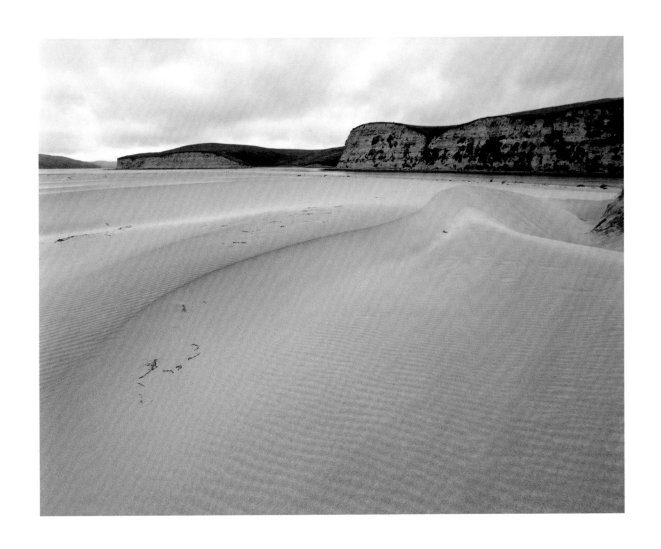

ON LIMANTOUR SPIT

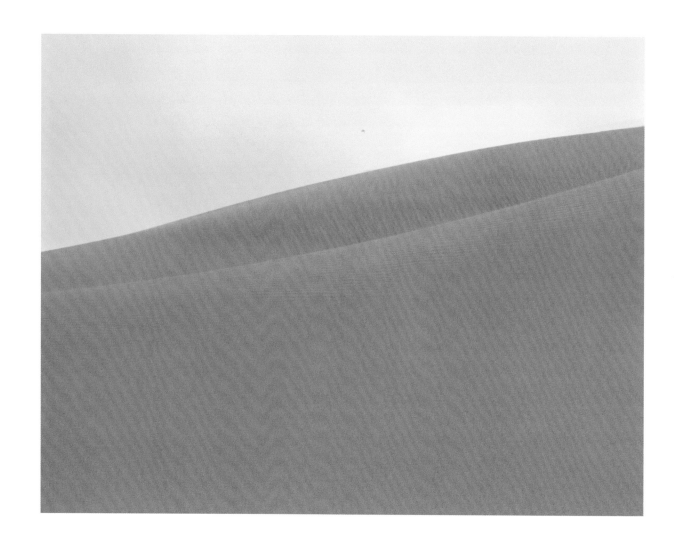

SAND DUNES, LIMANTOUR SPIT

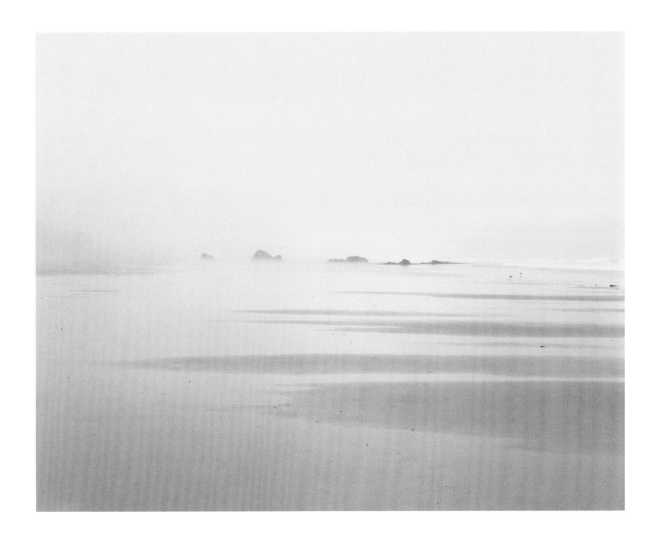

KEHOE BEACH

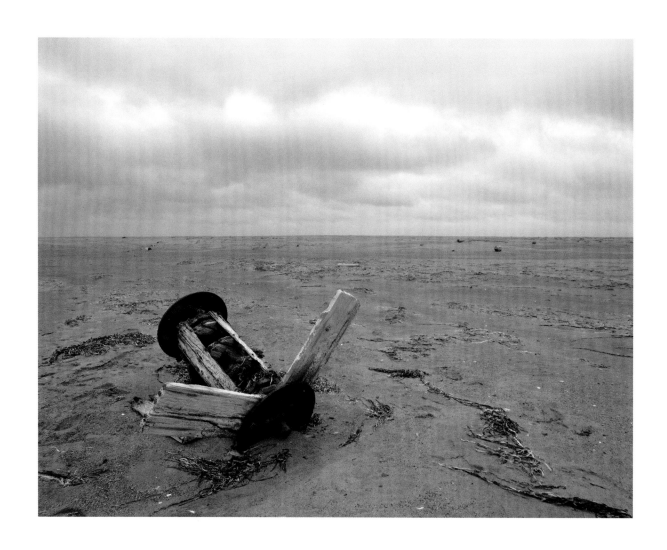

SATELLITE, LIMANTOUR SPIT

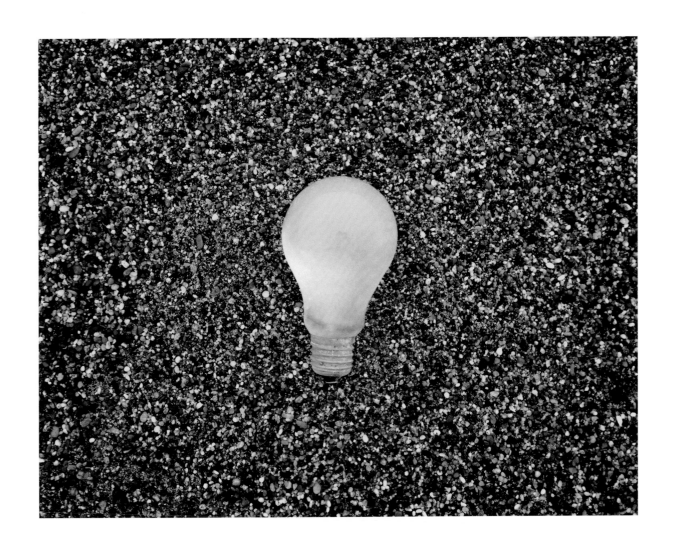

LIGHTBULB, THE GREAT BEACH

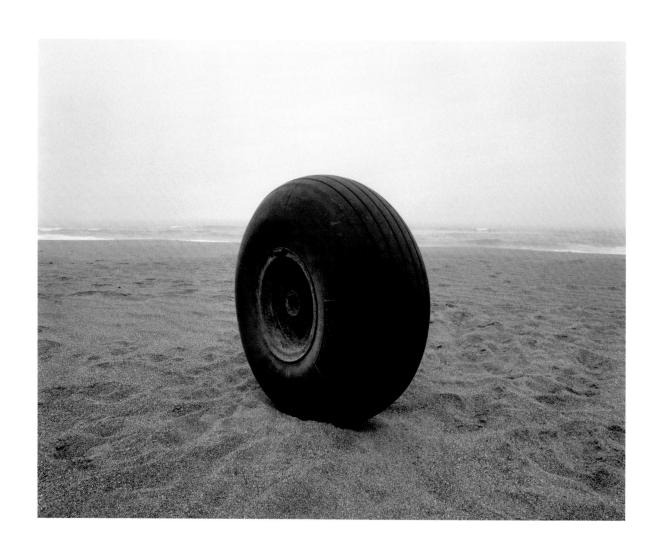

AIRPLANE WHEEL, THE GREAT BEACH

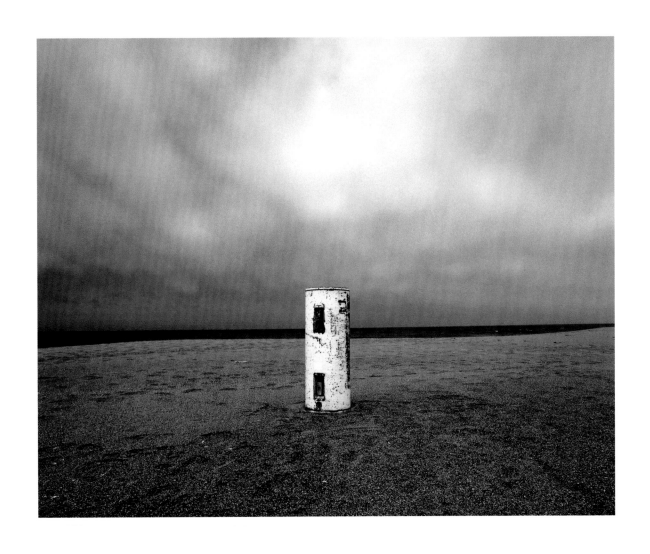

WATER HEATER, THE GREAT BEACH

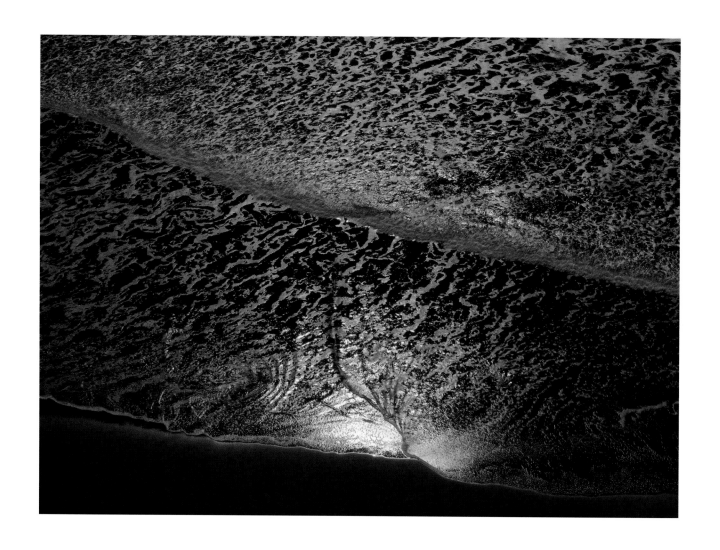

SURF, DRAKE'S BEACH

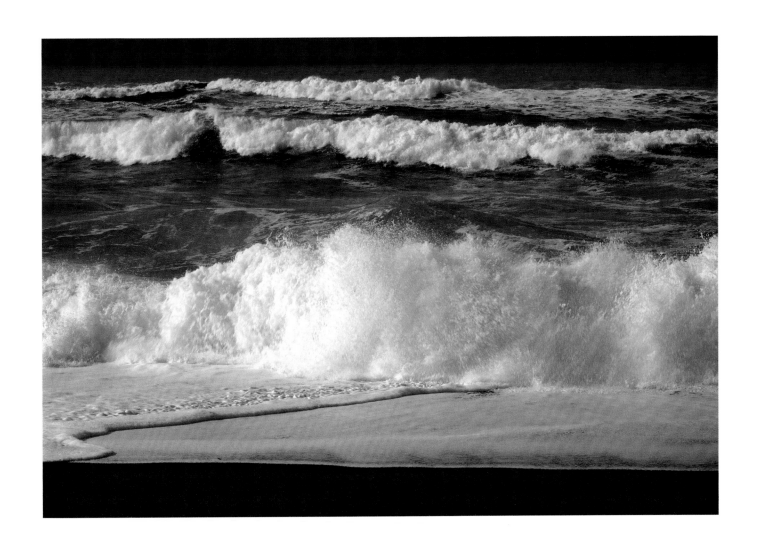

THREE WAVES, THE GREAT BEACH

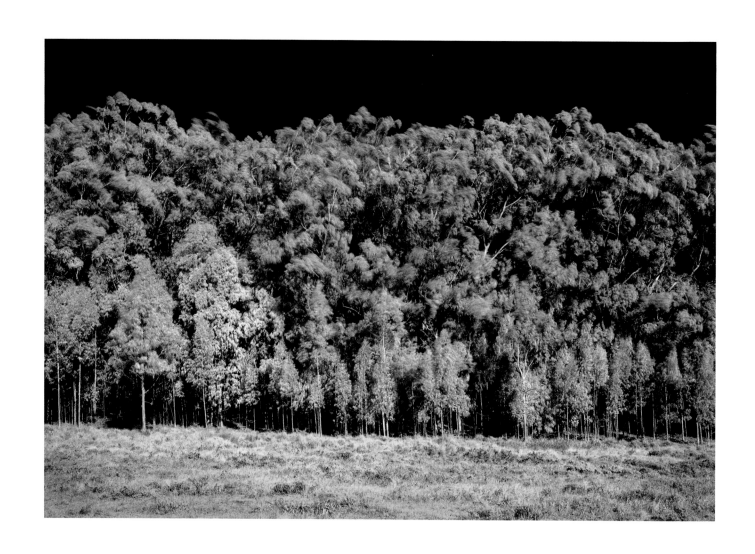

CAPTAIN CLAUSSEN'S EUCALYPTUS COLONNADE

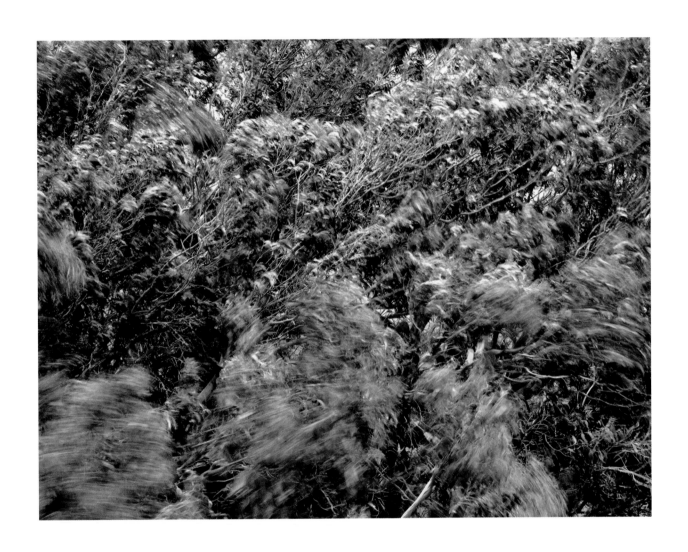

EUCALYPTUS AND WIND, DRAKE'S ESTERO

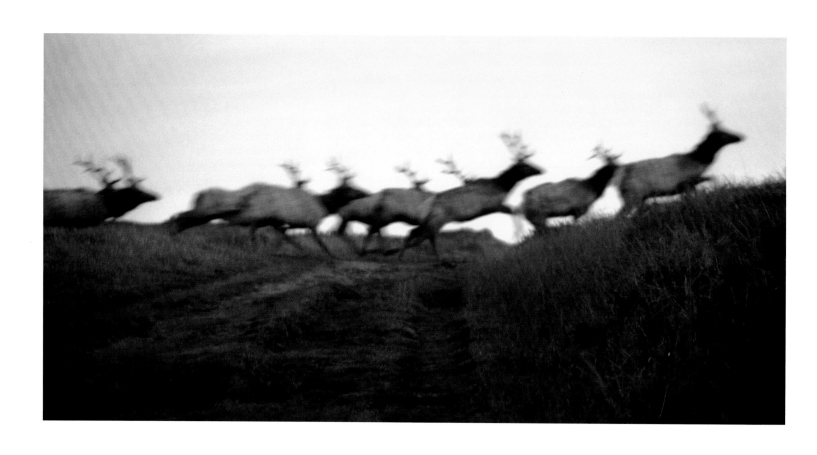

RUNNING ELK, TOMALES POINT

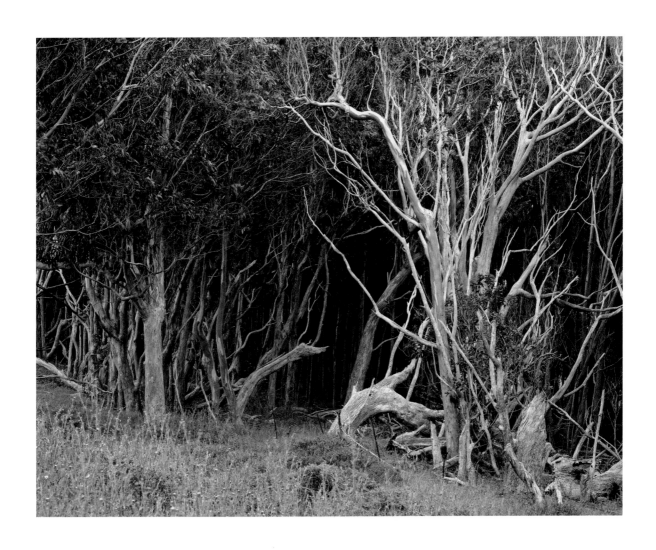

CAPTAIN CLAUSSEN'S EUCALYPTUS COLONNADE

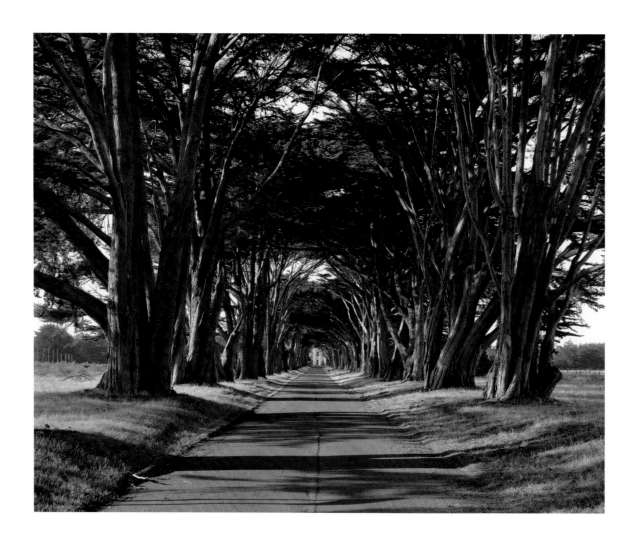

THE ROAD TO THE RCA BUILDING

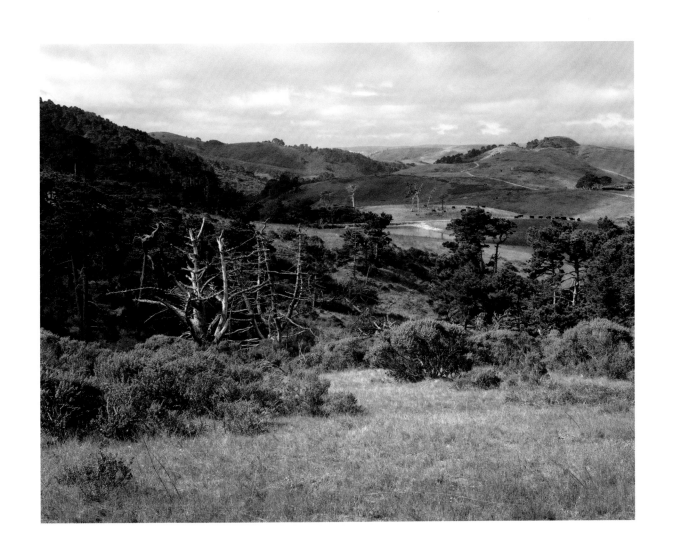

THE EDGE OF THE BISHOP PINE FOREST FROM PIERCE POINT ROAD

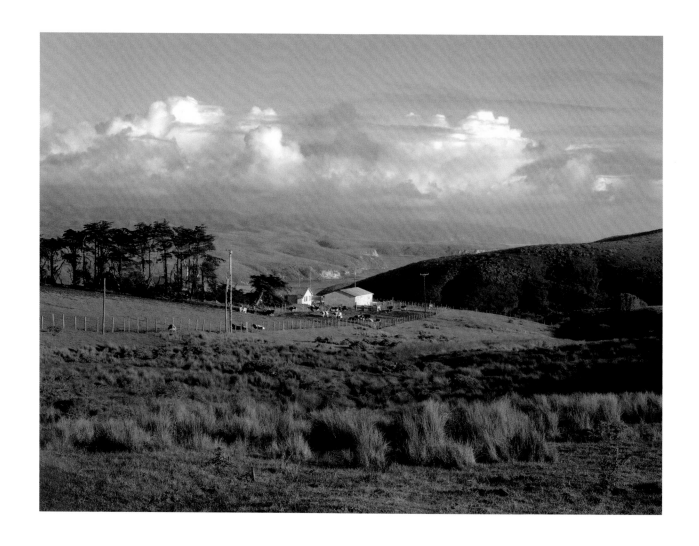

'E' RANCH

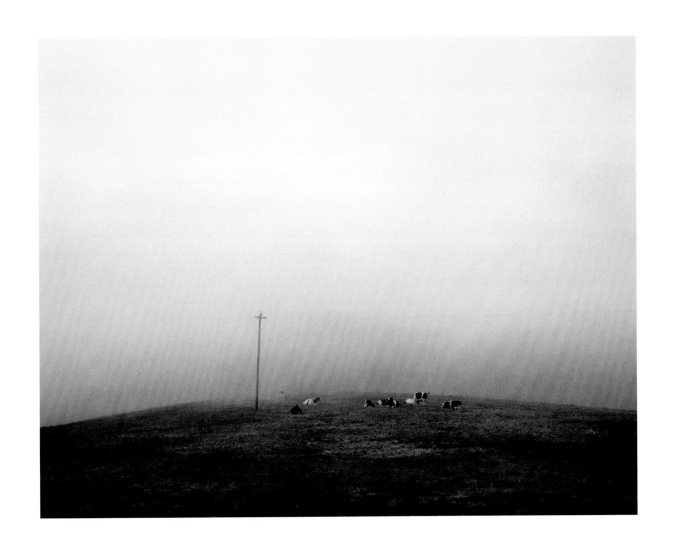

COWS AND FOG, NEAR CHIMNEY ROCK

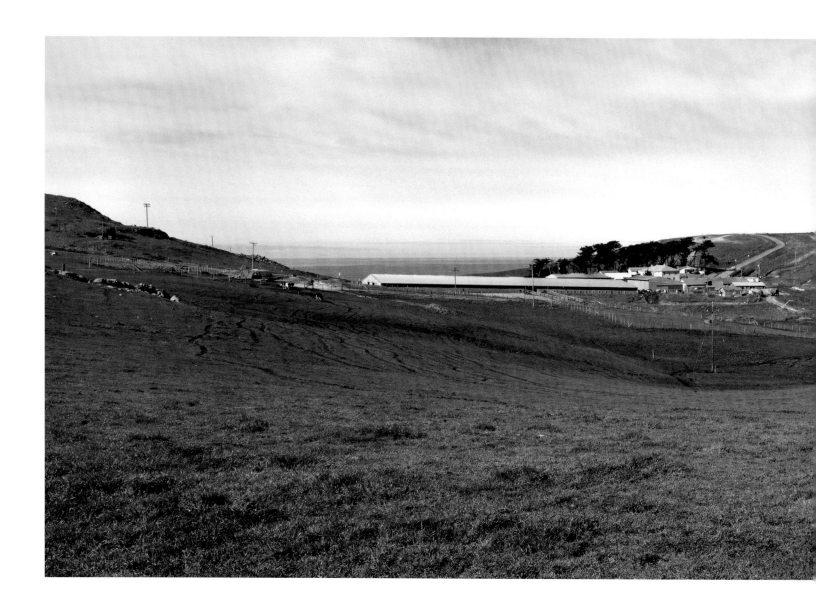

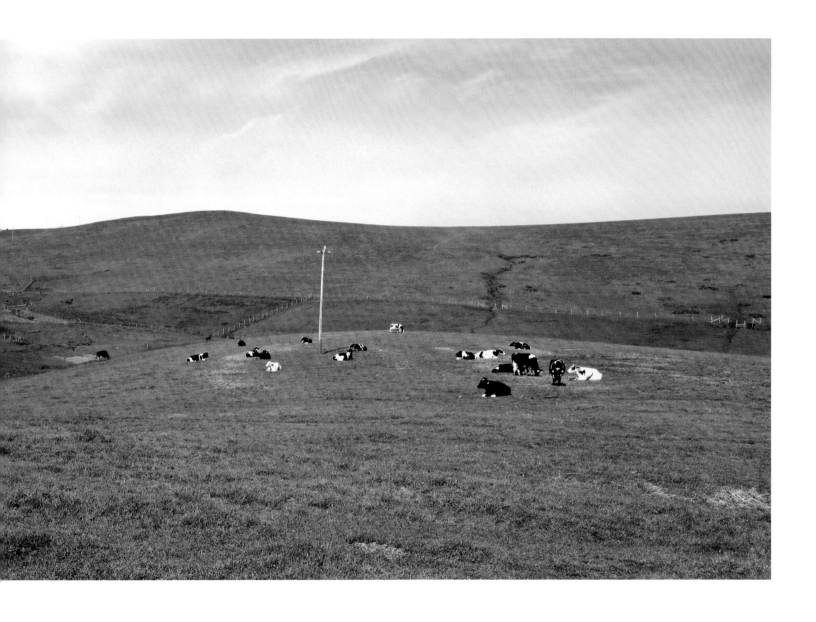

'A' RANCH

FIELD, STARLINGS, GATHERING STORM

SHIPWRECK, THE GREAT BEACH

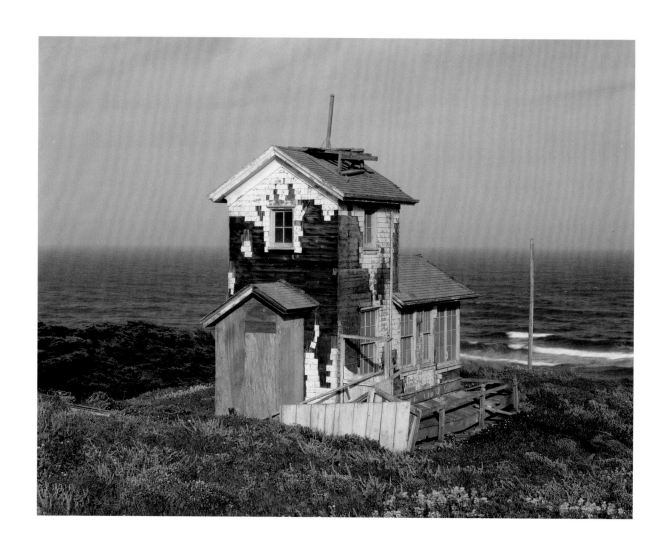

ABANDONED NAVY COMPASS STATION, THE GREAT BEACH

WINDOWS, ABANDONED NAVY COMPASS STATION

FROM INSIDE A BARN

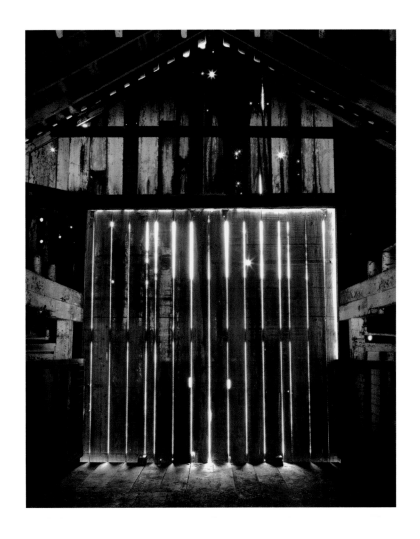

FROM INSIDE A BARN

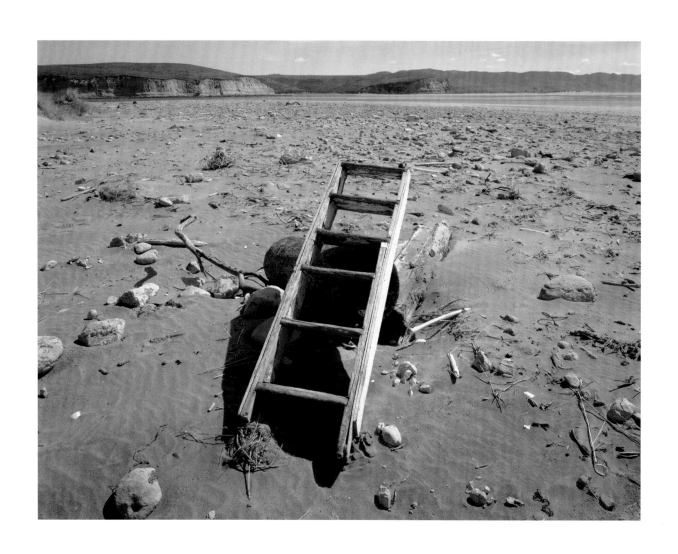

LADDER, DRAKE'S BEACH

FRIENDLY STARFISH, MCCLURE'S BEACH

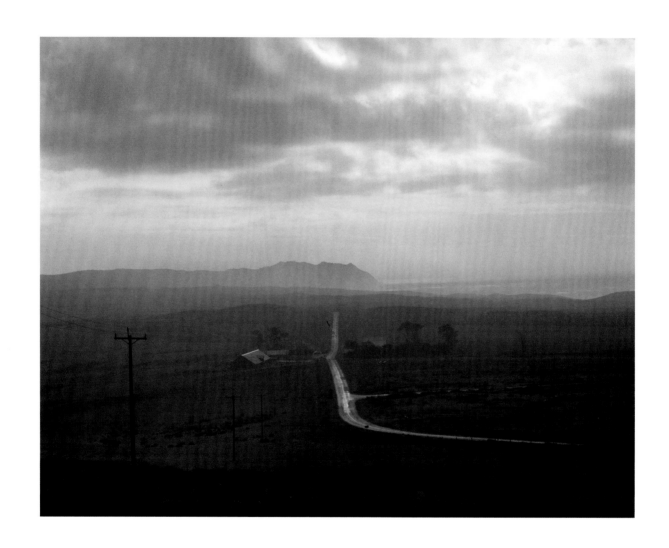

THE ROAD TO POINT REYES

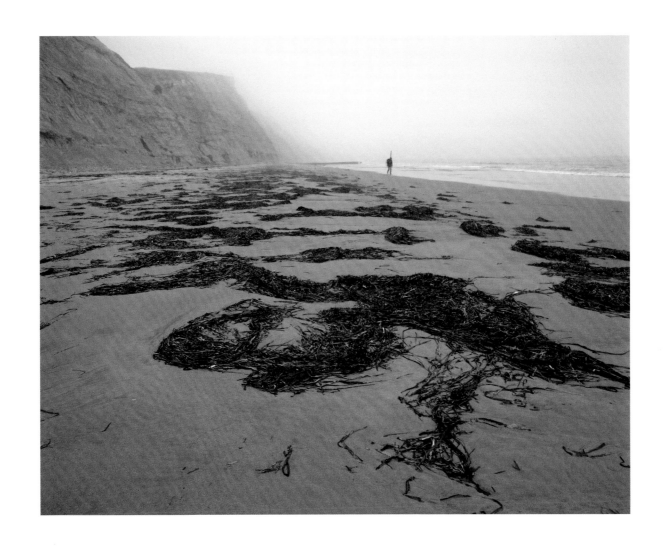

FISHERMAN, DRAKE'S BEACH

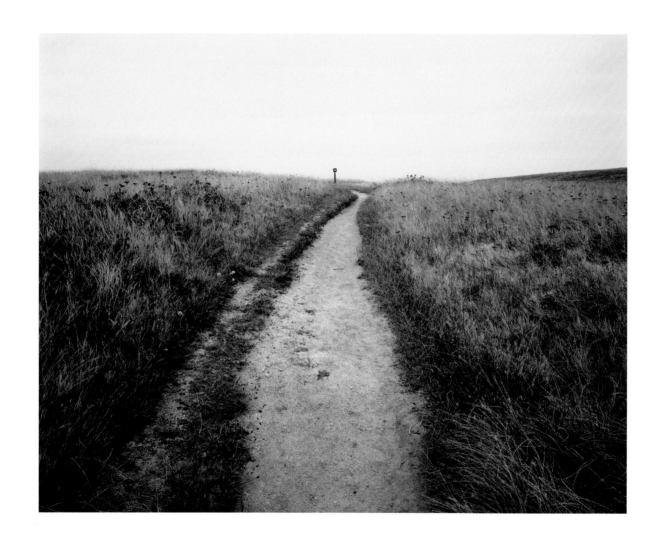

THE PATH TO CHIMNEY ROCK

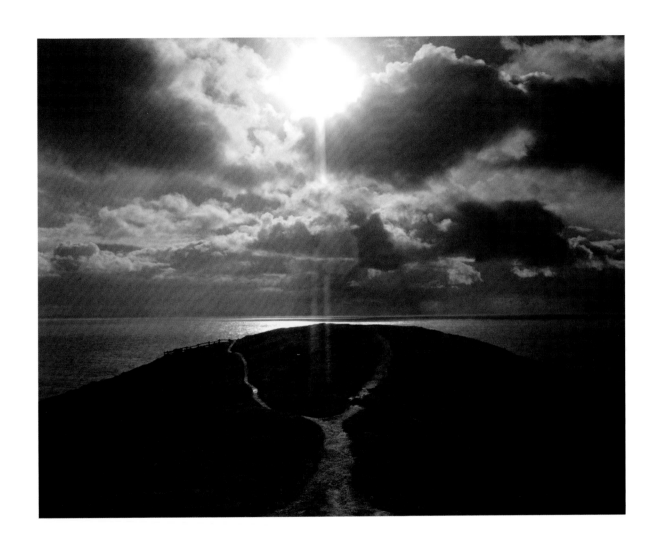

CHIMNEY ROCK, NEW YEAR'S DAY, 2005

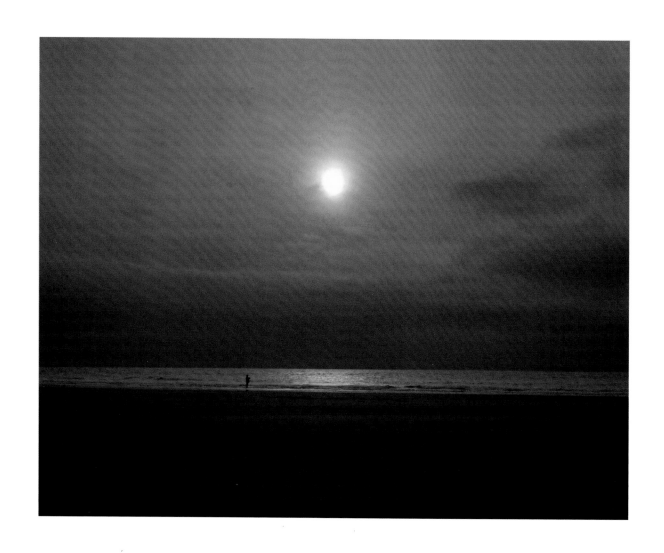

FISHERMAN, KEHOE BEACH

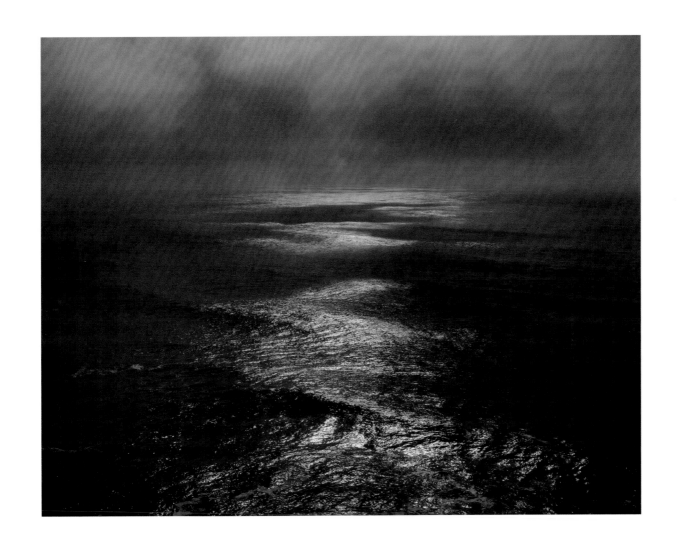

THE PACIFIC FROM CHIMNEY ROCK

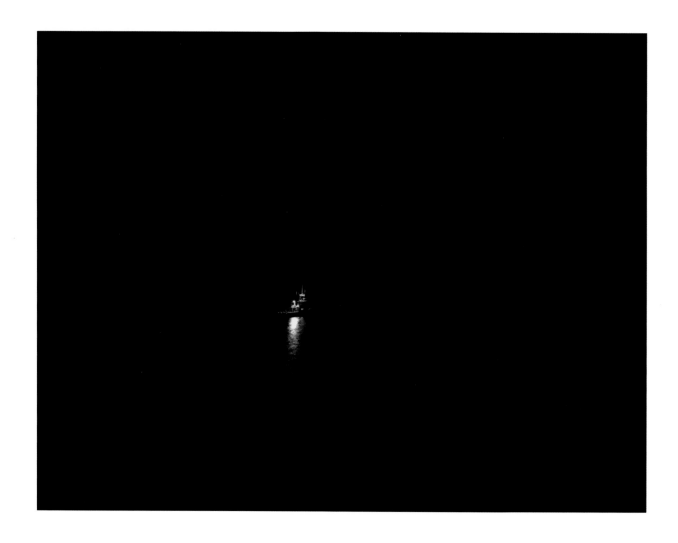

FISHING BOAT, DRAKE'S BAY

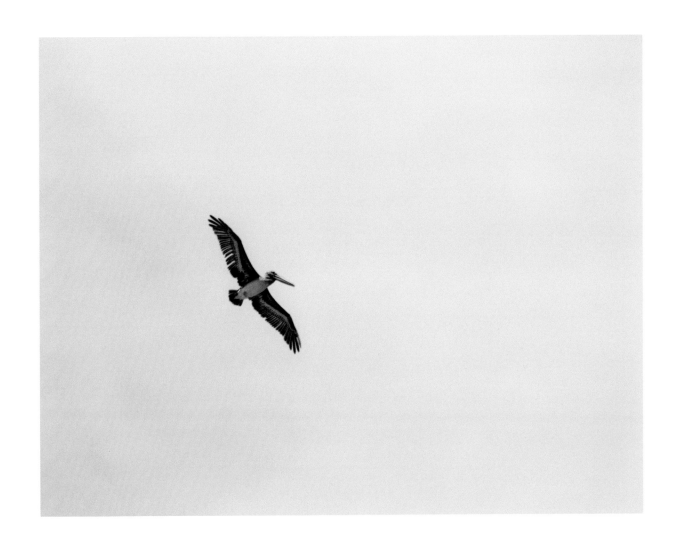

PELICAN, WILDCAT BEACH

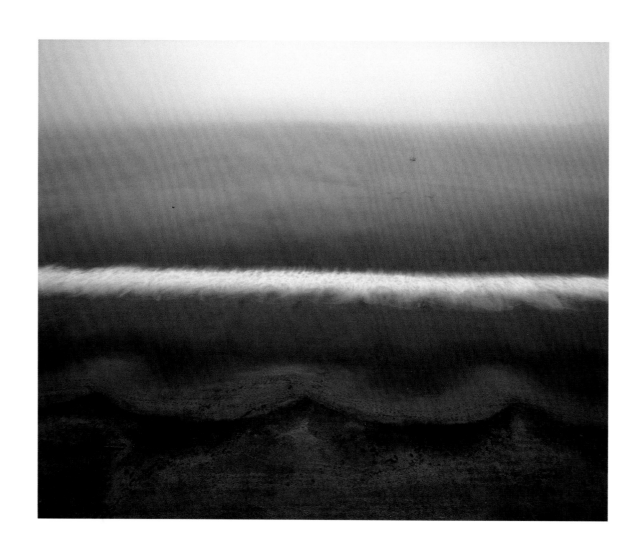

VIEW FROM THE EDGE OF A CLIFF, DRAKE'S BEACH

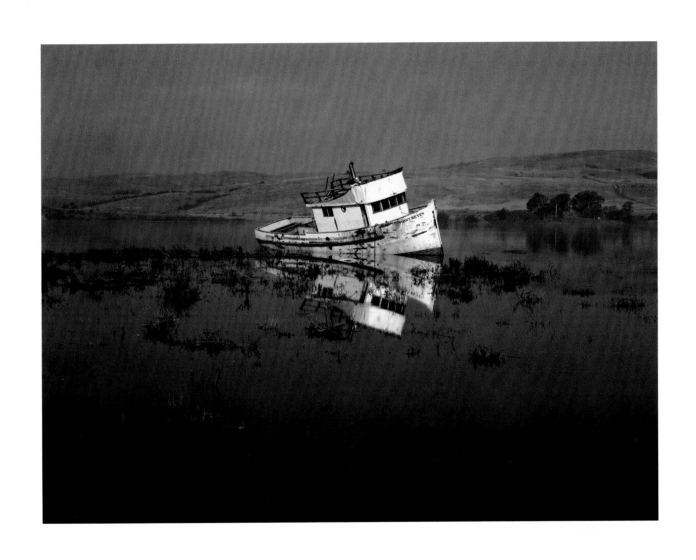

THE POINT REYES, UNUSUALLY HIGH TIDE, TOMALES BAY

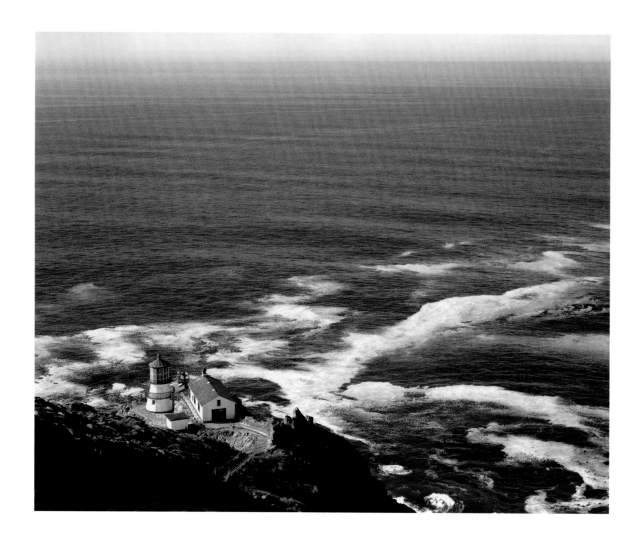

THE POINT REYES LIGHTHOUSE

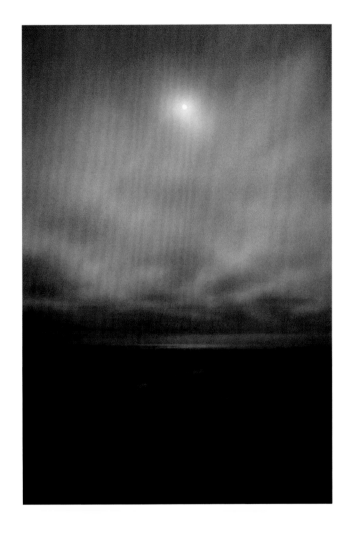

FULL MOON FROM CHIMNEY ROCK

STROLLER, ABBOTT'S LAGOON

SAND DOLLAR, BOLINAS CEMETERY

Author's Note

For reasons unnecessary to go into here, *Elegy from the Edge of a Continent* took a long and winding road to publication. In the time between my finishing the book and its finally seeing the light of day, a number of things happened on the peninsula. Vladimir Nevl, of Vladimir's Czechoslovakian Restaurant, passed away in 2008. Johnson's Oyster Farm on Drake's Estero was closed down at the end of 2014, and subsequently razed. I've no doubt that many other changes have occurred. Such is the way of things. I hope the reader will sympathize with my decision to not attempt to rewrite the book in light of an ever-changing present. Such an effort, it seems to me, would neither be desirable, nor frankly, be in keeping with the nature of reality. As we work in our rooms, the world turns on. Please know though, that in all things, I've done the best I can.

Sincerely, in earnest,

Austin Granger
November, 2015

Rest in Peace, Vladimir Nevl